THE SKETCHBOOKS OF
GEORGE
GROSZ

THE SKETCHBOOKS OF GEORGE GROSZ

Edited by Peter Nisbet

*With contributions by Catherina Lauer, Beth Irwin Lewis,
Peter Nisbet, and Beeke Sell Tower*

BUSCH-REISINGER MUSEUM
HARVARD UNIVERSITY ART MUSEUMS
CAMBRIDGE, MASSACHUSETTS
1993

This book has been published in conjunction with the exhibition *The Sketchbooks of George Grosz* held at the Busch-Reisinger Museum, Harvard University Art Museums, 32 Quincy Street, Cambridge, Massachusetts 02138, USA from 9 October to 12 December 1993.

The exhibition and publication have been made possible by the Friends of the Busch-Reisinger Museum.

ISBN: 0-916724-83-2

LIBRARY OF CONGRESS CATALOGING-IN-PUBLICATION DATA

Grosz, George, 1893–1959.
The sketchbooks of George Grosz / edited by Peter Nisbet ; with
contributions by Catherina Lauer ... [et al.].
 p. cm.
"Published in conjunction with the exhibition ... held at the Busch-Reisinger Museum ... from 9 October to 12 December 1993"—T.p. verso.
Four essays on individual sketchbooks and a complete summary catalog of all extant sketchbooks.
ISBN 0-916724-83-2
1. Grosz, George, 1893–1959—Notebooks, sketchbooks, etc.—Exhibitions. I. Nisbet, Peter. II. Lauer, Catherina, 1967–
III. Busch-Reisinger Museum. IV. Title.
NC251.G66A4 1993
741.943—DC20 93-32084
 CIP

Produced by the Publications Department, Harvard University Art Museums

DESIGN AND PRODUCTION: Eleanor Bradshaw

PROJECT EDITOR: Evelyn Rosenthal, Manager of Publications

COPY EDITOR: Caryl Morris

PHOTOGRAPHY: Rick Stafford, Photographic Services Department

PRINTING: Macdonald & Evans

CONTENTS

DIRECTOR'S FOREWORD

The Busch-Reisinger Museum is the preeminent academic center for the presentation and study of the art of the German-speaking and related cultures of Central and Northern Europe. Under the curatorship of Peter Nisbet, it has offered several exhibitions devoted to the art of modern Germany, including *Envisioning America: Prints, Drawings, and Photographs by George Grosz and His Contemporaries, 1915-1933* (1990), *El Lissitzky, 1890-1941* (1987), and *German Realist Drawings of the 1920s* (1986); and exhibitions deriving from or encouraging the work of the museum's graduate interns. The latter have included the exhibition *Paul Klee* (1993), and a catalogue of the drawings and prints by Adolph Menzel in Harvard collections, published in conjunction with the exhibition *Adolph Menzel, 1815-1905: Master Drawings from East Berlin*, organized by Art Services International (1991).

The Sketchbooks of George Grosz is in the tradition of these earlier exhibitions. It has been the major project of Catherina Lauer's internship, which was funded by the Friends of the Busch-Reisinger Museum, to whom we are sincerely grateful, and, like the Menzel catalogue project mentioned above, casts light on objects in other Harvard collections: in this case, the drawing collection of the Fogg Art Museum, which includes important sketchbooks by Jacques-Louis David, John Singer Sargent, and George Grosz, among others.

For the success of this exhibition we are indebted to numerous individuals, but none more than Peter and Martin Grosz, sons of the artist, and Peter's wife, Lilian Grosz. Representing the George Grosz Estate or themselves, they kindly lent more than 190 sketchbooks for study, publication, and exhibition. The chance to have the sketchbooks in-house for many months, allowing us to pore over their contents and subject them to careful scrutiny, ensured the thoroughness of the exhibition catalogue. In this respect, the Groszes continue to support the scholarly examination of their father's work, which they began in 1982 with the gift of the George Grosz Papers to Harvard's Houghton Library. We thank them for entrusting the sketchbooks to our care for the past many months.

The publication of the exhibition's catalogue was made possible by a grant from the Friends of the Busch-Reisinger Museum. Their ongoing generous support has been crucial to the success of the Museum and its programs. Founded in 1983, the Friends have been led until this year by Dr. Arend Oetker. We wish here to acknowledge our deep gratitude for his extraordinary commitment to the Museum and the Friends.

Our final thanks go to the authors of the catalogue, Peter Nisbet, Beth Irwin Lewis, Beeke Sell Tower, and Catherina Lauer. Their contributions enhance the Busch-Reisinger's reputation as a center for scholarship, and serve to remind us of the Museum's special role in this country as a leader in the effort to understand and appreciate better the art of modern Germany.

JAMES CUNO
Elizabeth and John Moors Cabot Director
Harvard University Art Museums

EDITOR'S INTRODUCTION

"From the Inside Pocket"

In the mid-1950s, George Grosz was contemplating the publication of a number of his sketchbooks. He discussed the plan in correspondence with his brother-in-law, Otto Schmalhausen in Berlin, who had found an interested publisher. When the question of a title for the proposed book came up, Grosz's suggestions included "The Pencil Is Not Stupid (If You Leave It Alone)" and "In Hogarth's Tracks." Another idea was "From the Inside Pocket."[1]

Grosz's plan at the time focused only on his later sketchbooks, especially his teaching notebooks and the sketchbooks he used on his arrival in New York City in the early 1930s; he remained adamantly opposed to publishing any earlier sketchbooks.[2] Nevertheless, "From the Inside Pocket" seems very appropriate as a motto for the present publication, a first introduction to the full range of his extant sketchbooks. The artist's inside pocket contains metaphorically what ours does literally: private evidence of identity, private resources, private papers—all kept close to the chest (indeed, to the heart), hidden. The sketchbooks surveyed in this publication, and displayed in the exhibition that it accompanies[3] do consistently show a relatively unfamiliar side of the artist, certainly for those inclined to think of (or to value) Grosz only in terms of his political and social "caricatures" produced during the Great War and the Weimar Republic that resulted from it.

This received view of Grosz is well summarized by the assessment that he produced "a magnificent visual pathology of a bankrupt society."[4] More specifically, Grosz is famous and admired for his "inexhaustible stock of profiteers, bloodthirsty generals, bald-headed lechers, kinky Mafiosi, and greedy prostitutes."[5] There are certainly glimpses of this Grosz in the sketchbooks, but they are rare. For example,

no sketchbooks are known between late 1918 and mid-1922, precisely the period of Grosz's greatest productivity as an intensely political satirist.[6] Instead of reinforcing this limited and limiting perspective, the present focus on the sketchbooks allows other less familiar aspects of the artist's long career to emerge from relative obscurity. In particular, the sketchbooks encourage attention to the artist's early years in Dresden and Berlin before the Great War; to his visits to Paris, the south of France, and other vacation spots during the 1920s; to the profound response to landscape in the later years; and to the content and method of the artist's teaching in New York.[7]

These episodes of Grosz's creative career are, of course, not wholly unknown. Nor should the existence of the sketchbooks count as a surprising revelation (though the total number of two hundred known, extant sketchbooks is perhaps unexpected). The careful reader of scholarship on Grosz over the years will have noticed many passing references to individual sketchbooks; some, indeed, have been widely published.[8] Nevertheless, a study of the sketchbooks *in extenso*, combining an in-depth study of four individual sketchbooks (with pages reproduced in their proper orientation) with a summary catalogue of all known, surviving sketchbooks, can prompt some new reflections.[9]

Sketchbooks, for all their multiple uses, are generally regarded as evidence of the artist's most immediate, unreflective activity. Visual diaries for recording drawings and dreams,[10] observations, and imaginations, these small volumes comfortably accommodate records of rapidly noted things and people seen; telephone numbers; compositional ideas; appointments; lists of books read; careful explorations of multiple views of a single subject; fantasies and facts. Examples of all these uses can be found in Grosz's sketchbook practice,

which extends over five decades, from 1905, when the artist was twelve years old, to 1958, the year before he died.

One recurring issue that is surely central to an evaluation of Grosz's achievement is the relative importance of the specific and the general in his work. To what extent is his work rooted in perceived reality, and to what extent in received archetypes and schemata? Time and again his sketchbooks prompt reflection on this by raising the question of his indebtedness to other models, other artists. Even the very first sketchbook alerts us to ways in which Grosz learned to draw, and to see, through imitating other masters, not just in their styles but in their very mode of thinking. Sketchbook 1905/1 includes copies after illustrated stories by Wilhelm Busch, after sentimental-romantic scenes by Ludwig Richter, after history paintings by Adolf Menzel, and, appropriately, after a page in a sketchbook by the Munich genre painter, Eduard Grützner.[11] This sense of indebtedness to tradition, discussed most fully by Beeke Sell Tower in this catalogue, continues throughout his life. Early drafts of his autobiography indicate that the title page was to have included dedications to several important influences, including Adolf Menzel, whose legendary industriousness and power of observation Grosz admired deeply.[12]

Even in his famous social and political caricatures, a tension seems to exist between abstracted satire and concrete specificity: sketchbook 1915/2, discussed by Beth Irwin Lewis in this catalogue, shows how much Grosz's caricatural types and emblems of social classes were perhaps also portraits of specific individuals, named in the captions to the drawings. Were Grosz's "trademark" faces derived from known people, from observation of anonymous individuals glimpsed from afar, from the artist's angry imagination, or even from very specific art-historical models?[13] Even those sketchbooks that seem

to be the most powerful evidence of Grosz as a relentless observer—those filled in the streets of New York such as the one discussed by Catherina Lauer in this catalogue—seem less spontaneous when measured against their intellectual roots in the artist's obsessive fascination with New York before his arrival and against the synthetic merging of many individual details in the almost collagelike, worked-up, full-scale watercolors of New York scenes.

In producing this catalogue and exhibition, the authors and editor hope to contribute to a more nuanced, intricate understanding of one of the great draftsmen of our century. In due course, the sketchbooks will surely offer up new insights for students of many particular aspects of Grosz's work, especially when combined with new research into other areas of his career.[14] The present publication should act as a catalyst for renewed attention to Grosz in this, the centennial year of his birth.

PETER NISBET

Daimler-Benz Curator
Busch-Reisinger Museum

NOTES

1. Grosz to Otto Schmalhausen, 1 March 1956, The George Grosz Papers, Houghton Library, Harvard University, bMS Ger 206 (807): "der Bleistift ist nicht dumm, (wenn man ihn allein laesst)," "…auf Hogaerth's [sic] Spuren…," "aus der Innentasche."

2. See his letter to Schmalhausen, 21 January 1947, ibid., in which he begs him not to publish any earlier work by him, including any sketchbook, all of which he declares to be "crap" [Scheiße]. "The earlier sketchbooks, along with some other works, recall for me (sadly and sentimentally) a time in which I was happier than to-day, and in which I still had stupid illusions…" (Die früheren Skizzenbücher nebst einigen anderen Arbeiten, bringen mir (sentimentalisch traurig) eine Zeit wieder nahe, in der ich glücklicher war als heutzutage und wo ich noch dumme Illusionen hatte…).

3. The illustrations in the present volume have not been chosen to match the page openings exhibited. Moreover, the exhibition included a number of prints and fully

worked-up drawings as comparative material. A full checklist detailing the contents of the exhibition is available from the Busch-Reisinger Museum.

4. Beth Irwin Lewis, *George Grosz. Art and Politics in the Weimar Republic*, rev. ed. (Princeton, 1991 [1971]), p. 212.

5. Gert Schiff, "Arcadia and Human Wasteland (Exhibition review of *German Realism of the Twenties: The Artist as Social Critic*, exh. cat. Minneapolis Institute of Arts [Minneapolis, 1980]" in *Art Journal* 41, no. 1 (Spring 1981): 68.

6. The Summary List of Sketchbooks preceeding the Catalogue of Sketchbooks (p. 148) gives a good over view of the rhythm of Grosz's production. There is, of course, a strong likelihood that a number of sketchbooks have been lost or destroyed. For an explanation of the numbering of sketchbooks used in this publication, see p. 146.

7. Of course, this volume does not aspire to a comprehensive survey of Grosz's career. It should be read in conjunction with the several available assessments of the artist's achievement, notably Hans Hess, *George Grosz* (New Haven and London, 1985 [1974]), M. Kay Flavell, *George Grosz. A Biography* (New Haven and London, 1988), and Lewis, *Grosz*, which contains an excellent bibliography. Readers with German should also consult the artist's selected letters, George Grosz, *Briefe 1913-1959*, ed. Herbert Knust (Reinbek, 1979), and the catalogue raisonné of his prints, Alexander Dückers, *George Grosz. Das druckgraphische Werk* (Frankfurt/Main, 1979).

8. This applies especially to three of the four sketchbooks in public collections: two in the Akademie der Künste in Berlin, which have been reproduced in facsimile (see the entries for 1917/2 and 1932/4), and one in the Fogg Art Museum (1950/7), from which pages have often been illustrated.

9. All known, surviving sketchbooks are numbered and inventoried on pp. 148-149 of this catalogue according to the criteria explained on p. 146.

10. Cf. Lawrence Gowing on "the habit of drawing and the habit of dreaming" in Cézanne's sketchbooks, in *Paul Cézanne: The Basel Sketchbooks*, exh. cat. by Lawrence Gowing, Museum of Modern Art, New York (New York, 1988), p. 11, and Theodore Reff on the same artist's use of sketchbooks "to record a fleeting observation or to seize again a recurrent dream" in *Paul Cézanne. Two Sketchbooks*, exh. cat. by Theodore Reff and Innis Howe Shoemaker, Philadelphia Museum of Art (Philadelphia, 1989), p. 8.

11. See "From Eduard Grützner's sketchbook. Mountain Guide," (1905/1, 20 recto), which Grosz copied on 11 October 1907 from a monograph that he owned, Fritz von Ostini, *Gruetzner*, Künstler-Monographien 58, (Bielefeld and Leipzig, 1902), p. 81, fig. 72.

12. Drafts of Grosz's memoirs, subsequently published as *A Little Yes and a Big No: The Autobiography of George Grosz* in 1946 and later in various German and revised English versions, are in Special Collections, The Getty Center for the History of Art and the Humanities, Los Angeles.

13. Hanne Bergius provocatively and convincingly juxtaposes a grossly bestial profile from Grosz's 1920 print portfolio *Gott mit Uns* and its putative model from a sixteenth-century painting (at Versailles) of Philip the Good's court jester, in her essay "Berlin: A City Drawn. From the Linear Network to the Contour," in Peter Nisbet, ed., *German Realist Drawings of the 1920s*, exh. cat., Busch-Reisinger Museum, Harvard University Art Museums (Cambridge, Mass., 1986), pp. 26 f. (figs. 14 and 15).

ACKNOWLEDGMENTS

Our greatest debt of gratitude in this project is owed to the Estate of George Grosz, both for lending the vast majority of the sketchbooks covered by our undertaking, and also for granting permission to reproduce and quote images and words by the artist, to which it holds copyright. Represented by Peter M. Grosz and Martin O. Grosz, the Estate has offered unfailing support and cooperation to *The Sketchbooks of George Grosz*. We are also enormously grateful to Peter and Lilian Grosz for making available the sketchbooks which they own privately, for their hospitality to Catherina Lauer during a research trip to the Estate, and for responding quickly and patiently to many inquiries of many different kinds. One of the great pleasures of working on George Grosz is the opportunity for regular contact with Peter and Lilian, and we are delighted once again to have enjoyed their company on this project.

We are proud that this publication has been enriched by contributions from two leading scholars of Grosz's work, Beeke Sell Tower of the Goethe-Institut Boston, and Beth Irwin Lewis of the College of Wooster, Ohio. Both colleagues contributed a great deal beyond their superb catalogue essays, and we thank them warmly. We also received help, information and advice from Sherwin Simmons, Ralph Jentsch, and from the Special Collections, Getty Center for the History of Art and the Humanities, Los Angeles; the Akademie der Künste, Berlin; the Whitney Museum of American Art, New York; the Metropolitan Museum of Art, New York; and the Solomon R. Guggenheim Museum, New York.

At Harvard, we wish to thank our colleagues at the Widener, Fine Arts and Houghton Libraries, for ensuring unproblematic access to vital research material in their care. In particular, we thank the Houghton Library and its director, Professor Richard Wendorf, also for permission to quote from the Papers of George Grosz, donated in 1982 by Peter and Martin Grosz.

Within the Harvard University Art Museums, we thank our director, James Cuno, for his understanding of and support for the scholarly and educational importance of this complicated undertaking. Supervision of the production of this catalogue and of the editing of its contents was in the capable hands of Evelyn Rosenthal, manager of publications, who deserves our special appreciation. She also coordinated our work with Eleanor Bradshaw of Portsmouth, NH, who is responsible for the elegant and clear design of the book.

The cataloguing of some two hundred sketchbooks necessitated almost constant consultation with our colleagues in the Center for Conservation and Technical Studies; we have depended very heavily and gladly on the expertise of Craigen Bowen, Philip and Lynn Straus Conservator of Works of Art on Paper, and Janice Burandt, intern. This publication has also entailed an enormous amount of photographic work, and we are very grateful to the entire Photographic Services Department under Elizabeth Gombosi, and to Rick Stafford and Catherine Weller especially, for their careful and skilled cooperation. As one of the sketchbooks to which we have given special attention is in the collection of the Fogg Art Museum, we acknowledge help from our sister institution's Department of Drawings (William W. Robinson, Ian Woodner Curator, Miriam Stewart, assistant curator, and Mary Ann Trulli, curatorial assistant). Anneliese Harding, a loyal museum docent, provided invaluable help in transcribing Grosz's difficult handwriting. At the Busch-Reisinger Museum, important work on various aspects of this catalogue has been ably undertaken by Emilie Norris, assistant curator, and Leigh Clark, staff assistant. Amee Yunn and Eileen Mullen also provided crucial assistance with many vital details.

No aspect of this publication (and the exhibition which it accompanies) would have been possible without the generous support of the Friends of the Busch-Reisinger Museum. Not only do they sponsor the annual graduate internship, under which Catherina Lauer, a German art historian pursuing her academic and museum career in the United States, spent the academic year 1992-1993 focusing on the sketchbooks of George Grosz, they also provided essential funding for this scholarly catalogue devoted to one of the great German-American artists of our century. Both aspects of this support exemplify the Friends' commitment to the scientific and educational goals of the Busch-Reisinger Museum, thereby also contributing to a deeper understanding of German culture in America. This project has many German-American resonances, and the support from the Friends is therefore especially appropriate and very much appreciated.

— *PN*

Marks of a New Beginning: Allegory and Observation in Sketchbook 1912/1

Peter Nisbet

Sketchbook 1912/1 will lead us in many different directions. By the end of this brief essay, we shall have touched on topics as disparate as the reputations of the philosopher Friedrich Nietzsche and the painter Lyonel Feininger, the Reichstag elections of January 1912 and the sinking of the Titanic in April, Berlin popular culture and the architecture of the industrial suburbs, and much else besides. The variety of drawing techniques, ranging from seemingly abstract investigations in colored crayons through nervous, scratchy pen lines to brushed compositions of surprising vigor, matches this diversity of subject matter. 1912/1 will emerge as one of the most varied of the extant sketchbooks, rich evidence of a searching, perhaps even indecisive, temperament. In particular, the sketchbook provides some rare early examples of Grosz's experiments with allegorical commentary on contemporary events, interspersed with the kind of documentary observation of social types and situations on which his reputation as an incisive recorder of modern Germany is now based. As a concentrated glimpse of Grosz at the moment just before his mature subjects and styles emerged, this sketchbook is enormously valuable.[1]

In early 1912, George Grosz was only eighteen years old.[2] He had been studying since September 1909 at the Dresden Academy. Very soon, he was to transfer to an art school in Berlin in order to continue his studies, this time under Emil Orlik.[3] Two years earlier, he had published his first illustrational drawing in the humorous magazine *Ulk*.[4] This had then been followed by about a dozen further contributions, highly competent but unexceptional exercises in the conventional post-*Jugendstil* manner of Bruno Paul and Karl Arnold, to magazines such as *Lustige Blätter* and *Sporthumor*.

Sketchbook 1912/1 vividly documents this moment of transition and exploration. Indeed, given the surprising lack of any extant sketchbooks from 1910 and 1911,[5] the years of his study in Dresden, the very existence of this sketchbook is evidence of a new phase in Grosz's creative career. The multifariousness of its contents is underlined by the noticeable lack of sequence in the drawings. This sketchbook has not been used to explore and analyze a motif or pictorial problem through a series of consecutive pages. Rather, Grosz has used it as a notebook of ideas and observations for diverse and apparently unconnected thoughts. Not only is a wide array of subjects addressed in no particular order, but even the sequence of execution, as documented in the dated pages, moves us, the perusers, back and forth through the book. A chronological reconstruction of Grosz's use of this book, though episodic and somewhat disjointed, can give a good sense of the artist's multiple interests at this moment in his career.

The earliest dated page in fact occurs toward the end of the book (33 verso). On 10 January, a Wednesday, Grosz draws a rather gruesome image of a monstrous, fat man gleefully feeding humans (actually, men) into an oversize meat-grinder, a composition he titles *The Man-Eater*.[6] The intention behind this macabre idea remains unclear. It may eventually be explained as a satire on contemporary politics, perhaps intended for use in one of the humor magazines Grosz was cultivating as clients for his illustrations. As we shall see, other drawings in 1912/1 do find their context here. In a broader sense, however, its most resonant echoes are with Grosz's much indulged fascination with murder, dismemberment, and the grotesque. Later in the same year, Grosz will draw an explosion scattering body parts in all directions (Sketchbook 1912/3, 12 verso, drawn on 28 April in Berlin); a few months later it will be a mad scientist creating a "homunculus" out of assorted human body parts lying around a makeshift laboratory.[7] Moreover, the pattern of portraying a single giant-figure

in relation to a crowd of "normal" or miniature humans will recur, both in this sketchbook and in Grosz's later career.

Only two days later, Grosz is drawing a study of the Berlin suburbs, a scene of contemporary realism entirely in tune with his instincts for the documentary subjects of modern life (2 recto).[8] An intensely colored crayon study of electricity poles in a broad expanse of earth and grass with gray blocks of new apartment buildings on the horizon, this drawing is joined by other studies of the same scene in gouache (1 verso) and in mixed media (inside front cover). The exploration of color relationships in these and related compositions (26 verso, 27 recto) indicate that Grosz is surely hoping for color reproduction of his illustrations in the magazines. A large number of the drawings in this sketchbook focus on the distinctive look of the somewhat desolate Berlin suburbs, which Grosz studies at various times for the perspectival peculiarities of their planar and spatial relationships. He brings out the blank facades of the tenement blocks, the fire walls, and the construction-site fencing, planar elements that both structure the spatial and psychological dynamic of the composition and also provide surfaces on which posters and advertisements, essential features of the commercial metropolis, can appear (for example, 4 recto, 5 recto, 6 recto and verso). Some of these sketches (20 recto and 21 recto) are directly related to a worked-up drawing of pedestrians gathering around a poster for the Circus Busch (fig. 1).

On the same day as this study of urban realism, Grosz is engaged with his friend and fellow artist Herbert Fiedler in thinking about Lyonel Feininger. The evidence of the sketchbook (3 recto and verso) seems to indicate that on 12 January, Fiedler draws a sketch of how he imagined Feininger's painting *Village Street in the Bretagne*. On the following page, Grosz apparently then draws what it actually looked like.[9] Why this particular painting should have been the topic of discussion is not clear, though it was in fact the first painting that the well-known caricaturist Feininger had ever exhibited (at the Berlin Secession in August 1910). Perhaps this work would have held special interest for young artists also facing the decision whether to remain illustrators or aim for something higher. In his memoirs, Fiedler reports that Grosz got to know

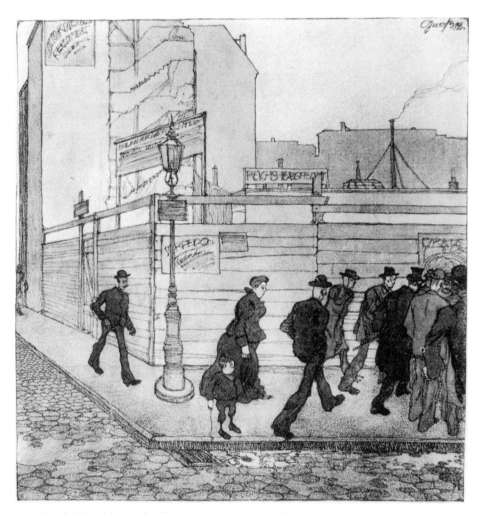

FIG. 1 Crowd. *Colored drawing for illustration, 1912. Technique, dimensions, and location unknown. From "Lebenserinnerungen," p. 57.*

Feininger, whom he much admired, in Berlin. Grosz would tell stories about the American painter and what he had learned from him.[10] Perhaps these sketchbook pages are evidence of just such an episode, with Grosz reporting on seeing the painting in Feininger's studio. At all events, they further reinforce the sense that Feininger was a serious presence in Grosz's artistic life.[11]

The following Thursday, Grosz designs a postcard for the upcoming Fasching carnival (9 recto). In blue crayon for the

figures and yellow for the background, he illustrates his slogan "Death to the Philistines"[12] with an apparently violent scene of two figures in carnivalesque costumes dancing around and attacking the portly, stolid figure of the Philistine. The theme of criticizing and wanting to triumph over the bourgeois is, of course, a familiar one in Grosz's oeuvre as a whole.

Three compositions date from the weekend of 20 and 21 January. Together, they exemplify the multiplicity of artistic personalities with which Grosz is at this moment contending. On the Saturday, he draws, in a fine, linear pen and ink style which has both the fluidity of his earlier *Jugendstil* manner and something of the nervous energy of his more modern work, a *Pupenjunge*, that is, a dandy, of elongated stature, immaculate dress, and effeminate demeanor (10 verso). Clearly, this figure from the cosmopolitan world of Berlin fascinates Grosz, who is himself known for his elegant, stylized attitudes. Wieland Herzfelde remembered Grosz's visit to the famous Café des Westens in Berlin in 1915, with powdered face and red lipstick, wearing a checked jacket, a bowler hat, and carrying a thin black cane with a death's head.[13] Some hint of the extent to which issues of sexuality are embedded in Grosz's attention to these homosexual types is given by the surprising presence, on one page of the sketchbook with two further studies of such a figure (now walking and gesturing affectedly), of a sketch, in the same technique, of a partial view of a woman's genitals and spread legs (13 verso). Is Grosz adopting the distanced view of the uninvolved artist-*flâneur*, or that of the aloof homosexual unaffected by such a sight?

On the same day, Grosz works on a composition from, so to speak, the opposite end of the social scale: a drunken man being helped along a Dresden street (7 recto and 8 recto).[14] This too became a fully worked-up drawing intended for illustration, setting the scene again in a desolate industrial suburb with curious bystanders and bleak house facades (fig. 2). In a curious way, even this drawing calls on Grosz's oft-repeated theme of the singular individual surrounded by the mediocre masses. Alcohol always played a very important role in Grosz's life,[15] and it is tempting to see in this drawing a kind of inverse exceptionalism, with the drunk/artist quite free of the

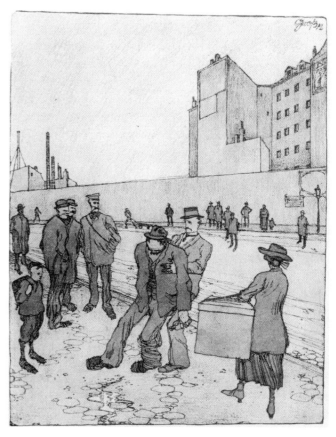

FIG. 2 Street Scene. *Colored drawing for illustration, 1912. Technique, dimensions, and location unknown. From "Lebenserinnerungen," p. 56.*

obligations and expectations of respectable society, which looks on disapprovingly.

On the following day, Grosz turns away from direct social observation of this kind and thinks instead about the immediate political scene. On a page with a roughly sketched-in composition of a snowman (with individualized features and a broad-brimmed hat) recoiling under the rays of the rising sun, Grosz elaborates the program for a "Political Idea": The Center party as a snowman. Melting slowly under the rays of the emerging Progressive party; in the foreground, the Agrarians are rolling new masses of snow in order to repair the snowman. The boys in the foreground could equally well be opponents of the Center party, throwing snowballs at it" (14 verso). The date

and language make it clear that Grosz is here commenting on the important national elections of January 1912, which had major consequences for the political development of the Wilhelmine Reich.[16] Not only did the working-class Social Democratic party replace the conservative and Catholic Center party as the largest party in the new Reichstag elected on 12 January 1912 (with run-off elections about ten days later[17]), but the Progressives (*Fortschrittliche Volkspartei*) were the only bourgeois party to register substantial voter gains. The power and vote percentage of the Center party were seriously diminished. In an image appropriate to the winter season in which it was drawn, Grosz shows its supporters among the agrarian interests trying to shore it up against the inevitability of progress (the garb and mien of the snowman do seem distinctly clerical).[18] We do not have enough evidence to decide whether Grosz's political allegory reflects his own political position or the political position of the journal to which he was perhaps hoping to sell his pictorial idea. In 1930, Grosz wrote that he had been entirely unpolitical in these years.[19] However, it seems plausible that Grosz would have positioned himself to the left of center, and been much heartened by the results of these elections.[20] Important in this context is that he chose to attempt a pictorial comment on daily political events, and that this commentary took the form of an allegorical cartoon involving personification. Moreover, the sketchbook contains other elaborate written ideas for such compositions.[21]

Five days later, on 26 January, Grosz returns to this allegorical mode, both for the casually and rapidly noted idea for a composition based on the image of a running-water tap (16 recto),[22] and for the much more elaborately worked-up scene of *The Modern Gulliver*, as Grosz titles his vision of a gigantic man whose arrival in the city or on its outskirts, by a river, attracts a crowd of curious onlookers, most armed with telescopes and cameras (9 verso, 10 recto, 11 recto).[23] Not only is the composition studied in several different ways, the color relationships are also explored in blue, orange, purple, and green crayon. What did Grosz intend by this contemporary rewriting of the Lilliputian chapters from Swift's *Gulliver's Travels*? Certainly, Grosz was much enamored of popular and children's literature, but he is here surely drawing on some

knowledge that Swift's famous piece of juvenile literature was, at one level, a sophisticated political satire on eighteenth-century politics. Given Grosz's engagement with the results of the 1912 election elsewhere in this sketchbook, it is surely plausible that Grosz is again commenting on the immediate political scene: is the cloth-capped, pipe-smoking Gulliver not the newly powerful, slightly threatening worker, dominating the political scene through the success of his party (the SPD), and attracting the intense curiosity of press and public?

Apart from one drawing of a street scene with some indication of running and falling figures, made in Dresden on 3 February (14 recto), Grosz does not return to using this sketchbook until late April, probably after his final move to Berlin.[24] Sketchbook 1912/2 is dated 2–18 April, accounting for some of the intervening period, as do many of the loose sheets cut from pocket-sized sketchbooks and gathered by Grosz according to subject matter into envelopes dated from April 1912 onwards.[25] However, these latter rapid notations of observed detail and street incident differ substantially from the use that Grosz makes of the larger hard-bound pages of 1912/1.

On 20 April, he draws an elaborate invention, showing a pot-bellied devil in hell greeting, congratulating, and awarding a medal to a certain Captain Smith (26 recto and 25 verso).[26] Only when we realize that this figure represents E. J. Smith, the captain of the largest and most modern passenger liner in the world, the Titanic, which sank in the North Atlantic with tremendous loss of life on the night of 14–15 April 1912, do these enigmatic compositions take their place among the sketchbook's various attempts at visual commentary on contemporary events. In another sketchbook, Grosz recorded the dramatic news on 16 April, alongside a drawing of a man reading a newspaper.[27] Four days later, in 1912/1, however, he offers his critical interpretation of the evil culpability of the ship's captain, whom some were accusing of recklessly endangering safety for commercial gain and glory by speeding through the fateful iceberg field. In the light of other compositions in this sketchbook, and in Grosz's later career, the specifics of Grosz's attitude are interesting. Once again, he seems fascinated by the grotesque spectacle of mass death caused by a single (super- or subhuman) individual. Just as he has begun this sketchbook

with the maniacal monster grinding helpless humans into meat, so, three months later, he fills some of its remaining empty pages with a bitter "homage" to someone he sees as a real mass murderer.[28]

Toward the end of the following week, Grosz returns to the everyday world around him. Sketches of the Berlin cabaret and circus (8 verso and 12 verso) are far more representative of the dominant direction of Grosz's art for the next few years. Train stations, newspaper vendors, street lights, café life: this standard repertoire of urban sights is fully covered by Grosz in an explosion of drawing activity surely inspired by immersion in the dynamic modern metropolis.[29] In his autobiography, the artist recalled sharing an apartment with Herbert Fiedler on his arrival in Berlin: "He and I would go to the outskirts, which were spreading like an octopus, and sketch everything about us: newly erected buildings, city dumps, trains steaming across bridges, and the streets in the process of being paved. We loved to hang around the amusement areas where the strange families of second-rate performers lived in colorfully decorated trailers."[30] However, just as Grosz's drawings of urban life on 20 January were accompanied on the same day by discussion with Fiedler about Lyonel Feininger, so too on 26 April Grosz not only studies the reality of the world of urban entertainment around him but also makes explicit acknowledgment of his artistic sources and models. A drawing in the loose brushed style which he also uses for some of his urban studies[31] shows a corpulent, stern-faced businessman holding a pair of scissors (13 recto). The caption indicates that this is copied from a drawing by Rudolf Wilke (1873–1908), one of the talented contributors to the satirical Munich periodical *Simplicissimus*. Wilke's drawing appeared in the 1904 New Year's issue of the journal, under the title "Bilanz" (Accounts).[32] One recent commentator has described Wilke's drawings in a way that may account for Grosz's sense of affinity:

> Rudolf Wilke's caricatures are characterized less by satire than by humor, less by accusation, than by compassion. … His depictions of beggars and tramps are typical. For him they are not humiliated, insulted supplicants but rather independent outsiders with a dignity of their own—marginal, dissident, drop-out characters who are closer to the origin and truth of things than the wealthy and powerful. […] In

depicting representations of the ruling class, the lines become harder, the ductus more incisive, verticals predominate and the figures have a rigid tense, rather evil quality—in contrast to the soft, fluffy lines used for vagabonds who belong to no class.[33]

In studying this caricature by Wilke, Grosz is expanding his repertoire of urban types, adding the coldhearted businessman to the dandy, the drunk, the entertainer, and others who begin to populate Grosz's world in 1912. Moreover, as this assessment indicates, Wilke was also appreciated for the range of his drawing styles, and in this he is again an appropriate model for Grosz to quote in a sketchbook characterized, as we have seen, by such a multiplicity of styles.[34]

The remaining, undated drawings in this sketchbook can all be grouped without difficulty around the different types of drawing that this chronological "reconstruction" has identified. However, even after such classification has brought some order to this sketchbook, its tentative and exploratory nature cannot be denied. It would surely be misleading to search for and artificially impose a coherence to this rich variety. Beyond noting that most of the drawings—whether observations of contemporary life or allegorical commentary on the events of the day—have the immediate present as their strongest point of reference, there is little in common among the various thematic and stylistic strategies Grosz experiments with in these pages.

It is this very diversity that makes the sketchbook's prominent title page so provocative (1 recto). How could one image in some way summarize or introduce all that comes after it? Assuming that Grosz designed this elaborate and self-conscious scene as a way of marking a new beginning as his time at the Dresden Academy was drawing to a close, what ambitions does the image announce, both to the artist himself and to the later peruser of the sketchbook (for the image seems in many ways more appropriate to a book destined for public consumption than for a student's notebook)?

First we see the carefully worded title and affirmation of authorship: "Georg Grosz. Compositions. Sketches."[35] The distinction neatly echoes the distinction between the two kinds of image we have found in this book: the "composition" being

the grander designs for allegorical commentary, the "sketches" being the observations of everyday life.[36]

These words are embedded in the surrounding scene, which shows a slightly comic man who has stood up from working with his sketchbook, pen and ink bottle on the table, in order to spin an old-fashioned zoetrope, presumably outfitted with a sequence of images he has himself drawn. Behind him hangs a portrait of the philosopher Friedrich Nietzsche, instantly recognizable with his bushy eyebrows and prominent mustache. On the other side of the composition, in an uncertain spatial relationship to the interior scene, stands a wagon of the type that might be found at a circus, or, given the wooden planks resting against it here, perhaps at a building site.

Why would the young artist offer such an image? After all, it seems willfully old-fashioned as a self-presentation: the depicted draftsman is surely older than teenager Grosz; the zoetrope probably had little or no role to play in the contemporary culture of the moving image (by 1912, the cinema was a ubiquitous entertainment, visited and loved as much by Grosz as by anyone else); and even the portrait of Nietzsche, dead for over a decade, clearly evokes the famous etching by Hans Olde, first published in *Pan* in 1900, and subsequently the all but official image.[37]

Of course, Nietzsche was by no means a forgotten figure. On the contrary, his stature and influence had been growing exponentially since the 1890s.[38] That he remained a figure of consequence also for the rising generation of artists is best shown by the dramatic portrait bust sculpted in 1912, the year of this sketchbook, by Grosz's contemporary Otto Dix, also studying in Dresden at the time (though not at the academy). Dix recalled being introduced to Nietzsche's writings in 1911, and perhaps Grosz discovered the philosopher's heady writings at the same time.[39] However, Grosz never gave such explicit allegiance to Nietzsche, and this drawn portrait, quoting Olde's perhaps already clichéd image, is at best a distanced, indirect homage.

Is Grosz alluding here to a passing enthusiasm? Are we meant to infer some direct sources in Nietzsche's writings for Grosz's ideas and images? Or should we be tempted to trace parallels in the world-views of the artist and the philosopher?[40] Certainly, the presence of Nietzsche in the intellectual climate of those years was inescapable; he was, to all intents and purposes, the one thinker with whom one had to reckon, although the rich and not always consistent variety of his positions made him an inspiration and a point of reference for many radically conflicting points of view in Wilhelmine Germany.[41]

Nevertheless, is there not an affinity between Grosz's and Nietzsche's thoroughgoing dislike of system? And between their cynical and misanthropic views of humanity? And could there not be an indirect link between Nietzsche's concept of the Superman, as elaborated in *Thus Spake Zarathustra*, and the many images in this sketchbook, where a solitary individual stands against or over the crowd: the Butcher, Gulliver, the Snowman, the Drunk, the Dandy, Captain Smith versus the little men, the Lilliputians, the boys of the Progressive party, the disapproving crowd, the hapless passengers. Grosz did not approve of all of these singular figures equally, but in his skeptical individualism, he may find some level of admiration for all such outsiders. Certainly as a compositional device, the solitary figure set against the teeming masses recurs throughout his career, whether as Noske, the Adventurer, the Agitator, Cain, or whoever.[42]

This focus on the individual returns us also to Grosz's title page, with its solitary, eccentric artist making pictures move. Who is this man who proudly displays Nietzsche on the wall of his studio? It is, in all likelihood, an ironic self-portrait of the artist,[43] the lone creator flanked by the profundity of Nietzsche and the mundanity of the construction wagon, making his two-dimensional representations of reality move artificially in a slitted drum, testing their visual effectiveness. Is Grosz here reflecting indirectly on two problems confronting him? For his observational sketches of everyday Berlin and Dresden life, he was surely conscious of the difficulty of "capturing life," of seeing past or through the schemata provided by his academic training and the examples of other artists (say, Feininger or Wilke), in order to render the vital contemporary reality. And for his political allegories, which he perhaps hoped would have a penetrating Nietzschean insight into the current state of culture, he had to face the problem of imply-

ing a story, of embedding a development over time into static images that should somehow suggest a before and an after, and offer a tacit explanation of what is happening.

Perhaps this title page, with its very enigmatic interaction of artist, and Nietzsche, the wagon, and zoetrope, is a way of addressing these two interrelated concerns: to what extent, Grosz may be asking himself as he leaves his academic training behind him and embarks on a career as an artist/illustrator in Berlin, will the images that follow prove adequate to the dynamism of modern life and its political/cultural developments? Will they find the right balance between immersion in the energetic spectacle of actuality, and distanced commentary on the hidden, "invisible" processes, whether social, political, or existential, which underlie the endlessly fascinating phenomena of the visual world? This remained an issue for Grosz for the remaining four decades of his life. If this interpretation of the title page is correct, then it is an entirely appropriate image to find at the start of this sketchbook, marking a new beginning.

NOTES

1. For details about this sketchbook, see entry 1912/1 in the Catalogue of Sketchbooks. All the pages of the sketchbook are illustrated after this essay, with the exception of: 11 verso (rapid graphite notation of a figure), 18 recto and verso (about three-quarters of this page have been cut out), 21 verso (blank), 30 recto (study of a sailboat), and 32 recto (indecipherable scribbles). 11 recto is illustrated in color on page 66. In my thinking about this sketchbook, I have benefited enormously from conversations with my fellow authors in this catalogue, and I gratefully acknowledge their assistance here.

2. Sources of information on this period of Grosz's life are relatively scarce. Apparently, no letters from before 1913 survive. Grosz's own reminiscences, in their various forms and with all the usual caveats about the reliability of such sources, are prime: George Grosz, *A Little Yes and a Big No: The Autobiography of George Grosz*, trans. Lola Sachs Dorin (New York, 1946), hereafter cited as *Autobiography*, especially chaps. 5–10, pp. 77–143, as well as an earlier version of these memoirs—the articles published in three parts with valuable illustrations as "Lebenserinnerungen" in *Kunst und Künstler* 29 (1930): 15–22, 55–61, 105–11 (hereafter cited as "Lebenserinnerungen").

3. Hans Hess says that Grosz graduated from the Dresden Academy sometime in late spring 1911 and moved to Berlin on 4 January 1912 (*George Grosz* [New Haven and London, 1985 (1974)], p. 260). The evidence of this sketchbook, presented below, indicates that he still spent much time in Dresden during January, suggesting that the final move to Berlin did not happen until later. An exact date for his enrollment in the Berlin art school has not been established. Herbert Fiedler recalled moving to Berlin on 1 March 1912, with Grosz following a little later, "after the end of the semester [in

Dresden]," implying that Grosz was still enrolled (Herbert Fiedler, "Memoirs," The George Grosz Papers, Houghton Library, Harvard University, bMS Ger 206 [1132], p. 124). The Grosz Papers contain photocopies of those sections of Fiedler's typescript that deal with Grosz in the years 1911–13. The typescript appears to have been written in the 1940s (see the correspondence between Grosz and Fiedler in The George Grosz Papers).

4. The best study of this aspect of Grosz's work is included as an excursus in Ulrich Luckhardt, *Lyonel Feininger: Die Karikaturen und das zeichnerische Frühwerk. Der Weg der Selbstfindung zum unabhängigen Künstler, mit einem Exkurs zu den Karikaturen von Emil Nolde und George Grosz*, Beiträge zur Kunstwissenschaft, vol. 10 (Munich, 1987).

5. Lothar Fischer, *George Grosz in Selbstzeugnissen und Bilddokumenten* (Reinbek, 1976), p. 19f., writes that Grosz filled sketchbooks in the summer of 1911 on a visit to Thorn, where his mother was now living, but his evidence (a letter by Grosz to Ulrich Becher of 6 February 1945) is far too vaguely and casually written to support this.

6. Der Menschenfresser. Sketches of the same subject in light graphite also appear on other pages (e.g., 33 recto and 34 recto), which are then often used for other drawings. 12 verso has the butcher nude, looking similar to the brutal executioner shown in a drawing in Sketchbook 1912/3, 5 verso, dated 28 April 1912. The notion that such drawings may be political commentaries is supported by the word "censorship [Zensur]," which is written on the guillotine in this latter drawing (captioned "Stupid and Brutal, Co., Inc." [*Firma Dumm & Brutal GmbH*]), implying that the thuggish, monstrous executioner is the government, silencing the voices of the decapitated heads, which, with their wire-rimmed glasses, do resemble male intellectuals.

7. Uwe Schneede, ed., *George Grosz. Leben und Werk* (Stuttgart, 1975), p. 25, fig. 37 (a drawing dated June 1912). These concerns will resurface with an explicitly misogynist cast in Grosz's images of sexual murder by men of women, with the earliest apparently also from 1912 (see, for example, Hess, *Grosz*, figs. 22–23, 26, 30), but here the mayhem seems exclusively masculine. The idea of the butcher dealing in human flesh long remained attractive for Grosz: see the gruesome 1928 watercolor of a butcher shop illustrated in Peter Nisbet, ed., *German Realist Drawings of the 1920s*, exh. cat., Busch-Reisinger Museum, Harvard University Art Museums (Cambridge, Mass., 1986), no. 49, pp. 114, 223; and the 1930 view of a slaughterhouse auctioned at Christie's, London, 20 May 1993, no. 601. As late as 1946, Grosz remembered reading Upton Sinclair's *Jungle* around 1909, with its vivid description of a man falling into a meat-grinder (letter to Herbert Fiedler, February 1946, in George Grosz, *Briefe 1913–1959*, ed. Herbert Knust [Reinbek, 1979], p. 365).

8. The portrayal of the city's expanding outer edge dates to the mid-nineteenth century, but experienced a particular popularity in the years immediately before the First World War. See the examples by Ludwig Meidner, Max Beckmann, Lyonel Feininger and others, reproduced and discussed by Dominik Bartmann, "Das Großstadtbild Berlins in der Weltsicht der Expressionisten" in *Stadtbilder. Berlin in der Malerei vom 17. Jahrhundert bis zur Gegenwart*, exh. cat., Berlin Museum (Berlin, 1987), pp. 243–94.

9. The text of the relevant inscriptions reads: 3 recto: "Wie ich mir Feiningers Bild Dorfstrasse in der Bretagne vorstellte. Wie es in Wirklichkeit aussieht siehe nächste Seite. H. Fiedler"; 3 verso: "Nach Feininger. Dorfstrasse in der Bretagne (G. Gross)" The writer of these words (Fiedler?) imitates Feininger's trademark circular dot over the *i*'s in his name. The picture (Hans Hess, *Lyonel Feininger* [New York, 1961], no. 48, p. 252, as "Longueil, Normandy") dates from 1909. It was not illustrated in the Berlin Secession exhibition catalogue, and not shown publicly again until 1913. (I am grateful to Achim Moeller for help with this point.)

10. Fiedler, "Memoirs," p. 142.

11. This discussion assumes that the conversation about Feininger takes place on the same day, 12 January, that Fiedler draws and signs his "Artistic Impression of G. Gross," the sketch for the "Methyl-alcoholic" on one of these pages (3 verso). This drawing probably belongs primarily in a discussion of Fiedler's (wholly unknown) oeuvre, or in an analysis of the (important) role played by alcohol in Grosz's life!

12. The full inscription actually contains one illegible word: "Skizze für eine Karnevalspostkarte./ Ein Tod den Musikern [?] / und / Philistern / Dresden / 18.1.12." Related sketches in light graphite are on 8 recto and 28 recto. Grosz had previously designed at least two other related works: a 1910 postcard for the singing competition at the 1910 "Gauklerfest" (Estate of George Grosz) and the official program for the 1911 "Gauklerfest" (Schneede, *Grosz*, p. 13), the annual festival put on in early February by students at the Dresden Academy to raise money to support the school canteen and needy students (as vividly described by Fiedler, "Memoirs," p. 108–9).

13. Wieland Herzfelde, *Immergrün* (Berlin, 1949), p. 139. Compare also Karl Hubbuch's description of his friend and fellow student Grosz in Emil Orlik's class: "Grosz was notable for his confident (not arrogant) manner. For his modern dress, American style: broad shoulders, wedge-shaped trousers, golden glasses, a watch on a leather chain in his outer pocket." (Quoted from a 1970 letter by Fischer, *Grosz in Selbstzeugnissen*, p. 21.) Sketchbook 1912/6 contains a drawing by Grosz of Hubbuch drawing in the Orlik class (30 recto, dated 11 December 1912). Fiedler ("Memoirs," p. 98) writes of Grosz's fascination with clothes during his Dresden years.

14. "Dresden / den. 20. Januar 1912 / Betrunkener. beobachtet in der Pillnitzstr...." Compare the inscription on the related drawing (8 recto). The specificity with which Grosz notes when and where he observed this scene is remarkable. Compare "Beggar with crippled hand observed in the Königgrätzerstrasse" (5 verso).

15. This is of course especially true in his later years. However, drink and its pleasures are an early obsession: consider, for example, the artist's youthful admiration for Eduard Grützner's genre paintings of genial monks enjoying wine to the full. Grosz often wrote warmly of Grützner (especially in his *Autobiography*, p. 112, and in many letters), and the earliest surviving sketchbook, 1905/1, contains copies of Grützner works made in October and November 1907. The sketchbook also contains Grosz's meticulous copy of Wilhelm Busch's picture story titled, significantly, "Silenus."

16. Detailed information on these elections comes from Jürgen Bertram, *Die Wahlen zum Deutschen Reichstag vom Jahre 1912. Parteien und Verbände in der Innenpolitik des Wilhelminischen Reiches*, Beiträge zur Geschichte des Parlamentarismus und der politischen Parteien, vol. 28 (Düsseldorf, 1964).

17. The run-off elections were held on 20, 22, and 25 January, with the choice of date determined locally. The exact relationship of Grosz's pictorial idea to the run-off elections is therefore not clear, but it should be remembered that the broad outlines of the shift in the political center of gravity had become clear on the first election day, January 12.

18. Interestingly, Feininger had in 1910 also drawn a caricature condemning the Agrarians' attempts to halt the forward march of Progress, though he used the symbol of the onrushing locomotive (Luckhardt, *Feininger*, p. 32, fig. 28). In particular, the Center party after 1909 opposed reform of the electoral law and further democratization of the political system (cf. Thomas Nipperdey, *Deutsche Geschichte, 1866–1918*, vol. 2 [Munich, 1992], p. 553). It was precisely an SPD demonstration about this issue that Grosz recalled observing during his student days in Dresden (*Autobiography*, p. 132).

19. "Lebenserinnerungen," pp. 109–10.

20. Grosz's published cartoons of these years are not so much records of any consistent political line as they are relatively gentle observations of social foibles. The more biting and politically topical compositions in this sketchbook represent a different approach, and their existence must prompt some revision of judgments such as that by Hess (*Grosz*, p. 17, following the artist), to the effect that politics at this time did not interest the artist, and by Beth Irwin Lewis that Grosz rarely commented on specific political events (*George Grosz. Art and Politics in the Weimar Republic*, rev. ed. [Princeton, 1991], p. 88). Although none has yet come to light, we cannot be completely certain that some of Grosz's explicitly political cartoons from this period were not published.

21. On the following page (15 recto) and presumably at the same time, Grosz noted two ideas for political commentary on German-English relations. In one, an

anglophile German newspaper would be attempting to restore the slowly decaying friendship with the English bulldog; in another, a German newspaper would be personified as Michel, the traditional symbol-figure of Germany. Michel, while attracting the English Bulldog with food, has turned his back. The bulldog leaps up and bites, until the German Michel slaps it hard, and it retreats, furious. Such an image would clearly relate closely to the ever intensifying Anglo-German rivalry and suspicion, especially in the wake of the second Morocco crisis in July 1911 and the ensuing anti-British hysteria. Furthermore, as a large part of the rivalry with Britain focused on naval policy, could the sketchbook drawing of a battleship (19 verso) be related to these proposed political cartoons? Another idea suggests "playing with toy soldiers" and "two children as monarchs," in which the two childish monarchs were surely to have been King George V and Kaiser Wilhelm. These ideas for political cartoons are very reminiscent of the images that appeared in *Simplicissimus* and other such journals.

22. The meaning of this is probably lost forever, as is the correct interpretation of the similarly sketchy drawing of the "dance around the political coffeepot" (Drehung um die politische Kaffeekanne) on the previous page (15 verso), though this latter composition does, interestingly, repeat the pattern of the outsize central object surrounded by miniature figures, seen both in the snowman image and in the *Modern Gulliver*, discussed immediately below.

23. The date on these sketches is unclear. They could be from 20 January, that is, from the weekend when Grosz was writing out his ideas for political pictures.

24. Another exception might be the sketches on 22 verso and 23 recto of the fifth annual six-day Berlin bicycle race held in 1912, from midnight on Friday, March 22, to midnight on Thursday, March 28. These drawings, again interestingly parallel to Feininger, who drew and painted a bicycle race in 1912 (Hess, *Feininger*, pp. 68, 69, 174, and p. 256, no. 94), belong alongside Grosz's other engagements with the public entertainments of the metropolis, as discussed above.

25. See the catalogue entry for 1912/8 for details. Also, Sketchbooks 1912/3 and 1912/4 were used between 26 April and 10 May. Several images in 1912/1 are picked up in 1912/3. For example, the figure of the cowboy running away and shooting back (1912/1, 17 verso) reappears in a composition showing his pursuers (1912/3, 1 recto), as part of a group of cowboy scenes in the later sketchbooks. A monstrous giant crushing miniature onlookers (1912/3, 21 verso) is reminiscent of the "Gulliver" drawings in 1912/1. There are further examples.

26. The captions of these drawings can be translated as follows. 26 recto: "Captain Smith in Hell. 20 April 1912. Südende [Berlin]. Small devil with medal on cushion. Medal." ("Kapitän Smith in der Hölle. 20.4.12. Südende. Kleiner Teufel mit Ordenskissen. Orden.") 25 verso: "The chief executive officer of hell congratulates Captain Smith." ("Der Geschäftsführer der Hölle beglückwünscht Kapitän Smith.")

27. 1912/2, 14 recto: "Titanic/Schreckliche/Schiffskatastrophe..."

28. Only three years later, Grosz would, in a gesture of far greater sophistication and complexity than these drawings, adopt the persona of William King Thomas, another real figure who had sacrificed much human life on a ship to financial profit in an insurance scam. See the essay by Beth Irwin Lewis in this catalogue.

29. This outburst of sketching activity exactly parallels Grosz's discovery of urban energy and excitement two decades later: New York in 1932 and 1933. See the essay by Catherina Lauer in this catalogue.

30. *Autobiography*, p. 138. Fiedler too provides a vivid account of the pair's sketching expeditions to cafés, department stores, and throughout Berlin ("Memoirs," pp. 142f., 146).

31. Among other examples in this sketchbook, see the scene of the man holding a placard in front of people skating, 24 verso. This scene finds echoes in the quick sketches of the man with the placard (reading "Ki-Ko Kroll") and people putting on roller skates, in 1912/2, 25 verso and 26 recto.

32. *Simplicissimus* 8 no. 40 (29 December 1903): 314. The drawing, which shows the full-length figure with monocle and cigar (omitted by Grosz), cutting a sheet of paper,

is accompanied by a caption that can be translated as follows: "The year's closing accounts aren't so favorable. And, to cap it all, I had to have my wife cremated in Gotha. Thank God that's only a one-time expense." Is Grosz's decision to copy precisely this drawing further evidence of his fascination with the connection between money and death, as seen also in the cases of the Titanic and William King Thomas? Underneath the date, Grosz inscribes his drawing "Nach Wilke / Simplicissimus" (After Wilke / Simplicissimus).

33. *One Hundred Caricatures from Simplicissimus, 1896–1914*, selected and commentated by Fritz Arnold, exh. cat., Goethe-Institut Munich (Munich, 1983), n.p. See also the illustrations and commentary in *Simplicissimus. Eine Satirische Zeitschrift, München 1896–1944*, exh. cat., Haus der Kunst, Munich (Munich, 1977).

34. Wilke's stylistic diversity is emphatically stressed by Emil Preetorius in *Der Zeichner Rudolf Wilke* (Freiburg, 1954), p. 10f. Fiedler remembered of Grosz that "all draftsmen interested him and all techniques. Rudolf Wilke, Thomas Theodor Heine and Lyonel Feininger above all" (*Memoirs*, p. 99 [my translation]). In a letter to Wilke's son, Grosz remembers the father as the only good draftsman for *Simplicissimus*, whom he values highly (Grosz to Ulfert Wilke, November 1941, Grosz Papers [890]).

35. "Georg Grosz. Entwuerfe/Skizzen." The high degree of stylization of the artist's own name was to be a constant throughout his career, one more sign that he was always inventing public personae for himself.

36. However, the distinction can also function within both categories—sketches being elements that go to make up compositions, whether allegorical or illustrational. The terminology of "sketch" and "composition" is, of course, entirely traditional and appropriate for the academy student Grosz.

37. *Pan* 5, no. 4 (1899–1900): before p. 233. The fullest information about this print, about the iconography of the philosopher's image, indeed about Nietzsche and the visual arts in general in this period, can be found in the excellent study by Jürgen Krause, *"Märtyrer" und "Prophet". Studien zum Nietzsche-Kult in der bildenden Kunst der Jahrhundertwende* (Berlin and New York, 1984).

38. The richest documentation for this explosion of interest can be found in the two volumes by Richard Frank Krummel, *Nietzsche und der deutsche Geist* (Berlin and New York, 1974 and 1983), the first volume covering the years to the philosopher's death, the second 1900–1918. A very useful recent discussion of Nietzsche's influence in Germany can be found in Steven E. Aschheim, *The Nietzsche Legacy in Germany,*

1890–1990, Weimar and Now: German Cultural Criticism, vol. 2 (Berkeley, Los Angeles, and Oxford, 1992).

39. For Dix and Nietzsche, in addition to Krause, *"Märtyrer und Prophet,"* p. 190f., see Dietrich Schubert, "Nietzsche-Konkretionsformen in der bildenden Kunst, 1890–1933," *Nietzsche-Studien. Internationales Jahrbuch für die Nietzsche-Forschung* 10/11 (1981/1982): 278–327. (The importance of Nietzsche to Dix throughout his career is being much emphasized in recent scholarship, beginning with the work of Otto Conzelmann.) In his memoirs, Grosz tells of a friend who compared Karl May to Nietzsche. The context of the anecdote indicates that it must have happened around 1911 (*Autobiography*, p. 98).

40. A full analysis of Grosz's relation to Nietzsche remains to be undertaken. In addition to the points tentatively raised here, one should, for the early years, consider evidence such as the Nietzschean flavor of the line "!!COURAGE: to AFFIRM the absurdity of existence!" from a poem written by Grosz for a Dada poster (quoted by Lewis, *Grosz*, p. 60). For the later years of Grosz's cultural pessimism, several explicit references to Nietzsche can be found in the correspondence, and it may be easier to find points of connection. Harry Neumann's consideration of some of the issues is unfortunately conducted at a level of psychological abstraction and philosophical generalization that is not very productive ("The Ugliness of Being Human: An Interpretation of Nietzsche's Ugliest Man and Grosz's Greyman in Modernity," *Independent Journal of Philosophy* 5–6 [1988]: 129–134).

41. For this see especially Aschheim, *Nietzschean Legacy*, passim.

42. These famous works are all reproduced in Hess, *Grosz*, figs. 68, 46, 125, 155. That visual artists could be attracted to this schema in their reading of Nietzsche is shown by Ernst Moritz Geyger's illustration of Nietzsche's parable "The Giant," published in *Pan* in 1895/96 (illustrated in Aschheim, *Nietzschean Legacy*, fig. 1, following p. 200). For excellent comments about Grosz's lifelong and complicated admiration for the figure of the winner and for success in general, see the interpretation by Matthias Eberle, *World War I and the Weimar Artists: Dix, Grosz, Beckmann, Schlemmer* (New Haven and London, 1985), chap. 3 ("George Grosz: The Irate Dandy").

43. Although, as mentioned, the figure seems older than Grosz's eighteen years, it does have important similarities to images Grosz made of himself in 1913, notably the drypoint self-portrait (Alexander Dückers, *George Grosz. Das druckgraphische Werk* [Frankfurt/Main, 1979], pp. 17, 125, nos. E 7a–d), with the aged face, the round glasses, and the thin bow tie.

inside front cover

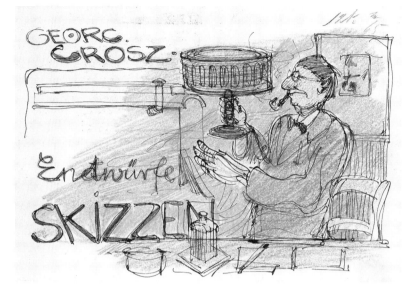

1 recto

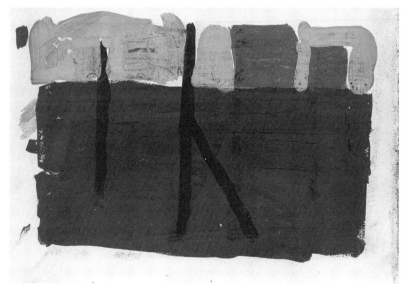

1 verso

2 recto

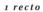

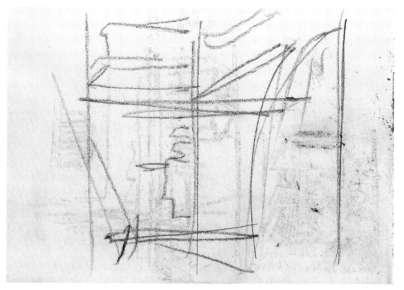

2 verso

3 recto

3 verso

4 recto

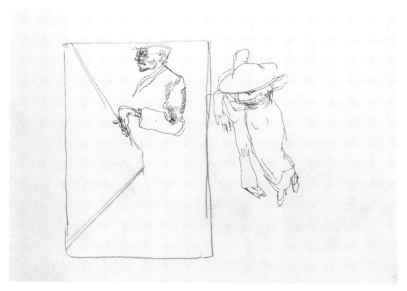

4 verso

5 recto

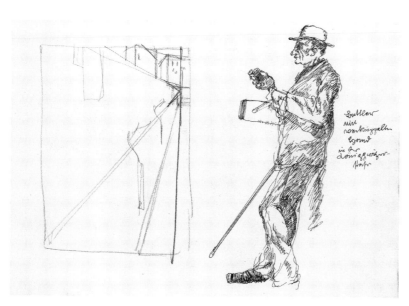

5 verso

6 recto

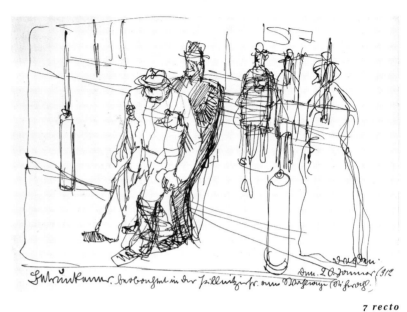

6 verso

7 recto

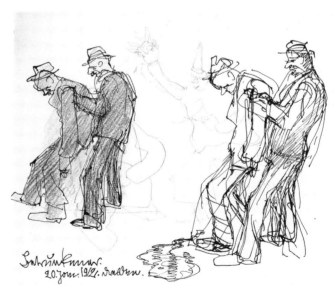

7 verso

8 recto

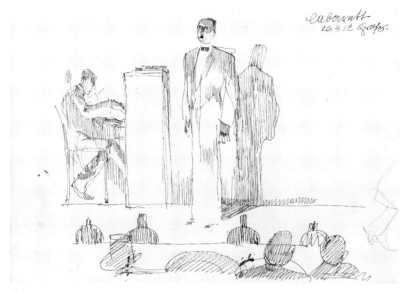

8 verso

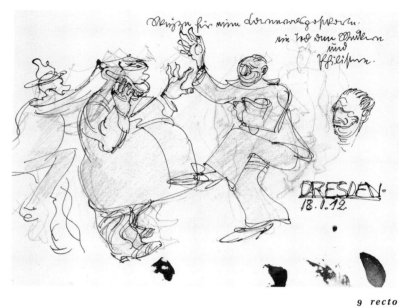

9 recto

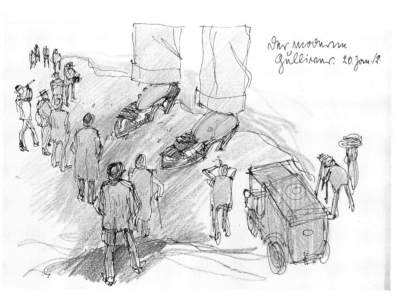

9 verso

10 recto

10 verso

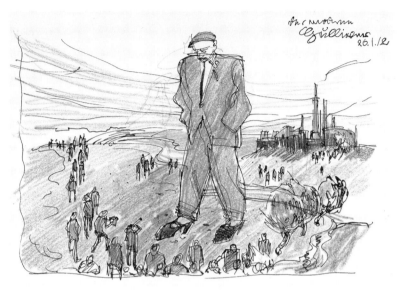

11 recto

12 recto

12 verso

13 recto

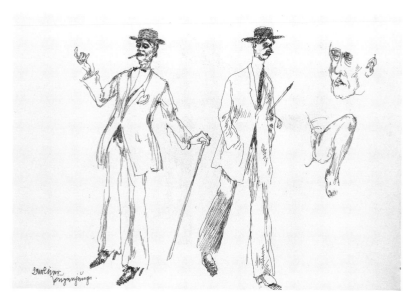

13 verso

14 recto

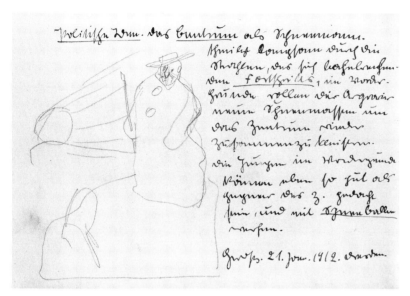

14 verso

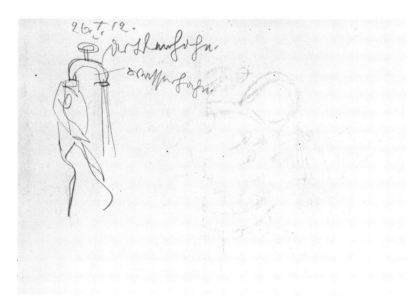

15 recto

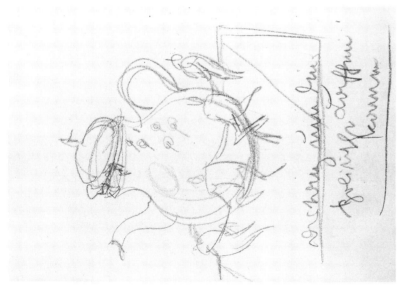

15 verso

16 recto

16 verso

17 recto

17 verso

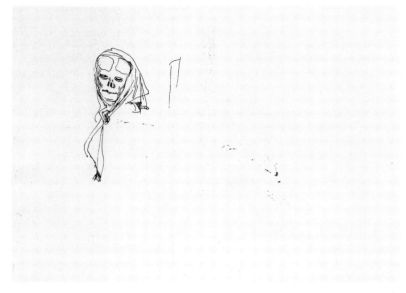

19 recto

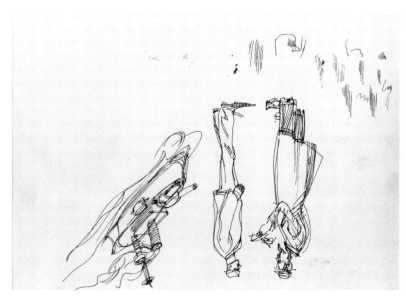

19 verso

20 recto

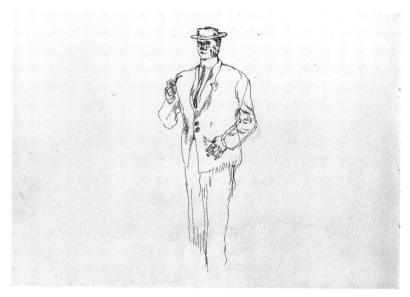

20 verso

21 recto

22 recto

22 verso

23 recto

23 verso

24 recto

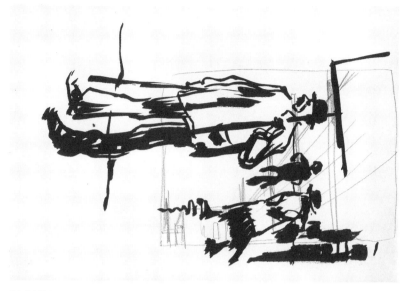

24 verso

25 recto

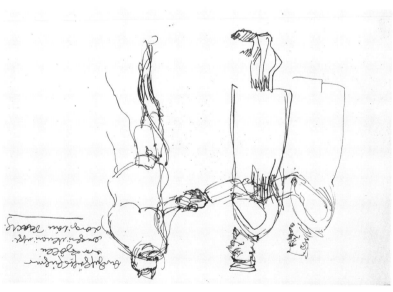

25 verso

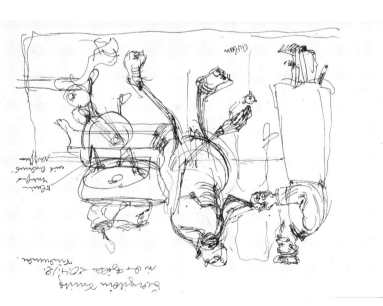

26 recto

26 verso

27 recto

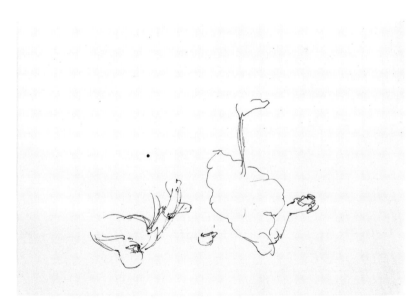

27 verso

28 recto

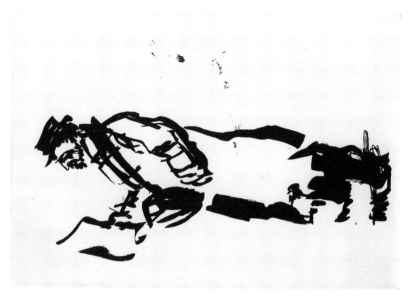

28 verso

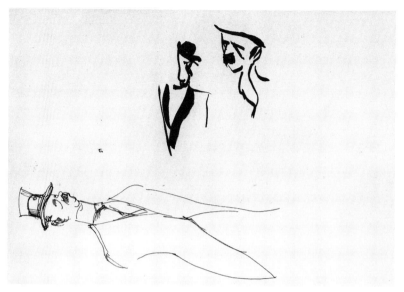

29 recto

29 verso

30 verso

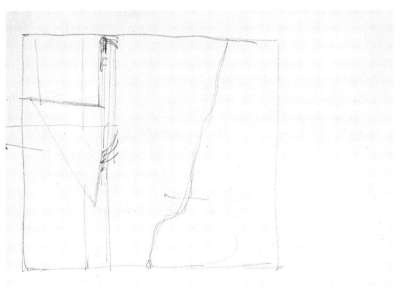

31 recto

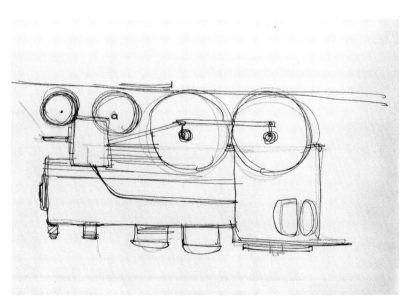

31 verso

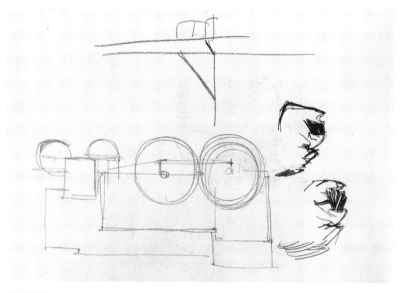

32 verso

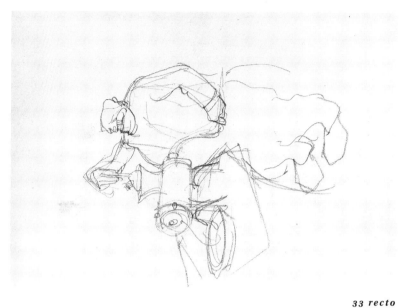

33 recto

33 verso

34 recto

34 verso

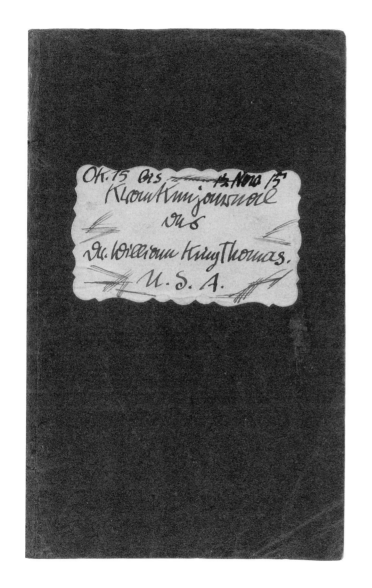

"THE MEDICAL JOURNAL OF DR. WILLIAM KING THOMAS. U.S.A. OCT. 15 TO 15 NOV. 15": SKETCHBOOK 1915/2

BETH IRWIN LEWIS

Six months after his first discharge from military service in May 1915, George Grosz wrote the title and date on this small sketchbook.[1] Before he was recalled into service in January 1917, he had created eight *Medical Journals of Dr. William King Thomas*. The fantasy of titling a sketchbook as a medical journal may have been inspired by the fact that the School of Arts and Crafts where he was studying under Emil Orlik had been turned into a hospital.[2] Grosz himself had spent almost all of February 1915 in a military hospital, where he endured painful and humiliating treatments for infections. Although there are no extant sketchbooks from that period, Grosz later wrote that he kept up his spirits in the hospital by sketching the hellish scene with its mutilated, brutalized soldiers.[3] He returned to Berlin with a temporary discharge in May 1915.

The previous sketchbook [1915/1], dated 15 July 1915, three months before the first Dr. William King Thomas notebook, provides testimony to his disturbed state of mind in the months after his discharge. It is the most introspective of all Grosz's sketchbooks, focusing upon images of sexual anxiety or desire and manifesting the dread inspired by his army experience. The notebook concentrates on two subjects: females and penises. Distorted nudes, ugly hags with clawlike hands, cadaverous sirens, and stylish fat women in transparent dresses are interleaved on these pages with smiling penises running on legs, smoking cigars, transformed into cannons, attached to minuscule bodies, serving as barbells, sprouting wings, and spraying semen.[4] The obsessive fascination with disembodied male genitalia and rapacious females culminates in several Mephistophelian heads and a graphic portrait of a dandy with a tube running up his nose and a half-opened skull held together by a hinge. Titled *Grosz/drawing. The Surgery Patient* (fig. 1),[5] this portrait together with the malignant officer's head on a preceding page are witness to the painful surgery Grosz had undergone in the military hospital for his sinus infection.

In the succeeding months, Grosz's letters to two friends from art school, Robert Bell and Otto Schmalhausen, present him as angry, aggressively satirical, skeptical of the war, and bitterly hostile to military discipline. He dreaded being recalled to duty and found waiting for the inevitable order intolerable—it was, he said, a sword of Damocles hanging over his head.[6] Despising the gray world of wartime Berlin with its insistence upon unquestioning obedience, Grosz, in his letters, took refuge within the characters of flamboyant aristocratic adventurers. In late September 1915, he began a cynical, despairing letter to Bell:

> I am boundlessly alone, that is, alone with my doubles [*Doppelgänger*], Fantômas-like figures in which I allow certain dreams, ideas, inclinations, etc., to become real. I tear, as it were, three other persons out of my inner imaginative life; I myself believe in these imaginative pseudonyms. Slowly three strongly delineated types have emerged: 1. Grosz. 2. Count Ehrenfried, the nonchalant aristocrat with manicured fingernails, intent only on cultivating himself: in other words, the distinguished aristocratic individualist. 3. The physician Dr. William King Thomas, the more American-practical materialistic balance in the mother figure of Grosz.[7]

The icon Grosz cites above as his model for choosing his imaginary pseudonyms was Fantômas, the French master criminal who was the villain-hero of a series of pulp novels that rapidly gained an international following and were turned into action films in 1913-14. Grosz, an avid reader of pulp novels and criminal fiction who was also immersed in intellectual and artistic circles pervaded by Nietzschean ideas, was drawn to the adventurer who, disdaining and flouting heavy-handed authority, asserted his own individualistic personality.[8] He wrote bitter, mocking letters in these months that were signed

by noble variations on his own name—Count Ehrenfried or Georg Ehrenfried Grosz, Ritter von Thorn; by imaginary archetypes of English individualism—Lord Edward Hatton-Dixon or Edgar A. Hussler; and by genuine historical adventurers—Graf Orfyrén-Beßler, an eighteenth-century charlatan,[9] and William King Thomas, a notorious ship owner from the *Gründerzeit* responsible for the murder of several hundred persons when he blew up his own ship in the Bremerhaven harbor in 1875 to collect the insurance.[10]

Not only did he write letters as pseudo-adventurers, but Grosz was also notorious among his friends for his provocative, belligerent role-playing throughout the war. At about the same time that he wrote the letter defining his *Doppelgänger*, Grosz startled a small gathering of antiwar intellectuals by pretending to be a Dutch businessman who planned to make a fortune from war souvenirs. His calm argument that war was nothing more than an opportunity for the smart businessman—whom he called "the actual king of our century"—upset the humanitarian assumptions of the gathering and shocked his listeners into vigorous argument about the war.[11] The ship owner Thomas, who pragmatically engaged in criminal activity for financial gain and ended up a mass murderer, must have had a peculiar absurdist appeal to Grosz, who was convinced that the mass murder of soldiers at the front continued because of the profits being raked in by capitalist heavy industry, war suppliers, and profiteers. Grosz's choice of this particular businessman's name as a pseudonym for his sketchbooks was an early dadaist act pointing to the profit motive, which he believed fueled the war, at a time when most middle-class Germans still viewed the war as a defense of German land and culture against outside aggressors.[12]

Significantly, however, Grosz in his letter made several crucial embellishments on the figure of William King Thomas, the first of which consisted of giving the businessman the additional title of physician. Secondly, Grosz turned Thomas into a practical American businessman. The multiple ironies associated with the name clearly fascinated Grosz and allowed him to express his own black humor, penchant for public provocation, and private industriousness. On one level, the association of doctors with mass murder was not surprising for

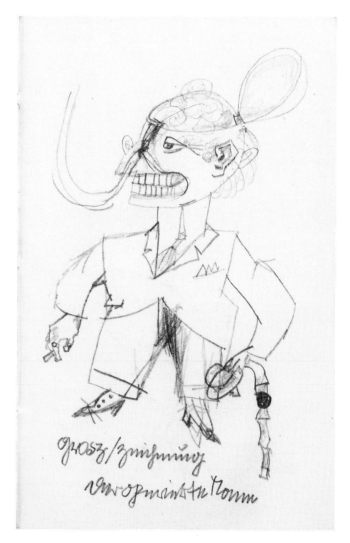

FIG. 1 *Sketchbook 1915/1, 25 verso*

a young man who, experiencing the slaughter of trench warfare in the surrealistic wards of military hospitals, recognized the power, frequently arbitrary, of physicians over the wounded. This linking of the venerated healer figure with murderer would, however, evoke an outraged response in German civilians who had no understanding of the horror of the war—a response that Grosz deliberately provoked in his Dada

actions. By the winter of 1915–16, Grosz had begun his public career as a sharp critic of a German society capable of producing the horror of World War I. In the literary journals *Neue Jugend* and *Die Weissen Blätter*, he published expressionist drawings and poems depicting a chaotic, violent world filled with brutish people.[13] He organized and participated in antiwar activities with his friends Wieland Herzfelde, John Heartfield, and Franz Jung—actions that became known, after Richard Huelsenbeck joined them in 1917, as dadaist. Given the sketchbook's dadaist title and Grosz's antiwar activity, we might expect to find the *Medical Journal* pages filled with mordant pessimistic drawings like those in his first two portfolios,[14] about which he later wrote, "I drew and painted out of opposition and attempted through my works to convince the world that this world is hateful, sick and lying."[15]

That is, however, not the case. Except for two groups of caricatural sketches in this first notebook, the drawings in the series of *Medical Journals* were dominated by observant clinical sketches drawn from Berlin urban scenes. This brings us back to the second, and more significant, alteration that Grosz made in the persona of William King Thomas. Characterizing his Fantômas-like physician double as "the *more American-practical materialistic* balance in the mother figure of Grosz [emphasis added]," Grosz buried the mythic mass murderer within the myth of the practical, efficient American, a myth that had dominated European thinking about Yankees throughout the late nineteenth and early twentieth centuries. The letters Grosz signed as William King Thomas were businesslike memoranda, filled with facts (some of which were phony nonsense), while long, sarcastic, cynical letters were signed with the pseudonyms of the aristocratic adventurers. This combination of pragmatic businessman and adventurer confirmed aspects of Grosz that remained in constant tension with the political activist and idealist throughout his life. With its provocative, contradictory layers of meaning, the persona of Dr. William King Thomas not only fit Grosz's sense of himself as a rebellious cynical loner, but also affirmed his own habit of practical hard work—a habit he later spoke of as his inheritance from the industrious, tenacious, Prussian craftsman who was his maternal grandfather,

a basketweaver in Finsterwald.[16] For Grosz, art grew out of practical, businesslike attention to the material world—not from abstract ideas and theories, but from exacting, careful honing of his craft and skills. All his sketchbooks, from the earliest linen-bound, ribbon-tied treasure in Stolp (1905/1) to the no-nonsense American spiral note pads (see, for example, 1950/2), are testimonies to his persistent and patient observation of human activity, dress, and character—an almost clinical examination of human behavior. Both Grosz's public stance and his published drawings were aggressive attacks on social and political systems in Germany, but the private world inside his sketchbooks over the years reveals little of that side of his work. Instead, the sketchbooks provide a constant, objective, often ironic, sometimes gentle view of the human figure in its many manifestations and settings. He worked intensely to be able to perfect the lines that captured scenes as disparate as the streets of revolutionary Berlin and Coney Island in New York.

In the first *Medical Journal of Dr. William King Thomas, U.S.A.*, Grosz turned his careful observation on people in wartime Berlin, occasionally with ironic commentary, and in a diagnostic style appropriate to an "American-practical materialistic" physician. Functioning as Dr. William King Thomas, Grosz devoted the largest number of pages in this sketchbook to clinical studies of individuals viewed in public places. Drawing with firm, sure strokes, Grosz transformed these figures into portraits that are also easily recognizable social stereotypes, as in "Landlord Schlammus" (Hausbesitzer Schlammus) (18 recto) and "Assessor Hammerstein" (Civil Servant Hammerstein) (20 recto), two predatory male types that prefigure the stereotypes of capitalists published in his major portfolios from 1918 to 1923. In some sketches, he experimented with alternate placements of a sloping shoulder or turn of foot, but most are delineated quickly and clearly with an economy of line. Grosz employed color infrequently but effectively, as in the green pimpled face and hands of the teenage girl with her blue eyes and brilliant red mouth, titled "Backfischchen" (Berlin slang for young teenage girl) (7 recto). His use of details like the pince-nez and cross for the stolid, self-righteous bourgeois matron, roundly ensconced in fox furs and muff (4 recto), immediately gives her a different social status

from that of the woman in the railway compartment who is seated in the same position (10 recto, titled "Im Eisenbahnabteil" [In the Railway Compartment]), but whose body language from her veiled hat to her high laced boots bespeaks her sexual availability—a coy sexuality made explicit through the flower in her hand that takes the shape of a penis, or the lightly indicated breasts under her dress. A second version of this woman toward the end of the notebook (28 recto) unmasks her sexuality by making her suit with its frilly borders transparent in order to focus upon the soft pubic hair and the shaded buttocks and breasts. This technique of providing a simultaneous view of the dressed and undressed female figure became a hallmark of Grosz's published drawings.

Soldiers occupied much of Grosz's attention in this notebook—not unexpectedly, considering wartime Berlin. In his autobiography, written during the Second World War, Grosz expressed disdain for the German soldiers who stood obediently at attention and followed orders in both wars, but his letters written at the time of this sketchbook, before his recall to service, are much more ironic about enlisted men.[17] The series of sketches here are astute, rather sad commentaries on what he later called "the reverse-side of the heroic:"[18] an elderly officer whose stoop and blotchy red face display weariness and, probably, dissipation (17 recto); dispirited soldiers who have traded sound limbs for the Iron Cross and artificial limbs, titled "der orthopädische Ersatzfuß" (the artificial foot) (21 recto and 24 recto); village types from East Prussia proudly wearing uniforms and military accoutrements, one of whom is a Schwejk-like figure, cheery, rotund, and naïve, presaging Grosz's 1928 drawings for Erwin Piscator's stage production of Hasek's *Adventures of the Good Soldier Schwejk* (22 recto and 23 recto).[19] *The Portrait of Sergeant Fritz Krause* presents a sober, round-faced peasant with his Iron Cross and honorary saber as the sentimental protector of German romantic dreams—the sun rising over a medieval village on the Rhine—and of Prussian imperial military aspirations—the imperial eagle and a sword of honor mounted on a classical column—both dreams evoking the patriotic song "The Watch on the Rhine" (25 recto, titled and inscribed "Porträt des Feldwebels Fritz Krause. Der Künstler hat den Feldwebel als Hüter des deutschen Rheins dargestellt" [Portrait of Sergeant Fritz Krause. The artist has depicted the sergeant as protector of the German Rhine]). Beside the doleful sergeant, the symbol of victory—a branch of laurel—is reduced to a kitschy pot of bay leaves. As in the drawings of civilians, Grosz here demonstrates an assured line and an unerring mastery of detail that created a realistic, though not naturalistic, typology of German soldiers. In the last military drawing (26 recto), Grosz shifts into a caricatural style, satirizing both the civilian view of heroic cavalry officers and portraits of the highest officer of the land, Kaiser William II, who before the war was frequently painted by artists such as Rudolf Wimmer and Max Koner, in uniform standing with a heroic gesture before luxurious draperies.[20]

Two bitter groups of drawings are set apart from the carefully observed figures of soldiers and civilians by crude lines and jagged forms, like those found in the July 1915 sketchbook (1915/1). These sketches move toward the "knife-hard"[21] style of the published drawings with which he became famous. Two pages of scribbled sketches (12 verso and 13 recto) mock the Christmas message "And Peace on Earth" (Und Friede auf Erden), (inscribed on both drawings) delivered by angels to the shepherds: in one scene, stick-figure soldiers fire artillery guns at the angel descending from the heavens ("Ballonabwehrkanone" [anti-balloon gun] is inscribed in the margin); in another, the angel, trumpeting peace, is caught in dark waves of destruction raining down on inert bodies and ruined buildings. A variation (14 recto) shows an exceedingly buxom angel carrying a cross, floating over a battlefield. On the facing page (13 verso) above words from the Christmas carol "Silent Night, Holy Night" (Stille Nacht, Heilige Nacht), Grosz scratched a grotesque Death's Head onto the body of a floating angel carrying a skeletal Christmas tree. Immediately following this cynical set of drawings are four scenes of death inscribed "Metzger Krieg" (Butcher War) (14 verso, 15 recto, 15 verso, 16 recto). In the first, of War as an executioner wielding a guillotinelike knife, Grosz works in a deliberately awkward and schematic style reminiscent of children's drawings. Two scenes of a man slaughtering someone with a samurai sword (one inscribed "Japan") and one of a woman committing suicide (inscribed "Der Selbstmord d. N." [The Suicide of N]) are

brutalized versions of his illustrations of adventure stories in 1912–13.

Grosz used this infantilized caricature style more effectively in five group scenes in which individuals make up part of a dramatic tableau. In the first he drew drastically simplified figures surrounding a man who has collapsed on the street, and then he added a visual punch with blood-red crayon to focus on the grotesque hemorrhage inscribed "Der Blutsturz in der Königgrätzerstr." (The hemorrhage in the Königgrätzerstr.) (5 recto). The style is a traumatized descendant of the line-drawn cartoons in *Fliegende Blätter* and *Simplicissimus* that he had once aspired to copy. In Grosz's hands, the focus of attention becomes painful and disturbing, in contrast to the mischievous or humorous incidents of the journals, and the figures are drawn in angular distortions, with a brazen sexuality that would have shocked Wilhelm Busch or Adolf Hengeler. Many of the figures in these imagined scenes are schematic restatements of the ones observed in streets and cafés in previous sketches. In the street scene, the woman on the right is a standing version of the woman in the railway compartment. Four other scenes depict dehumanizing situations common to modern urban life: the medical examination for venereal disease before a probing doctor, titled "beim Arzt" (at the doctor's) (6 recto), the hierarchical interview of student or employee before authoritarian officials (8 recto), the sexual selling of favors before wealthy males, titled "Intimes Interieur" (Intimate interior) (9 recto), and male domination over cowed women in the family, inscribed "Kaffeegesellschaft" (Drinking coffee) (19 recto). In all these, Grosz understood the humiliation of weakness before the arrogance of power, demonstrated always in the small gestures—playing with a pencil, casual crossing of legs, obsequious smiles, wine glasses and cigars, hands clasped behind the back, bent heads, defensively crossed arms, huge hands gesturing on a table.

These scenes are all set in urban interiors of homes and offices portrayed as economically and simply as the figures themselves. Just as Grosz had carefully observed and sketched the figures, so did he draw on his practical observation of their urban habitats. In this sketchbook, the final set of drawings, inscribed "Wartezimmer" (Waiting room) (29 recto, and 30 recto) reveals his repeated efforts to capture bourgeois interiors filled with overstuffed chairs, tile stoves, hanging lamps, ornate tables, plants, and an occasional dog. The painstaking repetition of motifs enabled him to capture the essential characteristics of these rooms and then to schematize them into stereotypical signs of social status and urban milieu, giving a critical edge to the figures within his published drawings.

Conceived through the trauma of his first military hospital ordeal, the Fantômas-like doubles served as Grosz's masks in confronting a murderous social order engaged in the massacre of its youth. In the year and a half between his nightmarish bouts of service, Grosz channeled his despair and anxiety to his friends—his personal public—through the belligerent, cynical, witty personas of the aristocratic dadaist adventurers in whose names he carried on an acerbic, morbidly inventive correspondence. The caustic drawings that reached the wider public at this time reflected the mordant, provocative views of Grosz's letters, although only a handful were signed with the dadaist pseudonyms. The *Medical Journals of Dr. William King Thomas* present a very different face. While their public side, their covers, still flaunt the provocative criminal name, the contents demonstrate George Grosz, the sober, conscientious artist, at his work. The multiple layers of Dr. William King Thomas—capitalist, businessman, mass murderer, physician, practical American materialist—provided a dadaistic mélange of contradictory meanings that clearly fascinated Grosz, who then superimposed his own interpretation to reinforce, in a bizarre fashion, the basic function of his sketchbooks: as an essential tool of a practical artist engaged in the businesslike observation of the human, material world around him.

NOTES

1. Krankenjournal des Dr. William King Thomas. U.S.A. Ok. 15 bis 15 Nov. 15. For details on this sketchbook, see entry 1915/2 in the Catalogue of Sketchbooks. All the pages of this sketchbook except blank pages are illustrated after this essay. 4 recto is illustrated in color on p. 68.

2. George Grosz, "Lebenslauf: Notizen für Prozess, 3 Dez. 1930," p. 2. Typescript in the George Grosz Papers, Houghton Library, Harvard University, bMS Ger 206 (1015).

3. George Grosz, *Ein kleines Ja und ein großes Nein* (Hamburg, 1955), p. 113.

4. Hags and penises also appeared in the work of Otto Dix when he returned from four years at the front. For Dix, penises were not comical figures but were bloodily mutilated and juxtaposed to disemboweled female torsos.

5. Grosz used the device of a man with his skull hinged open to reveal reactionary minds in later drawings and paintings, including his *Pillars of Society* (1926). Dix extended the concept of the "operated-upon man" to depict veterans who are virtually constituted out of prostheses.

6. George Grosz, *Briefe 1913–1959*, ed. Herbert Knust (Reinbek, 1979), p. 31.

7. "Ich bin grenzenlos einsam, d.h. bin allein mit meinen Doppelgängern, fantomatischen Figuren, in denen ich ganz bestimmte Träume, Ideen, Neigungen usw. real werden lasse. Ich fetze gleichsam 3 andere Personen aus meinem inneren Vorstellungsleben heraus, ich glaube selbst an diese vorstellenden Pseudonyme. Allmählich sind drei fest umrissene Typen entstanden. 1. Grosz. 2. Graf Ehrenfried, der nonchalante Aristokrat mit gepflegten Fingernägeln, darauf bedacht, nur sich zu kultivieren, mit einem Wort: der aparte aristokratische Individualist. 3. Der Arzt Dr. William King Thomas, der mehr amerikanisch-praktisch materialistische Ausgleich in der Mutterfigur des Grosz." in Grosz, *Briefe*, pp. 30–31. See Alexander Dückers, *George Grosz. Das druckgraphische Werk* (Frankfurt/Main, 1979), pp. 142–43, for a listing of all the pseudonyms Grosz used.

8. Grosz's fascination with role-playing has been widely recognized. In addition to his letters, see his own analysis in *Ein kleines Ja*, p. 21, and his interviews with Richard O. Boyer in the *New Yorker* (Nov. 27, Dec. 4, 11, 1943). See also Thomas Craven, "George Grosz," in *Modern Art: the Men, the Movements, the Meaning* (New York, 1934), pp. 204–17; Beth I. Lewis, "The Merchant from Holland," in *George Grosz: Art and Politics in the Weimar Republic*, rev. ed. (Princeton, 1991), pp. 3–11; Uwe M. Schneede, "The Doppelgänger Motif," in *George Grosz: The Artist in His Society* (Woodbury, N.Y., 1985), pp. 58–60; M. Kay Flavell, *George Grosz: A Biography* (New Haven and London, 1988), pp. 30–32.

9. Grosz signed the name as Graf Orfyrén-Beßler. Joh. Ernst Elias Beßler-Orffyré was featured in a book on great adventurers that Grosz illustrated for a friend after the war. Ignaz Jezower, ed., *Die Rutschbahn. Das Buch vom Abenteurer* (Berlin and Leipzig, 1922).

10. Dückers, *George Grosz*, pp. 142–43, points out that the case was sufficiently notorious for Grosz to have known of it before the war. The episode may have been featured in the horror peep shows that Grosz delighted in as a boy. Dückers states that he did own a copy of a guide to an international police exhibition, probably dating from 1926, that contained a photograph and death mask of William King Thomas, who shot himself just before his arrest. The guide is now in the George Grosz-Archiv of the Akademie der Künste, Berlin.

11. See Wieland Herzfelde's account of his first meeting with Grosz at this gathering in 1915 in "The Curious Merchant from Holland," *Harper's Magazine* 187 (Nov. 1943): 569–73.

12. Support for the war among artists, intellectuals, and the middle classes remained strong until the catastrophic failure of the German offensive at Verdun in the spring of 1916.

13. *Neue Jugend* (Berlin, July 1916–June 1917); *Die Weissen Blätter* 3, no. 11 (Oct.–Dec., 1916).

14. *Erste George Grosz Mappe* (Berlin, late 1916–early 1917); *Kleine Grosz Mappe* (Berlin-Halensee, Fall 1917).

15. Grosz, "Abwicklung," *Das Kunstblatt* 8, no. 2 (Feb. 1924): 36.

16. Grosz, *Ein kleines Ja*, p. 41.

17. For example, see Grosz, *Briefe*, pp. 42–45; *Ein kleines Ja*, chap. 7.

18. Grosz, "Lebenslauf," p. 2; Grosz Papers (1015): "Die, wenn ich so sagen darf Rückseite des Heroischen fing an mich zu beschäftigen."

19. Jaroslav Hasek's famous novel, *Die Abenteuer des braven Soldaten Schwejk*, was published in 1926. 22 recto is titled "Franz Müller. Artillerist aus Thorn-Marke" (Franz Müller. Artilleryman from Thorn-Marke). 23 recto is inscribed "Landsturm. Tischler Segewald aus Thorn-Marke." (Conscript. Carpenter Segewald from Thorn-Marke).

20. This drawing is inscribed: "Porträt Entwurf Für Franz Cohn aus Bromberg. Leutnant im Reg. 53. Der Leutnant steht in heroischer Geste vor einem roten Vorhang" and in the margin: "Das Pferd soll mit drauf" (Study for portrait of Franz Cohn from Bromberg. Lieutenant in 53rd regiment. The Lieutenant is standing in a heroic gesture in front of a red curtain./ The horse is to be included, too).

21. Grosz, "Abwicklung," p. 24.

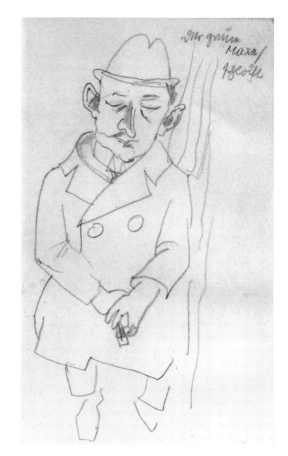

1 recto

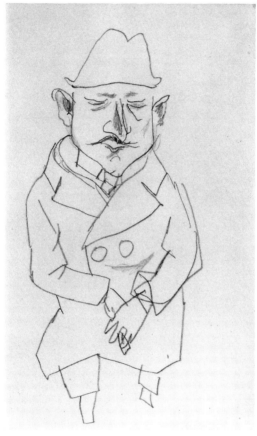

2 recto

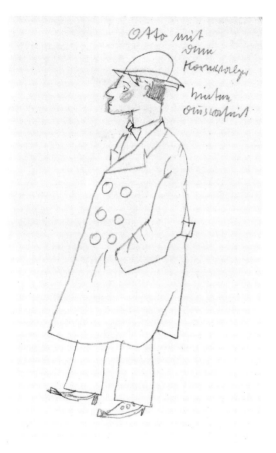

3 recto

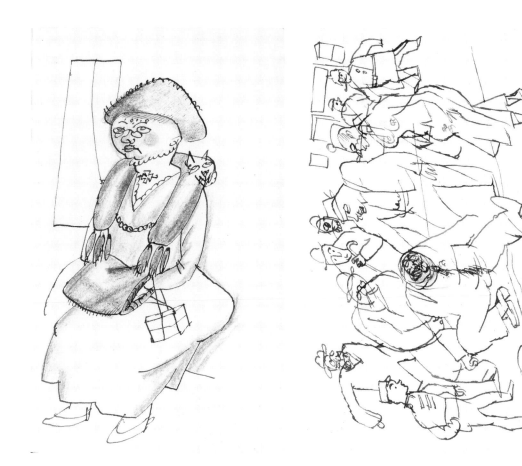

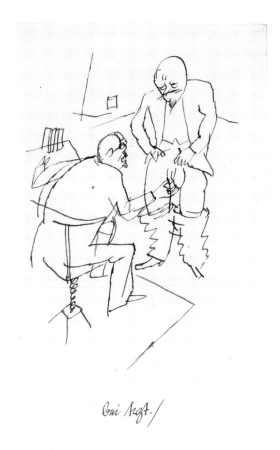

4 recto

5 recto

6 recto

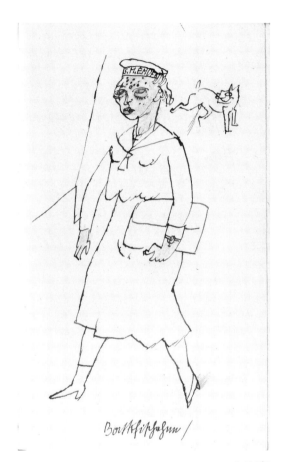

7 recto

8 recto

9 recto

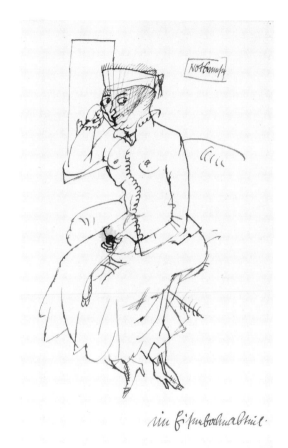

10 recto

11 recto

12 recto

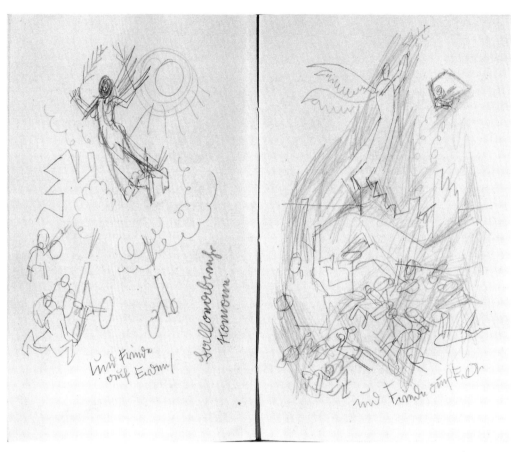

12 verso and 13 recto

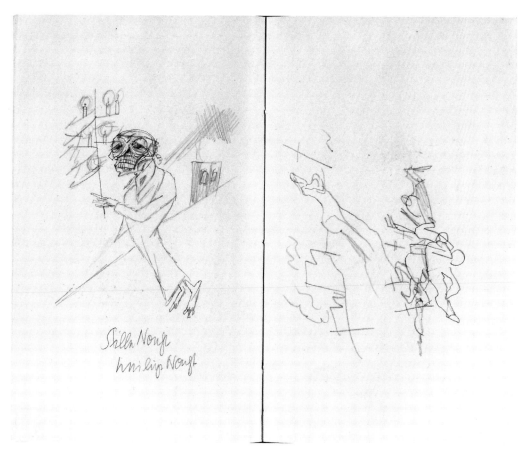

13 verso and 14 recto

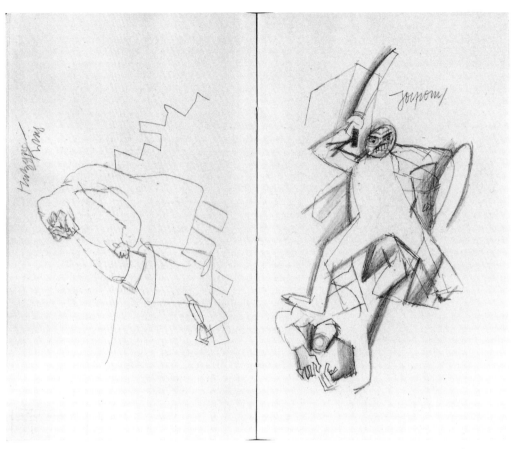

14 verso and 15 recto

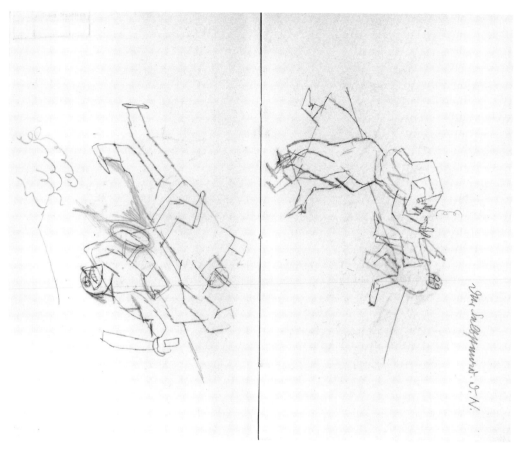

15 verso and 16 recto

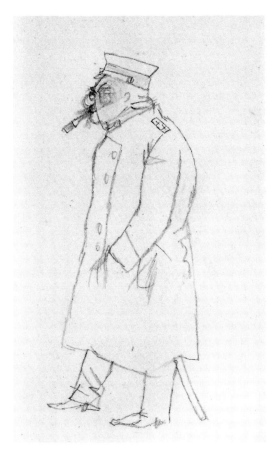

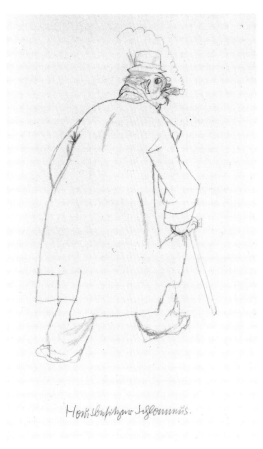

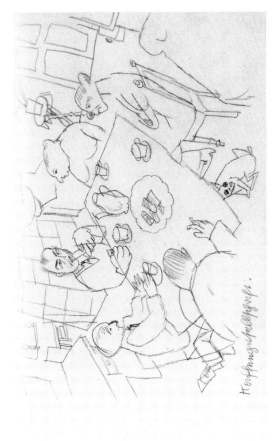

17 recto

18 recto

19 recto

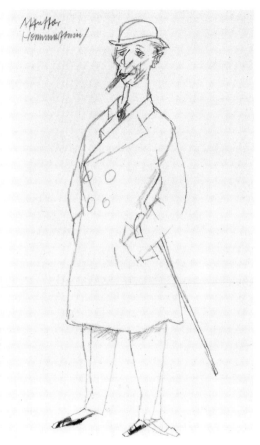

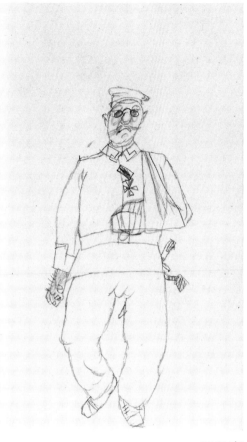

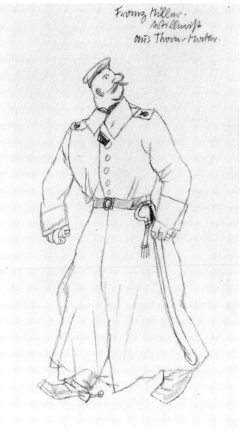

20 recto

21 recto

22 recto

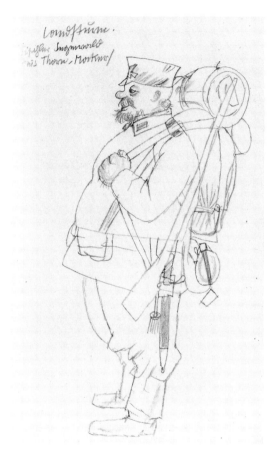

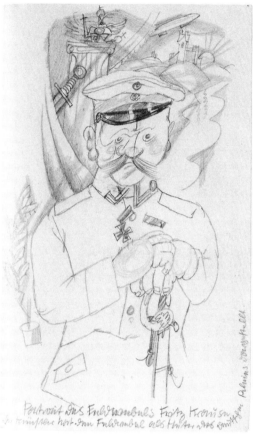

23 recto

24 recto

25 recto

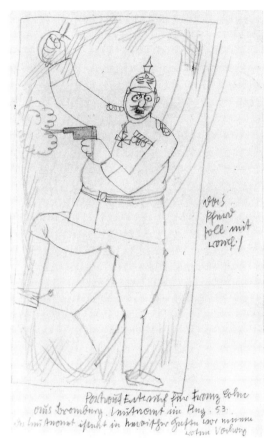

*Porträt Entwurf für Franz Cohn
aus Bromberg. Leutnant im Reg. 53.
Der Leutnant steht in kurzer Hose wie immer
ohne Vorhang*

26 recto

27 recto

28 recto

28 verso and 29 recto

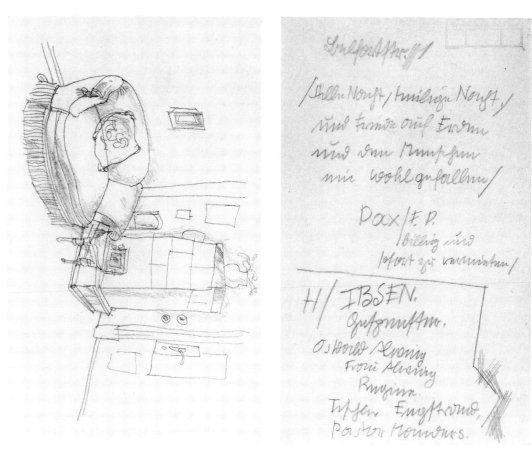

30 recto 30 verso

COLOR PLATES

1909/2, 28 recto
12.1 x 19.5 cm

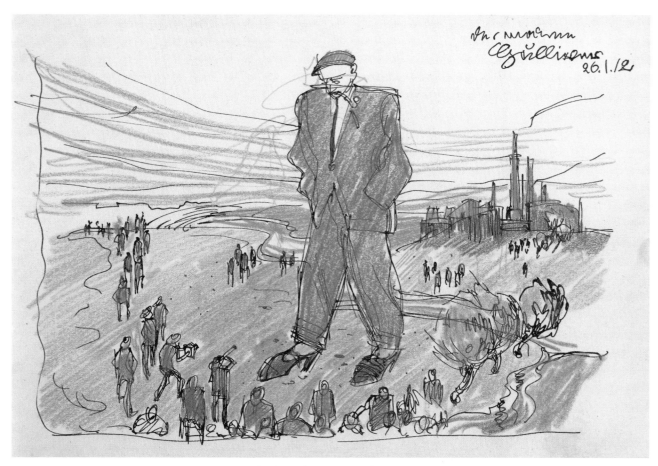

1912/1, 11 recto
16.8 x 25.0 cm

1912/3, 5 recto
18.6 x 28.0 cm

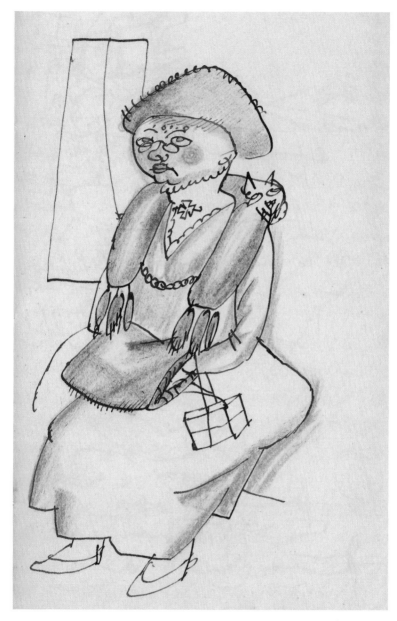

1915/2, 4 recto
16.4 x 10.4 cm

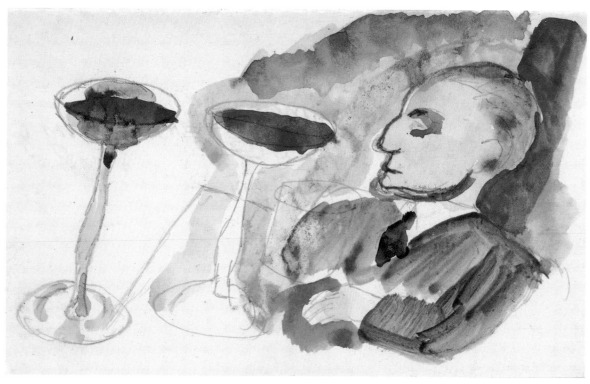

1916/4, 4 verso
16.5 x 10.2 cm

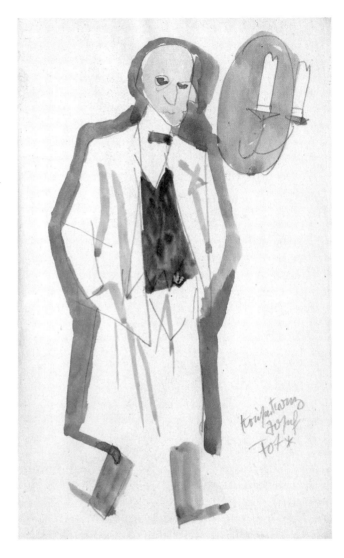

1916/5, 10 recto
16.4 x 10.3 cm

1924/4, 1 recto
20.9 x 16.8 cm

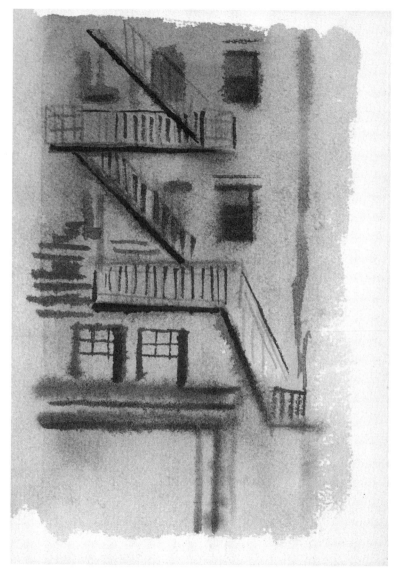

1932/7, 17 recto
17.0 X 11.9 cm

1932/8, 11 verso
17.0 X 12.0 cm

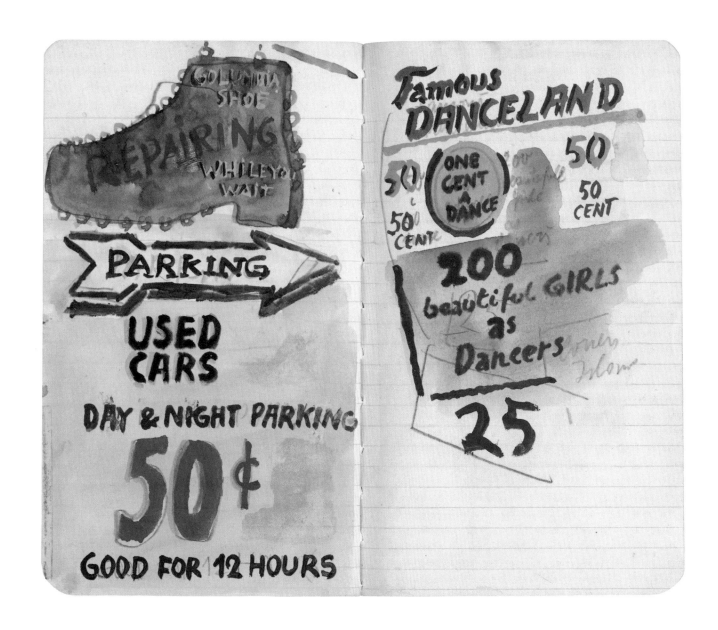

1932/17, 46 verso and 47 recto

17.3 x 20.8 cm

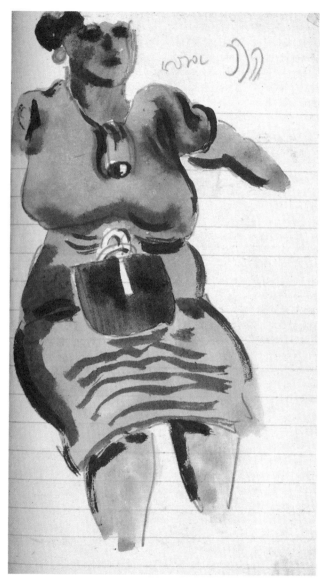

1933/10, 25 recto
14.9 x 8.8 cm

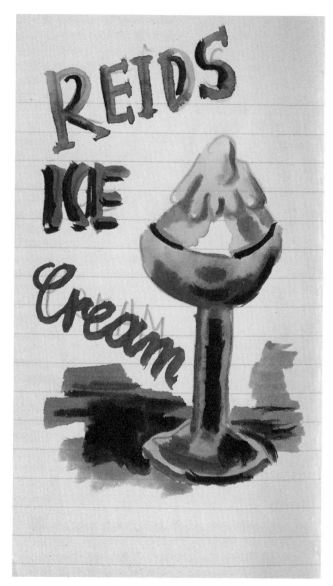

1933/11, 46 verso
14.9 x 8.8 cm

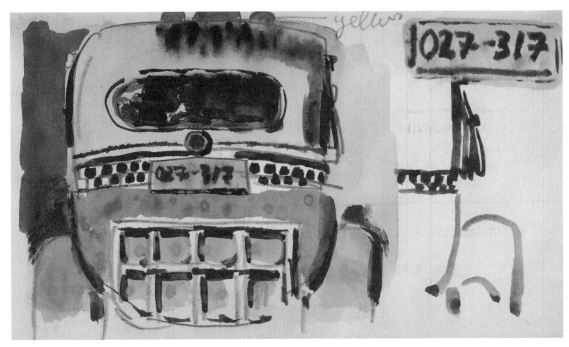

1933/12, 66 recto
15.2 x 8.7 cm

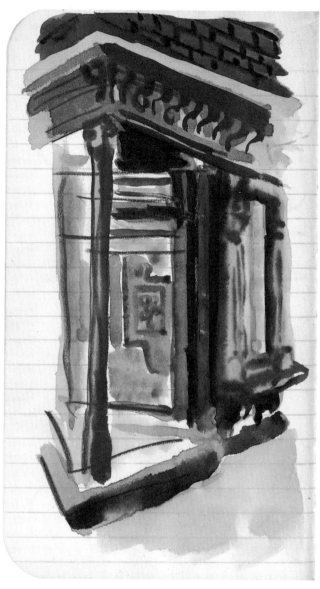

1934/1, 71 verso
15.1 x 8.5 cm

1934/3, 48 recto
15.0 x 8.5 cm

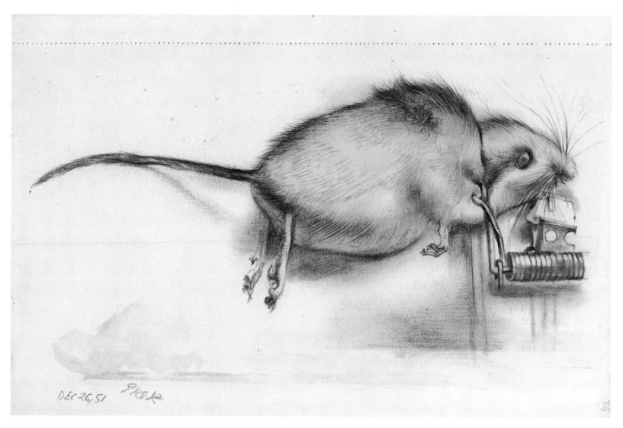

DEC 26/51

1950/7, 34 recto
23.3 x 15.3 cm

1951/1, 6 verso and 7 recto
23.7 x 30.8 cm

1952/2, 45 recto

19.0 X 12.2 cm

1954/3, 34 verso and 35 recto
14.9 x 18.6 cm

GROSZ IN THE STREETS OF NEW YORK: IMAGES OF A NEW WORLD IN SKETCHBOOK 1933/12

CATHERINA LAUER

A tremendous–uneasy futuristic city. Enormous, with all races of the world. I like it.[1]

When George Grosz arrived in New York City for the first time in June 1932 to teach the summer class at the Art Students League, his reaction to the city was overwhelmingly positive. This is shown in numerous enthusiastic letters to his relatives and friends back home, as well as in dramatically increased sketching activity. Having been in the city for about a month, he wrote to his brother-in-law Otto Schmalhausen, "Well, I stroll around a lot, I already filled nine sketchbooks, always there is something new to see and to note down."[2] Grosz stressed the ethnic diversity, distinctive habits, and tremendous pace of the city: "Here is constant movement, sound, and eternal light. [...] New York differs completely from European cities. Sometimes there might be this or that which reminds you of Berlin or Paris ... but the whole way of life is so different from that abroad ... far less gemütlich, ... everything constantly without time and in constant rush."[3] In June 1933 he wrote to his friend Herbert Fiedler, "At first I walked like a drunk through this bustling and alive, more than picturesque city [...]. So full, so lively, so dramatic ... overfull. The old and new are randomly mixed up ... above all is a touch of Italy (or perhaps Marseille [*sic*]) [...] I constantly walk around with small sketchbooks to take notes of all this."[4]

Owing to his enthusiasm for the "New World," Grosz returned to settle in the United States in January of 1933, and his family followed a few months later. Between 1932 and 1935 Grosz's work almost entirely celebrated metropolitan street life, a development that eventually ceased in 1936.

It appears that his New York experience added new inspiration to Grosz's childhood dream of America.[5] From early on, Wild West imagery appeared in his work. An entire sketchbook from 1909 depicts Wild West scenes, and in prints such as *Memory of New York* (1915-16) and *Texas Picture for My Friend Chingachgook* (1916-17) he combined crude Wild West characters with images of the metropolis. His 1932 encounter with the "real" New York revitalized these youthful fantasies. Grosz repeatedly commented on America's being still "Desperado Country, Colonial land," and described it as a "large CHILDISH-brutal-laughing country."[6] At other times he alluded even more explicitly to Wild West imagery: "Gold digger atmosphere—it is still here, the saloon world of the adventurers which is now hidden—adventurers with their unrestricted desires."[7] Not only did the artist evoke the imaginary characters of his youth, but he also lived the part of the adventurer when he explored different parts of Manhattan.

In his role as explorer and observer of the city Grosz stands in the nineteenth-century tradition of the artist-*flâneur*, of whom Baudelaire wrote:

> The crowd is his element, as the air is that of birds and water of fishes. His passion and his profession are to become one flesh with the crowd. For the perfect *flâneur*, for the passionate spectator, it is an immense joy to set up house in the heart of the multitude, amid the ebb and flow of movement, in the midst of the fugitive and infinite. To be away from home and yet to feel oneself everywhere at home, to see the world, to be at the center of the world, and yet to remain hidden from the world — ... The spectator is a *prince* who everywhere rejoices in his incognito.[8]

While Baudelaire was describing the artist Constantin Guys, the description certainly applies to Grosz in his role as meticulous and witty observer of the crowd, and his passionate and continuous attempt to capture city life in all its variety. Grosz seems to have been quite conscious of his role as spectator, referring to himself as "see-man."[9] Yet unlike Baudelaire's

flâneur, who merely observes and draws from memory, Grosz drew directly in the street.

Grosz's sketchbook 1933/12 is characteristic of his New York sketchbooks with regard to content.[10] It covers a period of change in Grosz's life, when he moved from Manhattan to suburban Queens. Since his arrival in January 1933, he had been living like a nomad,[11] moving from one place to another. Grosz began the sketchbook on 3 November 1933 at the Hotel Raleigh on West 72nd Street in Manhattan. By the time he filled the last page on 22 January 1934, he was already living in Bayside, Long Island, where he moved after his family arrived. Despite this move to a more suburban setting, however, the artist's gaze remained, with few exceptions, focused on New York street life.[12]

Grosz quickly grew familiar with the New York environment. Already in 1932, after four weeks in the city, Grosz had noted that he almost felt at home since he was now familiar with the streets and different transportation systems.[13] Exploring New York by bus, subway, and on foot, he expressed his fascination with the city's diversity and contrast in a multitude of drawings, including images such as the steel structure of a bridge, high-rise buildings crowned by water towers and a General Motors ad, and an elderly lady carrying a cat (4 recto, 7 recto, 28 recto). Apart from numerous depictions of people, it is especially the new, peculiar, and uniquely American objects such as water towers, fire escapes, and skyscraper facades that find frequent expression in his sketchbooks. His selection of images appears almost random, so that sequence is of little importance. While each drawing may stand on its own, it is the totality of the sketchbook images that captures an impression of the city and illustrates what Baudelaire called the artist-*flâneur's* "delight in universal life."[14]

On daily excursions Grosz sketched scenes of street vendors, strollers, people riding on the bus or subway, and a large number of street signs and advertisements. In order to facilitate drawing in any situation, Grosz attached a rigid cardboard support to the back cover of most of his New York sketchbooks. While he would draw in pencil in the street, he often made notes on various colors or color combinations on site (see 64 verso, 65 recto, 66 recto, 71 verso). Later he would execute some of the drawings in watercolor in his studio or hotel room. Thus the drawings that originated in the streets are frequently limited to their characteristic outlines or appear half-finished, while the watercolors are rendered in great detail. Examples such as the rendition of a lion at the entrance of the New York Public Library or the drawing of a window display illustrate the sketchy character of some of his street drawings (see 49 verso, 50 recto). Several examples of watercolors show that Grosz modeled them after the drawings done in the street. In cases such as an advertisement for "Strawberry Sunday" [*sic*] or a film poster, the watercolor is superimposed over the preliminary pencil sketch (61 verso, 65 recto). Occasionally, the watercolor appears next to the original street drawing, such as in the study of a jeweler's shop sign (52 verso).

Grosz's sketchbook 1933/12 is of particular interest because the artist used several of the sketchbook images and assembled them in the watercolor *New York, New York (Times Square)*, 1934 (Solomon R. Guggenheim Museum, fig. 1). The only visible person in this picture is a male figure wearing a hat, a shirt with rolled-up sleeves, and a pair of striped pants, who is walking down a street with cascading shop signs, thus once again evoking the image of the urban cowboy and adventurer.

Some of the most brilliant sketchbook drawings reappear in this work, among them the evocative drawing of a New York Yellow Taxi (66 recto). Also included are a laundry cart (1 recto), which changes its name from "Sussex" to "Essex Laundry," as well as three advertisement signs. Grosz does not simply copy the single sketchbook images but slightly alters or crops them when composing the watercolor. Thus the "Soda" shop sign in the upper right corner has a slightly different design from the one in the sketchbook (51 recto), and the bell that ornaments the "Dinner" sign swings to the left in contrast to the straight hanging bell in the book (62 verso and 63 recto). The "Laundry" sign, however, is almost identical to the sketchbook prototype (51 recto). While Grosz adopted a number of images from 1933/12 in this watercolor, at least three other details can be found in other sketchbooks from the same year. The unusual "Chiropodist" sign and the fire hydrant in the foreground are taken from 1933/9 (figs. 2 , 3), and several drawings

FIG. 1 New York, New York (Times Square), *1934. Watercolor and ink, 66.4 x 48.3 cm. Solomon R. Guggenheim Museum, New York. Photo: Robert E. Mates; ©The Solomon R. Guggenheim Foundation, New York.*

of barber poles in the same sketchbook could have inspired the pole on the right. In addition, the railroad bridge and facades in the upper left of the picture are likely to have been influenced by a similar drawing in 1933/11, and the chair in the bottom right corner can be found in sketchbook 1933/10, where it appears next to shoeshine equipment.

Interestingly, the "Soda," "Laundry," and "Chiropodist" signs reappear in the print "The Bowery" which belongs to the portfolio *Bagdad-on-the-Subway*, 1935.[15] As in the

Guggenheim watercolor, shop signs, fire escapes, and a barber pole create the ambience for a man and a woman walking down the street. Furthermore, the print includes a shop sign, "Alerail," which also appears in sketchbook 1933/12 (57 verso) with additional text and more differentiated colors. Similarly, the representations of the "Soda," "Laundry," and "Chiropodist" signs are less elaborate in the print, with the last mentioned reversed and lacking part of the lettering.

This traditional use of the sketchbook as visual record for the artist illustrates that the books had a practical application. While the sketchbook drawings are documents of Grosz's street walks, the finished watercolor is a studio production, blending real-life images into a fictive composite where time and exact location are of minor importance. Proof for this can be found not only in the fact that Grosz used segments from sketchbooks that originated at different times in 1934, but also in single examples such as the "Chiropodist" sign and the laundry cart, which, according to the sketchbook, originated in different locations. Grosz also used his sketchbook images in several other watercolors. It appears safe to assume that the artist frequently relied on his sketchbooks as a source of inspiration. The extent to which he drew upon them, and whether he used them systematically or at random, is a question that awaits further investigation.

The 1933/12 sketchbook also provides excellent examples of one of Grosz's characteristic drawing techniques. Grosz frequently depicts an object in context and then as an isolated detail, a technique reminiscent of a camera close-up. For instance, beside the drawing of the New York taxi is a drawing of its license plate (66 recto). Similarly, the "Dinner" advertisement sign appears in its architectural context as well as in close-up (see 62 verso, 63 recto). Such sensitivity to detail is characteristic of Grosz's work. However, the detail and its context are not always as obvious as in the examples above. A close-up of a *Herald Tribune* newspaper box appears on 14 verso, and several pages later the detail reappears in a compositional context (44 verso). An eye for detail can also be detected in drawings such as a Mickey Mouse head and a boot (50 verso), and an open manhole (40 verso). Grosz was guided by similar interests in his approach to the human figure, for it is usually

Fig. 2 *Sketchbook 1933/9, 23 recto*

Fig. 3 *Sketchbook 1933/9, 55 recto*

a special detail—a person's dress, the accessories, or an interesting task—that captures his interest (11 recto, 28 verso, and 29 recto).

Although Grosz produced numerous watercolors in the 1920s, he used this medium only sporadically in the sketchbooks prior to 1932. Thus his frequent use of watercolor, the medium with which he gained a reputation in the United States, was a novel development within the New York sketchbooks and signaled the artist's new engagement with his surroundings. Soon after his arrival in June 1932, he exhibited eight watercolors in the staff show of the Art Students League. The *New York Times* heralded his work: "As water colorist, Grosz is superb. His draftsmanship, both in this medium and in black-and-white, is always keenly alive, vigorous, revealing."[16] A year later, in June 1933, Grosz mentioned that he painted about sixty watercolors, some of which were shown in exhibitions between 1933 and 1935.[17]

Most of the New York watercolors were strikingly apolitical. (This is particularly true of Grosz's New York harbor series for which, interestingly enough, none of the sketchbooks includes preliminary drawings.) Although his Berlin sketchbooks and an increasing number of portrait paintings in the late 1920s already indicate an apolitical tendency, it is nevertheless surprising that Grosz distanced himself from politics altogether as soon as he entered the "New World" in June 1932. It appears

that Grosz tried to establish a nonpolitical image, for he denied any affiliation with the Communists, "asserting that in his work he is independent and in politics takes no part at all."[18] Yet even in his private life a change toward a less political attitude began to crystallize. In a letter to his friend Fiedler, he seemed content with the status quo: "You only have to look out here [and you will find the scene] crowded with images. Yes I am definitely not an inhabitant of an ivory tower. I depict the life around me ... to copy this, simply said, fulfills me [...] day and night."[19]

One may speculate that Grosz initially tried to present a low profile, but a concentration on less political images largely continued throughout his career in the United States. However, numerous anti-Nazi and anti-Stalin drawings from the late thirties and forties, as well as drawings relating to the Spanish Civil War, prove that he did not reject political satire altogether. In defense of his move away from social political criticism, Grosz later commented: "As with Goya, there is more than this 'dark side' to my work...I want to paint pic-

tures that are positive … women on the beach, landscapes, wind, dunes, grass. [...] So you see, these two sides can live separate lives in the same person."[20]

Grosz opened his sketchbook with a drawing of a man pushing a Sussex Laundry cart (1 recto), thus combining two of his favorite subjects: people and written advertisement. It is especially the latter category that is prominently displayed in the New York sketchbooks. Bold shop signs such as posters advertising gasoline or movies (64 verso, 65 recto), or a building facade with a lubrication advertisement (41 recto), fill the sketchbook's pages. Grosz was just as interested in the particular setting as in the design itself. A characteristic example is a billboard sign inscribed "Katherin Hepburn [sic]," (25 verso, 26 recto) squeezed between two parked cars, or the blue letters of a shop sign for "Grand Rapid Furniture," (53 verso) which is placed on the brick facade of a building with a fire escape right next to it. Grosz frequently expressed his fascination for striking promotion in a somewhat romantic tone:

> Then I went to the Broadway which crosses 57th Street right at the Art League.[...] Great Street. Between small old houses red with fire escapes on the outside, suddenly skyscrapers. All facades are covered with advertisements, already lit during the day. Movie theaters open early. Half Sankt Pauli [Hamburg's red light district], half Friedrichstrasse [famous street in Berlin], half Paris—and yet very different due to the surprising views on erect narrow skyscrapers. [...] Facades [that are] more than covered, advertise entertainment. Films with … larger than life-size enlargements of the admired movie stars.[2]

Accordingly, street signs fill the pages of his sketchbooks, many of them rendered in watercolor.

While advertisements are profusely illustrated in the New York sketchbooks, the subject of advertising and graphic art had interested Grosz for a long time. In a biographical statement written before his second trial in 1930,[22] Grosz mentioned his interest in commercial design: "After [working at the Dresden Academy] for two years, I went to Berlin to the Kunstgewerbeschule [in 1912]. The stipend tempted me, but also I wanted to learn something more practical because I soon wanted to earn money. I wanted to become a graphic and poster designer [...]."[23] Grosz's German work of 1915–16 contains

numerous examples of advertisements. In pictures such as *Metropolis* (1916–17) or *Memory of New York* (1915–16) Grosz superimposed names of cafés, hotels, and restaurants over the architectural background in a somewhat random fashion. These ads are not attached to architectural structures but appear to float freely over the compositions. Their visual impulses act as acoustic sounds that hover over the streets of the city. Grosz expressed fascination with street advertisement in his dada essay "Kannst Du radfahren?" (Can You Cycle?), published in *Neue Jugend* in 1917: "Ho! Ho! Once again the walls of the houses are screaming: Regie-Zigaretten, Satrap, Palast-Hotel, Teppich-Thomas, bade zu Hause, Steiners Paradiesbett…ho!…Sarg's Kalodont…Passage-Cafe…AEG …Ceresit."[24]

In his list, the brand names, advertising slogans, and hotel and café names appear in their corresponding typefaces. This rhythmic arrangement of names creates a visual walk through the streets, and their accumulation reflects the visual bombardment on a viewer. The dotted lines introduce the notion of movement; one can read them as a turn of the head or a glance into a side street, until attention is caught by yet another sign.

The dadaists not only included various advertising techniques in their art but also promoted themselves as consultants in this field.[25] In the "Prospekt zur Kleinen Grosz Mappe," Grosz and Heartfield designed a promotional montage for the Grosz portfolio that included images of a dancing woman, a cigar, a gramophone, a hot-air balloon, a car, and ships, all loosely scattered over a quarter page. Various skulls and crossbones, crosses, and a coffin alternate with titles of the prints. The title of the portfolio as well as the words "Just released!" appear repetitively in boldface type. The chaotic arrangement of the single elements in combination with death symbols and images of entertainment creates a sensational effect in true Dada fashion.

However, unlike contemporaries such as Kurt Schwitters, Max Burchartz, or some of the Bauhaus artists, Grosz does not appear to have been interested in celebrating advertising as an apt vehicle of mass communication. Likewise, the poetic alteration of picture and text as it was explored in the collages

of the Cubists, as well as in the work of Futurists and Surrealists, did not interest him. Starting in 1917, Grosz's sketchbooks include some brand names and shop signs that echo the designs of his paintings and prints from that period. While only a few such examples can be found in existing sketchbooks between 1918 and 1923, a major interest in commercial signs can be found in sketches from a trip to France in 1924. Coincidentally, this change occurs shortly after his conviction on charges of "offending public morality" with his portfolio *Ecce Homo*, in February 1924. Yet it remains speculative whether this was a conscious move away from the heated debates about his political satire. Grosz continued his social-critical work in the late 1920s, but at the same time produced an increasing number of oil portraits, still lifes, and a profusion of advertisements in his sketchbooks.

Grosz's growing focus on ads during the 1920s was paralleled by a proliferation of billboard signs and posters in the streets of Berlin. In 1930, Adolf Behne commented on a huge billboard arrangement at the Potsdamer Platz: "This is not an advertising section but an art exhibition, although it is a bad one."[26] The rapid expansion and installment of signs and images dramatically changed the appearance of the city and led certain people to fear for the destruction of their *Heimat*, which was being buried under cosmopolitan modernization.[27] Especially after World War I, promotional styles and techniques were designed on the American model, which is not surprising considering that America had been viewed for decades as the paradigm of modernization and commercialization.[28]

In spite of his familiarity with neon advertisements and billboard signs in Berlin, Grosz was enchanted by the street advertisements in New York, particularly on Broadway: "When one strolls along the Broadway at night … everywhere neon advertisements … catch attention … this Coney Island character of the boulevards, the people glazed and lit in red, green and yellow light […]."[29] Behind each tempting sign lay pleasure and entertainment, each thrilling advertisement an invitation to new and fascinating adventures. Thus the artist could romantically view himself as an "adventurer" who was exploring the exteriors and enticing interiors of the city of New York.[30]

Grosz's interest in popular culture and images of the metropolis apparently ceased in 1936, when he turned to new subjects.[31] In retrospect, his sketchbook of 1933/12 marks the end of a fruitful phase. In 1935, Grosz's sketchbook production declined dramatically, and in 1936 street life and advertisements began to disappear.

Initially, Grosz had received considerable publicity after his arrival in 1932,[32] and it might have been this attention that led the artist to anticipate a great artistic career in the United States. At that time he wrote his brother-in-law, "Well, I am a well-known man … in the future I will have the chance of my life here […]."[33] In the years to come, these hopes turned out to be somewhat disappointed in an environment that began to favor Abstract Expressionism. Still, the New York sketchbooks stand as a record of that hopeful moment, their fresh drawings enthusiastically celebrating the "New World" and a promising future.

NOTES

1. Grosz to Herbert Fiedler, 9 September 1932, The George Grosz Papers, Houghton Library, Harvard University, bMS Ger 206 (hereafter cited as Grosz Papers), (582): "Eine unheimlich-unbehagliche futuristische Stadt. Riesengross, mit allen Rassen der Erde. Ich habs gern." (Unless otherwise noted, English translations are my own.) I would like to thank Beth I. Lewis, Peter Nisbet, and Emilie Norris for their invaluable suggestions and comments on this essay.

2. Grosz to Otto Schmalhausen, 14 July 1932, Grosz Papers (807): "Gut also schön strolche hier viel herum, habe schon neun Skizzenbücher voll, immer gibts neues zu sehen und zu notieren." The term "note" is Grosz's expression for sketching.

3. Grosz to Eva Grosz, 20 July 1932, Grosz Papers (607): "Hier ist dauernd Betrieb, Geräusch und ewig Licht. […] New York ist vollständig anders wie europäische Grosstädte. Es erinnert einem [*sic*] manchmal wohl an dies und das in Berlin od. Paris…aber dann ist die ganze Art zu leben so verschieden von drüben…viel weniger, gemütlich,…alles dauernd ohne Zeit in einer ewigen Hetze." NB: ellipses points in quotations from Grosz's letters are his, unless enclosed in brackets.

4. Grosz to Herbert Fiedler, 13 June 1933, Grosz Papers (582): "Zuerst ging ich wie ein Betrunkener durch diese wimmelnde lebendige, mehr als malerische Stadt. […] So voll, so lebendig so dramatisch…übervoll. Altes und Neues wahllos durcheinander…über allem ein Schlag Italien…(oder vielleicht Marseille [*sic*]) […]. Ich laufe dauernd mit kleinen Notizbüchern herum, um all das zu notieren."

5. This subject has been explored by Beeke Sell Tower in *Envisioning America: Prints, Drawings, and Photographs by George Grosz and His Contemporaries, 1915–1933*, exh. cat., Busch-Reisinger Museum, Harvard University Art Museums (Cambridge, Mass., 1990).

6. Grosz to Eva Grosz, 22 August 1932, Grosz Papers (607): "[…] grossen KINDLICHEN-brutalem-lachendem Lande."

7. Grosz to Eva Grosz, 12 June 1932, in George Grosz, *Briefe 1913–1959*, ed. Herbert

Knust (Reinbek, 1979), p. 138: "Goldgräberatmosphäre—da ist sie noch, die jetzt zugedeckte Saloon-Welt der Abenteurer, Glücksritter mit ihren hemmungslosen Trieben."

8. Charles Baudelaire, *The Painter of Modern Life and Other Essays*, trans. and ed. , Jonathan Mayne (London, 1964), p. 9.

9. Grosz to Eva Grosz, 8 August 1932, Grosz Papers (607): "Das gerade diese Stilmischungen sind für einen Sehmann so überaus interessant."

10. For details about this sketchbook see entry 1933/12 in the Catalogue of Sketchbooks. Over half of the drawings in this extensive sketchbook are illustrated after this essay. In addition to blank sheets, the following have not been reproduced: 3 recto, 5 recto, 6 recto, 10 recto, 12 recto, 13 recto, 21 recto, 22 recto, 25 recto, 26 verso, 27 recto and verso, 30 recto and verso, 33 recto, 36 recto and verso, 37 recto, 43 recto and verso, 44 recto, 45 verso, 46 recto and verso, 47 recto, 52 recto, 55 verso, 56 recto and verso, 58 verso, 59 recto and verso, 60 recto, 66 verso, 67 recto, 68 verso, 69 recto, 74 recto, and 77 verso. 66 recto is illustrated in color on page 75.

11. Grosz to Otto Schmalhausen, 29 September 1933, Grosz Papers (807): "[…] see I live now quite as a nomade …from one Hotel and apartement to annother…yeah it keeps you elastic…does'nt [*sic*]?"

12. Exceptions could be seen in a series of detailed studies depicting people riding on a bus or train, scenes that could have been executed on the ride from Long Island to Manhattan, where he taught at the Art Students League and at the Grosz-Sterne School (see 71 verso, 72 recto). Also, a drawing of a New England-style house and church (69 verso, 70 recto) is likely to be another suburban image.

13. Grosz to Otto Schmalhausen, 14 July 1932, Grosz Papers (807).

14. Baudelaire, *The Painter of Modern Life*, p. 11.

15. Alexander Dückers, *George Grosz: Das druckgraphische Werk* (Frankfurt/Main, 1979), p. 205-206 (M VII, 2).

16. *New York Times*, 9 June 1932, 26:3.

17. Grosz to Herbert Fiedler, 13 June 1933, Grosz Papers (582).

18. *New York Times*, 4 June 1932, 17:2.

19. Grosz to Herbert Fiedler, 13 June 1933, Grosz Papers (582): "Hier brauchst Du nur hinzusehen, schon wimmelt es voller Bilder. Ja ich bin durchaus kein Bewohner eines elfenbeinfarbenen Turms. Ich stelle das Leben um mich herum dar……dies wiederzugeben, schlicht ausgedrückt füllt mich, […] Tag und Nacht aus."

20. English translation by M. Kay Flavell, *George Grosz: A Biography* (New Haven and London, 1988), p. 215; Grosz to Erich Cohn, 19 January/February [?] 1942, Grosz Papers (549): "[…] aber wie beim Goya lebt ja nicht nur diese 'Nachtseite'……nay……nein… ich möchte Bilder malen, die 'positiv' sind…Frauen am Strand, landschaftern [*sic*], Wind Dune Grass, […] ja so leben eben zwei Seiten getrennt in einem […]."

21. Grosz to Eva Grosz, 12 June 1932, Grosz, *Briefe*, p. 137: "Ging dann zum Broadway, der dicht an der 57. Strasse gleich bei der Art League kreuzt. […] Tolle Strasse. Zwischen kleinen alten Häusern, rot mit Feuerleitern außen, unvermittelt Wolkenkratzer. Alle Fassaden übersät mit Reklamen, auch bei Tage schon erleuchtet. Kinos schon früh in Betrieb. Halb Sankt Pauli, halb Friedrichstrasse, halb Paris—und dabei durch die überraschenden Ausblicke auf aufgerichtete schmale Turmhäuser doch wieder gänzlich anders, […]. Die Fassaden übervoll Vergnügungen anzeigend. Filme mit…über-überlebensgrossen Vergrösserungen der angebeteten Filmhelden."

22. Grosz's print *Christ with the Gas Mask*, which was part of his portfolio *Hintergrund*, led to charges of blasphemy. For more information on this subject see Beth Irwin Lewis, *George Grosz: Art and Politics in the Weimar Republic*, rev. ed. (Princeton, 1991), p. 219ff.

23. English translation by M. Kay Flavell, *George Grosz: A Biography* (New Haven and London, 1988), pp. 313–14; George Grosz, "Lebenslauf," 3 December 1930, Grosz Papers (1015): "So ging ich nach zwei Jahren dort ab und nach Berlin an die Kunstgewerbeschule. Das Stipendium lockte mich, aber auch wollte ich mehr Praktisches lernen, denn ich musste bald Geld verdienen. Wollte Schrift und Plakatmaler werden […]."

24. George Grosz, "Kannst Du radfahren?" *Neue Jugend* (June 1917) Supplement, "Prospekt zur kleinen Grosz Mappe": "Ho! Ho! schon wieder brüllen die Häuserwände: Regie-Zigaretten, Satrap, Palast-Hotel, Teppich-Thomas, bade zu Hause, Steiners Paradiesbett…ho!…Sarg's Kalodont…Passage- Cafe…AEG… Ceresit."

25. See *Neue Jugend* weekly edition, May 1917, last page. Hanne Bergius writes on the dadaists' advertisement campaign: "The dadaists' advertisement consulting should not be understood as conforming to the consumer world but [rather as a way to] ultimately profit from [the consumer world's] strategy and 'mass psychology' in order to reach their own aims… With advertising the artists reflected that the artifact becomes a consumer good. At the same time [the dadaists] tried, in a subversive way, to undermine this consumer character by advertising Dada—the strategy against bourgeois culture" (my translation). In Hanne Bergius, *Das Lachen Dadas: Die Berliner Dadaisten und ihre Aktionen* (Giessen, 1989), p. 97.

26. Alfred Behne, *Das neue Frankfurt* 3: 1926–1927; in Jochen Boberg, "Reklamewelten," *Die Metropole: Industriekultur in Berlin im 20. Jahrhundert* (Munich, 1986), p. 187.

27. For example, see Theda Bheme, *Reklame und Heimatbild* (Berlin, 1931).

28. Tower, *Envisioning America*; Boberg, "Reklamewelten," p. 188.

29. Grosz, to Eva Grosz, 22 August 1932, Grosz Papers (607): "Wenn man so den abendlichen broadway entlangbummelt…überall die Lichtreklamen…ins Auge stechend…dieser coney islandcharackter des boulevards, die Menschen übergross und angeleuchtet vom roten grünen und gelben Schein, […] [*sic*]."

30. Apart from the romanticism that Grosz read into New York's advertisements, his constant focus on the subject might have had a practical side as well. A spelling mistake such as the one in the jeweler's shop sign "Etablished 1893" [*sic*; see 52 verso, 53 recto] illustrates the artist's struggle with the English language. Accordingly, reading and copying written signs perhaps served as a method of learning new words and expressions.

31. See essay by Beeke Sell Tower in this catalogue.

32. Prior to Grosz's arrival, members of the Art Students League had heated discussions as to whether Grosz should teach at that institute. While John Sloan defended the German artist, others objected to having Grosz teach the summer class. Moreover, the dispute was amply discussed by the press, so that Grosz's arrival caused some sensation. For more information see the *New York Times*, 1932: April 9, 17:8; April 17, sec. 8, 10:1; April 22, 21:8; April 29, 7:3; May 17, 19:6; May 27, 26:2; June 4, 17:2.

33. Grosz to Otto Schmalhausen, 23 September 1932, *Briefe*, p. 163: "Well, ich bin ein bekannter Mann—habe hier in Zukunft die Chance meines Lebens …"

inside front cover and 1 recto

2 recto

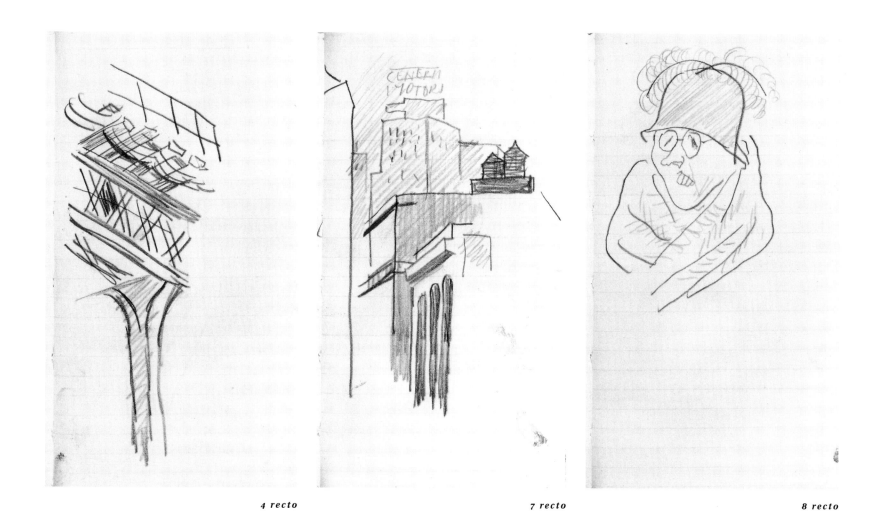

4 recto *7 recto* *8 recto*

9 recto

11 recto

14 recto

14 verso and 15 recto

16 recto

17 recto *18 recto*

18 verso and 19 recto

20 recto

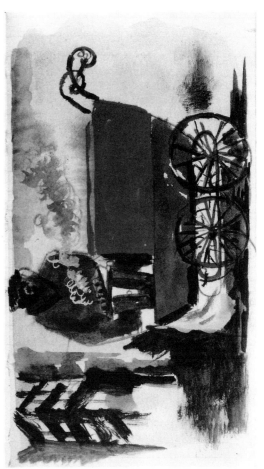

22 verso and 23 recto

24 recto

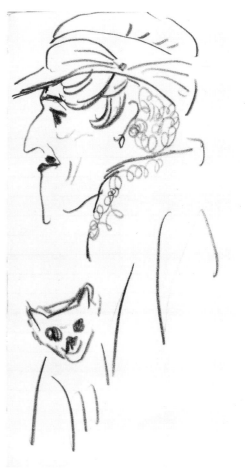

25 verso and 26 recto

28 recto

28 verso and 29 recto *31 recto*

31 verso and 32 recto

34 recto

35 recto

40 verso and 41 recto

41 verso and 42 recto

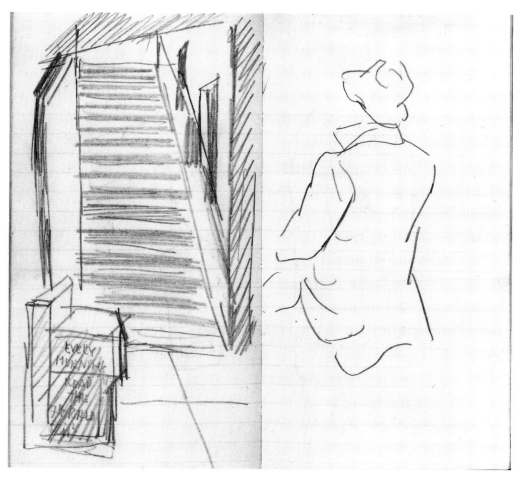

44 verso and 45 recto

48 recto

48 verso and 49 recto

49 verso and 50 recto

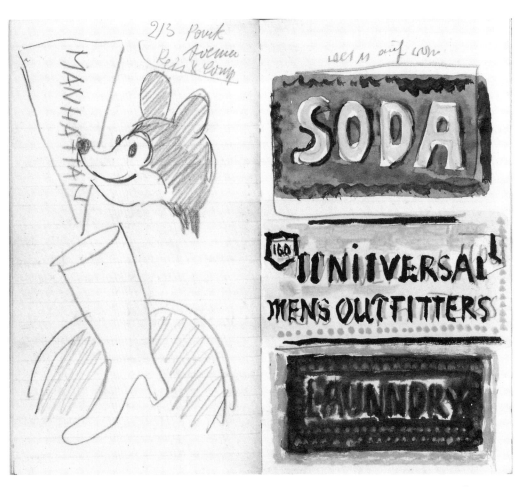

50 verso and 51 recto

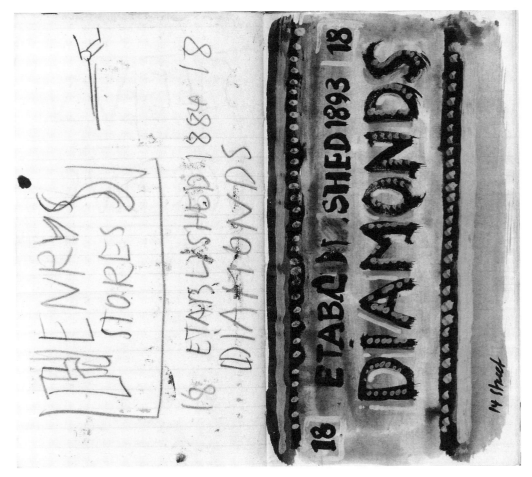

52 verso and 53 recto

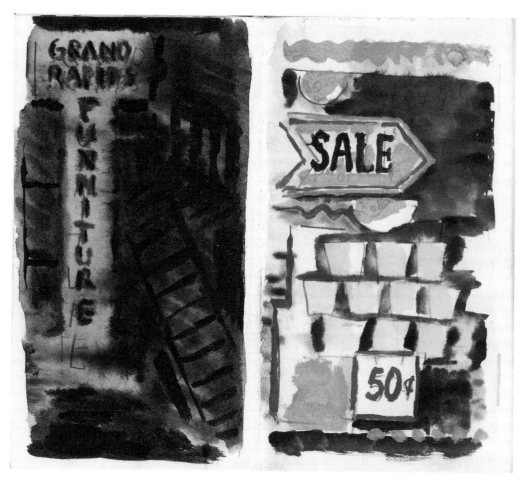

53 verso and 54 recto

55 recto

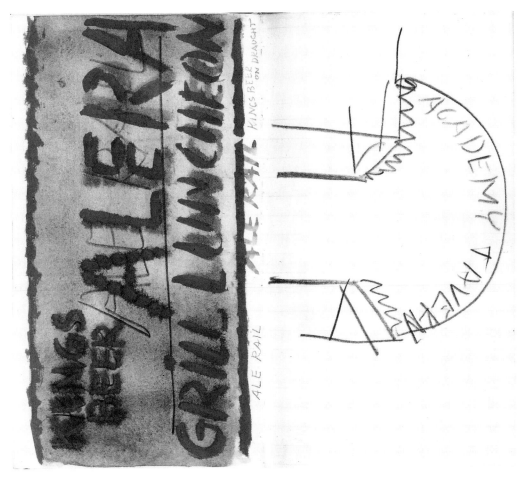

57 verso and 58 recto

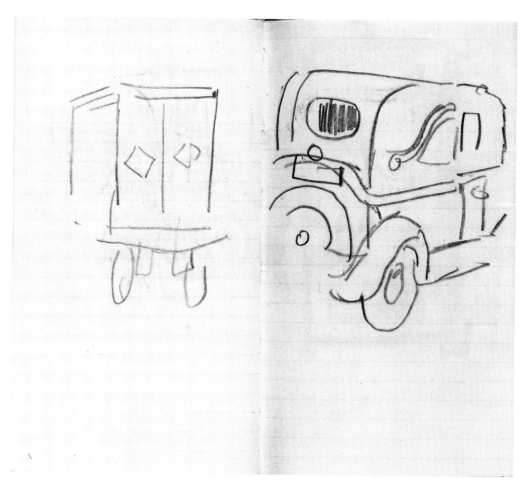

60 verso and 61 recto

61 verso and 62 recto

62 verso and 63 recto

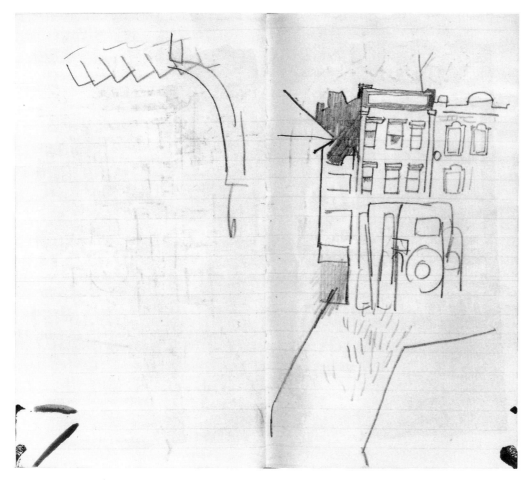

63 verso and 64 recto

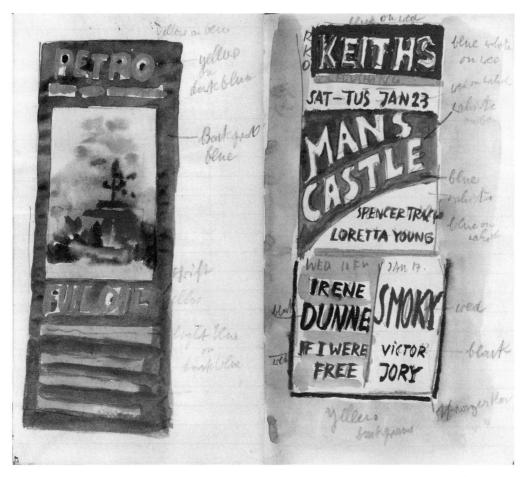

64 verso and 65 recto

66 recto

67 verso and 68 recto

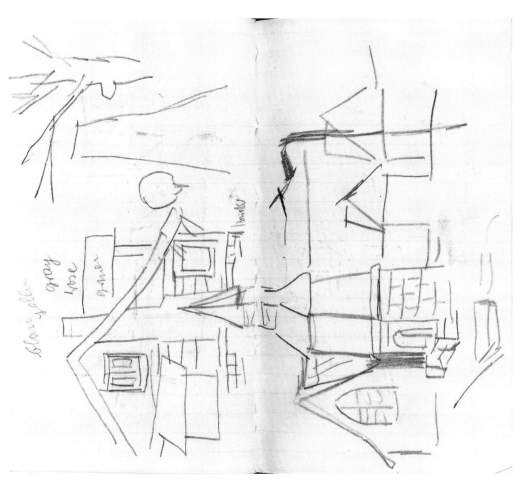

69 verso and 70 recto

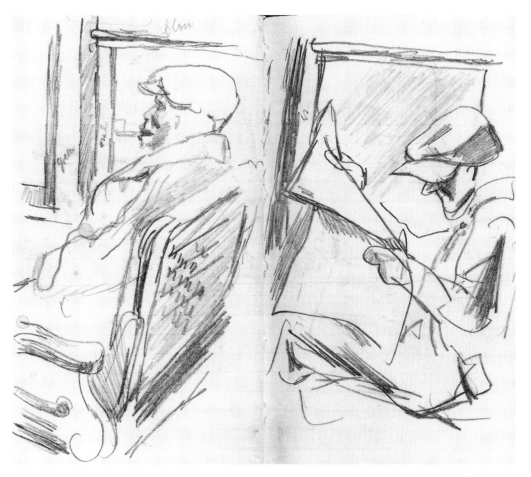

71 verso and 72 recto

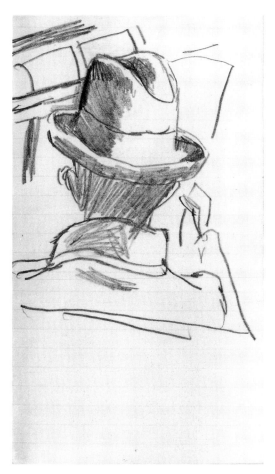

73 recto

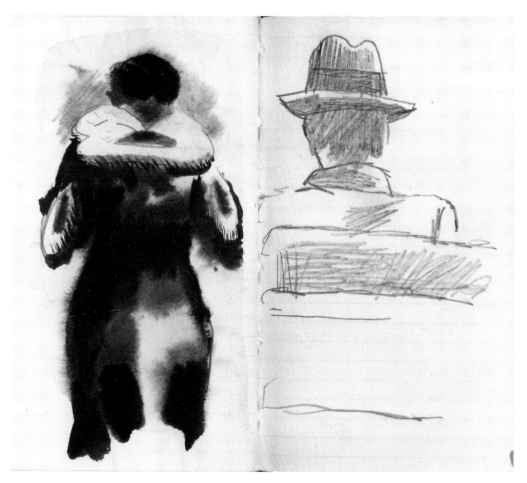

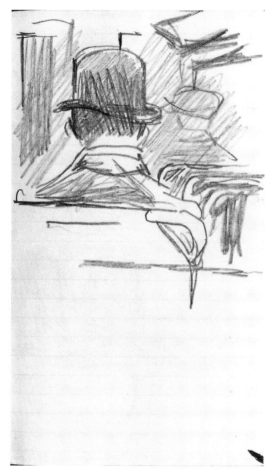

74 verso and 75 recto

76 recto

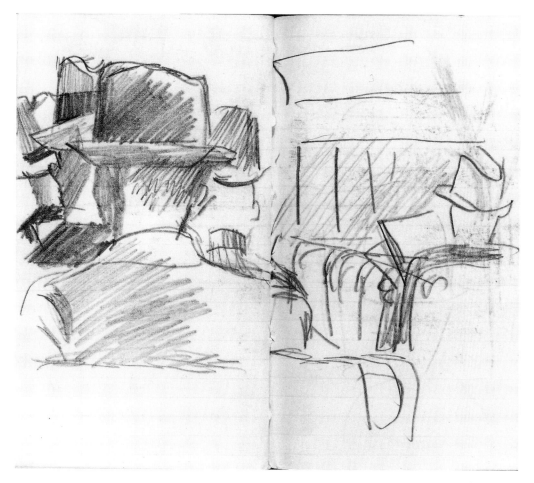

76 verso and 77 recto

78 verso and 79 recto

80 recto

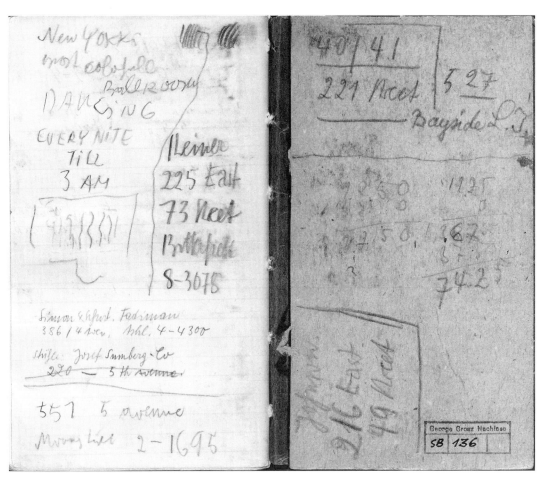

80 verso and back inside cover

Of Mice and Manhattan: Sketchbook 1950/7 in the Fogg Art Museum

Beeke Sell Tower

The "Mäusezeichbuch (mice drawing book)," as George Grosz called the sketchbook now in the Fogg Museum, occupies a special place in the artistic record of his lifelong sketching practice.[1] Grosz himself valued it highly, signing each page individually for the collector Leon Harris, who acquired it in 1952 (front inside cover).[2] Describing the sketches of dead mice as "very good drawings after nature, life-size," the artist wanted to include them in a book about his sketchbooks that he intended to publish in Germany in 1955. He also considered submitting them to *Life* magazine for publication.[3] In requesting photographs of the sketches from Leon Harris, Grosz noted that "these drawings range close to Pisanellos," thus hinting at his ambition to achieve the same freshness of observation and delicacy of line as the Italian quattrocento master.[4]

Among Grosz's many *Zeichenbücher* the Fogg sketchbook also stands out for its unusual concentration on just two subjects: a series of New York sketches executed for a commissioned oil painting of the city in the summer of 1950, and the group of sixteen closely observed drawings of dead mice made later over a period of time, these being interspersed with three drapery studies and a drawing of a nude woman.[5] Serendipitous or intended, this startling shift from grand Manhattan views to a small nature motif juxtaposes two major themes of Grosz's American years: New York—the place of his public persona as artist and teacher and a symbol of his Americanism—and nature, his private world of retreat. Nature and its representation figured large in his ruminations on his European roots. Moreover, the contrast between the loosely drawn modernist manner of the city sketches and the old-masterly realism of the mice drawings reflects the different stylistic directions that Grosz had been pursuing since the mid-twenties. The sketchbook thus encapsulates some of the con-flicting tendencies in Grosz's work, which he often described as an "inner rift" within himself.[6]

By 1950 Grosz's artistic output had slowed down considerably. As his letters of the late 1940s and early fifties vividly document, these were difficult years both in artistic and personal terms.[7] He struggled with finding his own position in the postwar art scene, while his worsening alcoholism impeded his productivity. During the war and early postwar years he had expressed his outrage and despair about events in Germany in a series of apocalyptical paintings that drew on the long tradition of allegorical art from Bosch to Goya. In works like *Peace II*, 1946 (fig. 1), he fused his personal sorrow about his mother's death in a Berlin bombing raid with the universal tragedy of the war's destruction. Although friends like John Dos Passos and the critic Edmund Wilson applauded his attempts at modern history painting, the works found little success with a larger public. Among a New York avant-garde enthralled with Surrealism and the emerging Abstract Expressionism, Grosz's rather eclectic symbolism appeared dated, and the conservative buying public preferred more cheerful and decorative pictures, as Grosz was told by his patron Erich Cohn.[8] In works such as the 1948 watercolor *Uprooted (Painter of the Hole)* (fig. 2), Grosz turned to his former satirical arsenal for a sardonic comment on his own dilemma and the futility of art. In the guise of one of his "stick figures"—Grosz's trope for starved, demoralized postwar humanity—the artist confronts the viewer with an angry stare, brush clenched between his teeth. With his feet and hands metamorphosing into roots, with furry legs, huge fishy eyes, rodentlike hair and whiskers, and a prison iron around his neck, the artist appears like some modern-day "Wildman," a creature as terrifying as he is terrified. He is surrounded by abstract paintings, each "representing" a hole suggestive of bomb craters. In front of his body he holds a badly

FIG. 1 **Peace II,** *1946. Oil on canvas, 119.4 x 84.5 cm. Collection of Whitney Museum of American Art, New York, Purchase, 47.2.*

stretched canvas with a rat emerging from the gaping painted hole that seems to pierce through the artist as well. The abstraction Grosz disdained serves here as vehicle for his sense of the loss of all meaning, in art as in life. Such bitter nihilism Grosz found echoed in his readings of Alfred Kubin, Hermann Broch, and Franz Kafka, whom he often invoked in his letters. Taking his cue from Sartre's *Being and Nothingness,* which was then all the rage on both sides of the Atlantic, Grosz, tongue-somewhat-in-cheek, proclaimed the hole the ultimate symbol of nothingness.[9]

His lack of commercial success convinced Grosz to resume teaching at the Art Students League in 1949. Teaching and the weekly trips to the city from his home in Huntington, Long Island, became an unloved chore, his popularity as a teacher notwithstanding. A year earlier Grosz had turned down the offer of a professorship in Berlin, but his wife—homesick for Germany and her family—continued to press for their return to Germany. Grosz had never looked upon America as only a temporary refuge—in the sense of Adorno's dictum "Heimat ist das Entronnensein" (homeland is the state of having escaped)—but had intended to settle there permanently.[10] Among the émigrés of his generation he outwardly seemed more assimilated than most others. Enchanted since youth with his idea of America, Grosz had set out to create a new American identity for himself when he arrived in 1932.[11] He never quite achieved this transformation (into an illustrator celebrating the American way of life à la Norman Rockwell, as he liked to claim); nor did he achieve the expected material or critical success, despite a number of exhibitions and commissions, culminating in the 1954 retrospective at the Whitney Museum.[12] As his fellow émigrés, with whom he had so often argued in defense of America, returned one by one to West or East Germany, Grosz stuck to his decision to remain in the United States. He squarely faced his situation in a 1948 letter to his friend, the writer Ulrich Becher, who was returning to Europe: "I have been a failure since I came to the United States, but I am not a deserter. I stick with my failure. OK."[13] Yet he felt increasingly isolated and, in some ways, his exile began in the 1950s. A small inheritance eventually enabled the Groszes to return to Europe for a few months in the summer and fall of 1951. The trip did not resolve Grosz's conflicts, but rather seems to have confirmed his alienation from Germany and its burgeoning postwar art scene.

Amid such artistic and material uncertainty, briefly sketched here, the commission for a painting of Manhattan was very welcome to Grosz. His patron was Kathleen Winsor, author of the best-selling novel *Forever Amber,* and Grosz hurried to complete it, lest she should change her mind about it.[14] Despite the haste, Grosz took much care over working out the composition; in the sketchbook we can follow his work process. He

FIG. 2 **Uprooted (The Painter of the Hole),** *1948. Watercolor, 89.5 x 69.2 cm. Busch-Reisinger Museum, Harvard University Art Museums, Cambridge, Mass., Association Fund, BR 1949.711.*

contour in one drawing, on the contrasts of light and shadow in another, and on the vivid pattern of the windows in yet a third. He also uses various media and drawing methods. Some sketches are executed in pencil, ranging from fairly detailed rendering to thickly drawn abstracted outlines; others are lightly washed brush drawings, at times evoking the Chinese brush drawings Grosz admired. The most developed sketch, a horizontal, double-page composition brushed lightly with yellow, green, gray, and burgundy-red washes, is organized along the lines of a traditional landscape composition with its layered progression from fore- to background (10 verso, 11 recto). The foreground, to which the viewer has no visual access, is filled with mid-rise rooftops "populated" by water towers and small sheds. Massed blocks of set-back buildings frame the middle ground with its spire shape as picturesque accent, leaving open a view into the distance with further layers of buildings. Although this composition seems complete in itself, it proves to be only a small segment of the final painting, which offers a sweeping, richly stratified view across the architectural labyrinth of Manhattan[16] (fig. 3). The painting, which may be either the original executed for Winsor or a variant thereof, is a composite view of the individual motifs drawn in the sketchbook, many of which are recognizably integrated into the picture. (4 recto, 5 recto, 6 recto, 7 recto, 9 recto, 10 verso, 11 recto, and 13 recto can be discerned in the black-and-white reproduction of the painting, which I have not seen in the original.)

With its high viewpoint and multilayered view, the compositional scheme of the painting is related to other Manhattan cityscapes Grosz painted after the war, such as *Golden City,* 1946 (fig. 4). With their lively visual clutter of building shapes, window patterns, and the interplay of light and shadow, many of them seem informed by the photographic vision of photographers such as Alfred Stieglitz or Berenice Abbott, who often used similarly elevated viewpoints. For the painterly execution, with its loose brushwork and textural surface effects, Grosz employed a mildly modernist manner, as it was practiced by many American artists of the thirties and forties.[17] By loosely sketching the building shapes and obscuring distinctive skyscraper crowns with clouds, Grosz transmutes the specific motif

executed the sketches from the balcony of Winsor's high-rise apartment, shifting his viewpoint somewhat as he experimented with compositional arrangements and focused on individual aspects of the scene before him.[15] The first sketch in the book is a detailed study of two skyscrapers, one of them the Chrysler Building (1 recto). On the following pages his drawing manner becomes sketchier, as he alternates between images of a few distinctive buildings and views of the skyline. In some sketches he experiments with ways of depicting the cubic masses of the buildings, focusing on the significant

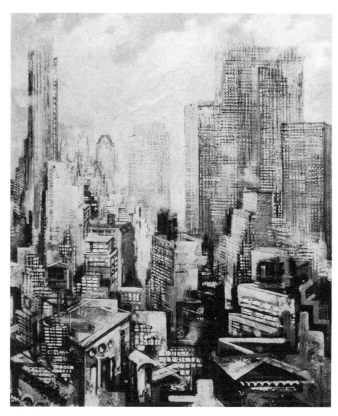

FIG. 3 New York Skyline, *1950. Oil on masonite, 81.3 x 66.0 cm. Present location unknown.*

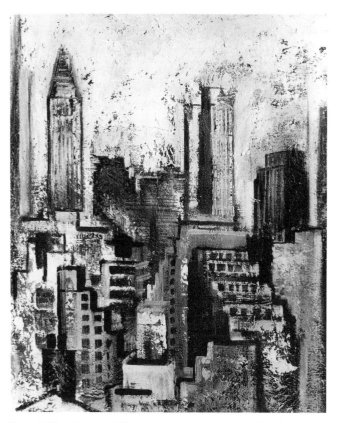

FIG. 4 Golden City, *1946. Oil on canvas, 60 x 38.1 cm. Present location unknown.*

into a generalized, somewhat anonymous panorama. Rather than elevate the skyscraper to iconic status, the artist focuses on the visual impact of the city at large. The absence of any visual access to the scene—be it a rooftop foothold in the foreground or a street offering orientation in the maze of buildings—gives Grosz's sketches and the final painting as well a rather distanced quality. Grosz's representation may well reflect his own altered perception of the city. In the 1930s his fascination with the bustle and drama of city life had been reflected in joyous views of Manhattan and the many scenes focusing on its inhabitants, often marginalized figures rendered with much empathy. By 1950, in the Fogg sketchbook and related works, Grosz treats the city no longer as a place teeming with life, but rather as a still life seen from afar, or in the more poignant

French expression, as *nature morte*—dead nature. New York, which he had from his youth envisioned as a spiritual home of sorts, the city where he had arrived with high expectations and endless curiosity, seemed no longer welcoming and exciting. Rather, it had become the site and symbol of what he perceived as personal failure and defeat.

The New York sketches document not only Grosz's effort to produce marketable work but also his participation, however reservedly, in American artistic discourse of the postwar years.[18] The group of mice drawings that fill the second half of the Fogg sketchbook belong to another, specifically German discourse on nature and the artistic values of the past. These drawings afford a glimpse into the artist's private meditations on his work and his ambition to become what he

described in 1942 as a "mystical Menzel."[19]

Sometime in 1950 or 1951 Grosz took up the sketchbook and began to draw the dead mice that had been caught in his house. A few are drawn in their traps, one of which bears the cynical trademark *Victor* (23 recto), which Grosz may well have relished for its political suggestiveness in the postwar era of Allied victors. The other mice are depicted in varying poses of *rigor mortis*, with staring eyes and limbs stiffly extended. Taken together, they proceed over the pages like a medieval Dance of Death.[20] Each image takes on a different quality, as the artist experiments with viewpoints and compositional placement, with degrees of light-dark modeling and patterns of line. Within the series the drawings progress toward closer-up representations, a bolder drawing technique, and stronger, more dramatic dark-light contrasts. With the exception of a page marked 1950, only the last two drawings are dated: one, of a mouse and a separate head study, is inscribed "51/22 Dec. Htg" [Huntington]; the other, a single mouse with its head in the trap, is dated "Dec. 26, 51." (33 recto, 34 recto). (See note 5.) This final image, lightly washed in brown and gray, is the most delicate and masterful among the drawings, worthy of Grosz's own comparison with Pisanello's exquisite animal drawings.

Rodents, primarily rats, played an important iconographic role in Grosz's allegorical work of the war and postwar years.[21] He often commented on their meaning as symbols of insatiable greed and of his own *Weltekel* (disgust with the world).[22] In some paintings he imagined them as the ruthless last survivors of the Apocalypse, a vision he eerily replayed in nocturnal rat-shooting expeditions with his son Peter to the local town dump, where rats scurried around the smoldering fires.[23] Mice, to be sure, are more harmless creatures than rats, and easier prey.[24] It has been suggested that the trapped mice of the Fogg sketchbook served the artist as metaphor for his own sense of being trapped and finished.[25] If indeed they are a self-image, it would be with an ironic suggestion of self-entrapment, for it was the artist himself who set and emptied the traps.[26] Yet such a reading focuses only on content and ignores the extraordinary quality of the works as drawings.

Individually and as a group the drawings document a masterly draftsmanship and artistic concentration that were quite unusual in Grosz's diminished production of the early fifties. He draws his motif with keen observation of every detail and obvious delight in the almost abstract patterns generated by his rendering of the mouse fur. True to the dictum "There is no line in nature," which he borrowed from Cézanne for a 1944 essay on drawing, Grosz creates the contours of the bodies from a myriad of fine pencil strokes.[27] Within each drawing Grosz shifts from detailed modeling to a few sparse lines, from thick, reinforcing pencil strokes to the thinnest hairline marks—"drawing for the sheer pleasure of working with planes, lines, dots and hooks to represent textures, or blacks and whites, to conjure up sfumati and chiaroscuri," as Grosz wrote in his essay.[28]

The mice drawings reflect not only Grosz's long-standing practice of working after nature but also his keen interest in the drawing methods of earlier masters, from Renaissance and Chinese artists to Grandville and Menzel. Moreover, they can be understood as arguments in the German debate on figurative art and old-masterly realism, a debate that had begun in the 1920s but that had taken on renewed relevance in postwar Germany. "Grosz discovered nature...on his flight from politics," the writer Günther Anders, a fellow émigré in New York, noted in his small, perceptive monograph on the artist.[29] This flight had begun in the mid-twenties when Grosz—disillusioned with the political left—was no longer content to be the satirical chronicler of the politics and social mores of Weimar Germany.[30] In redefining himself as a painter he turned to both a renewed study of nature and the traditions of older art, often perceiving one through the other. His drawings of his mother and other closely observed portraits of the later twenties render homage to Dürer and his time.[31] In keeping with the growing neotraditionalism of many artists and writers during the later years of the Weimar Republic, Grosz chastised the cultural decline in the wake of Germany's Americanization in a 1931 article. He argued that the artist should return to his roots: "Why not continue a 'German' tradition by looking back to our ancestors?"—that is, Northern European artists like Bruegel, Huber, and Altdorfer.[32] Grosz's somewhat *völkisch* ringing plea for the "good...painting and drawing tradition" of Germany was of course for nought with the National Socialists, who attacked his art as prime examples

of *undeutsche* and degenerate tendencies.[33] Grosz fled Germany just before Hitler assumed power in 1933.

With the rise of the Nazi regime Grosz vigorously distanced himself from Germany and all that it represented, but he did not relinquish his love for its old artistic culture. Throughout his years in America he turned to German and other European art as a source of renewal for his own art and "an antidote against any kind of pessimism."[34] Studies after nature and the study of older art became the cornerstones of Grosz's teaching, as they had been the cornerstones of his own artistic training at the Dresden Academy.[35] As his artistic disappointments in America led him to retreat more and more into nature and solitude, he gazed at Cape Cod, the Hudson Valley, and his surroundings on Long Island through the lens of Dürer and Altdorfer, remembering the Pomerania of his childhood.[36] And he sought to cope with the horrors and absurdities of the present by invoking the fantastic art of Goya as his model. With growing disdain for modern art, Grosz sought solace from his artistic isolation in his inner dialogue with the European past.

When he finally returned to Europe in 1951, Grosz made some sketches of the Bavarian countryside in an old-masterly manner reminiscent of the artists of the sixteenth century Donauschule.[37] Yet he quickly realized that tradition was no longer the watchword on a postwar German art scene anxious to catch up with the international avant-garde. Grosz diagnosed a "colossal emptiness" in the German art world and bitterly realized that his art "was no longer modern there" and would not be understood or valued.[38]

In grappling with the discomfiting recognition of his own artistic *Unzeitgemässheit* in both America and Germany, Grosz found encouragement in the celebrated polemical book *Verlust der Mitte* (Art in Crisis: The Lost Center) by the Austrian art historian Hans Sedlmayr.[39] Grosz read it with tremendous interest during the spring of 1950 and recommended the book to his friends; he even wrote to compliment the author himself.[40] Sedlmayr had stirred up great controversy in Germany with what amounted to a condemnation of most modern art. He argued that, with the demise of church and nobility as patrons of the all-encompassing *Gesamtkunstwerk* in the wake of the Enlightenment, art had lost its center and

never regained it. Writing from a traditionalist perspective, Sedlmayr traced a trajectory of decline and ruptures in modern art, singling out abstraction as symptomatic of the loss of meaning. A renewal of the "eternal image of man," Sedlmayr suggested, might yet come from artists who had fully plumbed the depth of the *Abendland's* catastrophe without losing the belief in a divine order.[41] Grosz found his own mistrust of modern art confirmed in Sedlmayr's book; moreover, he found himself somewhat exempt from Sedlmayr's harsh judgment. Although Sedlmayr approvingly quoted a certain Otto Mauer's condemnation of Grosz—"disastrous and degenerate to the core [is] the cold cynicism of Grosz's lithographs…"— he added in a footnote that this judgment no longer pertained to Grosz's recent work. The book illustrates a 1936 charcoal drawing by Grosz, executed in a baroque chiaroscuro manner, of a draped dummy evoking the figure of Death. Sedlmayr cites it as an example of the modern artistic fascination with death and chaos.[42] For Grosz the book validated his recent work, as he wrote to his friend and collector Marc Sandler: "Of course the writer [Sedlmayr] cites from my writing, but only refers to my earlier bitterness and has most likely not yet seen my later oils and is not familiar with my endeavors to go back to a 'New Humanisme' [*sic*] as expressed in your painting *The Wanderer* and other newer oils, landscapes and not to forget nudes… naturally he says that only a painter who went through all that modern hell can give birth to a new *Mitte* as he calls it."[43]

Grosz's apparent hope that his allegorical paintings would be recognized as the art of a "new center" proved to be futile. During the 1950s he rarely attempted works on such an ambitious scale. His sketchbooks and letters, however, attest to his continued search for his own artistic equilibrium. In 1948 he had written to his old friend Otto Schmalhausen, "All of our newer art suffers from too much fantasy, invention, instead of nature. With the OLD [Masters] one finds BOTH in a perfect symbiosis. As Leonardo says: in a time of struggle, in a time where everything caves in on you, the truly great artist must be able to draw a simple pear after nature—I agree, I agree."[44] Amid the personal crises in Grosz's life and the larger crisis he perceived in art and culture, the mice drawings occupy a place akin to Leonardo's "simple pear after nature." Nature, in

these drawings, however, is not just the *nature morte* of a still life, but might more fittingly be described as *nature assass- inée*, murdered nature, in Günther Anders's phrase. "The objects in Grosz's universe appear cold, mute and soulless," Anders wrote, "because they seem to have been MADE cold, mute and soulless; because they look as if they are victims of a rape or a murder."[45] Grosz eschewed the sentimentalization of his dead trophies; only a few are depicted in typical victim poses (29 recto). Many of the mice look oddly both dead and alive, caught in a trap they seem to be aware of but do not under- stand. Ultimately, Grosz's dead mice are *confrères* not of Dürer's lovingly drawn hare, but of Grandville's strangely metamor- phosed creatures or Kafka's beetle Gregor Samsa. The drawings are imbued with the mood of existential "Nothingness" of the war's aftermath.

In the midst of this rodent *danse macabre* we find a char- coal drawing of a nude woman from behind (20 recto). For Grosz the sensualist, the female nude had always represented "life, the future, the bearer of the coming."[46] Even the mice drawings, for all their clinical observation of death, are filled with a sense of renewed artistic energy. Resolutely antimod- ern in style, yet modern in their expressive content, they con- vey Grosz's spirited partisanship for the realist tradition, which was rapidly losing out in the new West German art scene. In the private sketches of his drawing book, the artist, it seems, for a brief time had indeed found his own "new center."

Notes

1. For details on this sketchbook, see under no. 1950/7 in the Catalogue of Sketchbooks. All the pages of this sketchbook with drawings are illustrated after this essay. 34 recto is illustrated in color on p. 77. The credit line for all illustrations is Fogg Art Museum, Harvard University Art Museums, Cambridge, Mass. Anonymous Gift in gratitude for the friendship and kindness of Dean Wilbur Joseph Bender 1955.95. For providing information and helpful suggestions for this essay, I want to thank Peter Grosz and Ralph Jentsch and, at the Busch-Reisinger Museum, Catherina Lauer, Peter Nisbet, and Emilie Norris.

2. Grosz inscribed the sketchbook "To Leon Harris with all my best wishes. George Grosz, June 1952, Huntington." Leon Harris was then a recent Harvard graduate and young department store owner from Dallas. He had commissioned Grosz to paint a series of pictures of Dallas, which Grosz visited in May and June and again in the fall of 1952. Cf. M. Kay Flavell, *George Grosz. A Biography* (New Haven, 1988), p. 272ff.

3. Grosz to Otto Schmalhausen, 30 March 1956: "Dann über Mäusezeichbuch (*sic*):...sehr gute Zeichs n. d. Natur, lebensgross. Nun will ich erstmal die Zeichs hier dem *Life* anbieten...." George Grosz, *Briefe 1913-1959*, ed. Herbert Knust (Reinbek, 1979), p. 496. All translations from the letters are mine.

4. Grosz to Leon Harris, 31 May 1955, Busch-Reisinger Museum, Harvard University Art Museums.

5. The exact date of these drawings is unclear. One of the sixteen drawings of mice is inscribed "1950" (17 recto), but that date may well have been added from memory when Grosz signed all the pages in 1952. Peter Grosz, the artist's son, recalled in a con- versation with the author (April 1993) that on his visits with his wife after their May 1951 wedding, his father would describe the mouse-trapping rituals of the household. Flavell, *Grosz*, p. 272, suggests that Grosz made the drawings before and after his trip to Europe.

6. The "inner rift" was also a conflict between outward reality and the irrational as Grosz stated in his letter to Marc Sandler of 4 May 1956: "Sie [i.e., the curators of his show in Louisville] sind nicht fähig, den inneren 'Riss' zu verstehen—so kann ich wie Goya das Nichts und das Schöne erblicken, Rationales und Irrationales." (They are incapable of understanding the inner "rift"—like Goya I can perceive both nothingness and beauty, the rational and the irrational.) Grosz, *Briefe*, p. 498.

7. For a detailed account of Grosz's later years and his personal difficulties see Flavell, *Grosz*. His letters give the most vivid account of Grosz's material and spiritual life dur- ing his American years.

8. Letter to Wieland Herzfelde, 1 January 1950 : "Erich Cohn sagt natürlich, die mor- biden, kritischen Sachen, die *Stickmen* ... kauft selten einer; male Landschaften, male Ansichten von New York usw., die würden weggehen wie warme Semmel." (Erich Cohn says of course, the morbid, critical things, the *stickmen*... are rarely bought; paint land- scapes, paint views of New York etc., they will sell like hot cakes.) Grosz, *Briefe*, p. 440.

9. On *The Painter of the Hole* and the stickmen series, which continued into the fifties, see also Flavell, *Grosz*, p. 253ff. and Hans Hess, *George Grosz* (New Haven, 1974), p. 226, 233ff.

10. Theodor W. Adorno, *Dialektik der Aufklärung* (New York, 1944), here cited after Anthony Heilbut, *Kultur ohne Heimat. Deutsche Emigranten in den USA nach 1930* (Weinheim, Berlin, 1987), p. 145.

11. On Grosz's earlier enthusiasm for America, see Beeke Sell Tower, *Envisioning America. Prints, Drawings and Photographs by George Grosz and His Contemporaries, 1915-1933*, with an essay by John Czaplicka, exh. cat., Busch-Reisinger Museum, Harvard University Art Museums (Cambridge, Mass., 1990).

12. Cf. the chapter "I Wanted to Become an American Illustrator" in George Grosz, *A Little Yes and a Big No: The Autobiography of George Grosz*, trans. Lola Sachs Dorin, (New York, 1946), p. 323ff.

13. Grosz to Ulrich Becher, July 1948: "Ich bin hier ein failure, since I came to USA, but ich bin kein Desertör, I stick with my failure, OK." Grosz, *Briefe*, p. 411.

14. Grosz to Otto Schmalhausen, 15 June 1950: "Ausserdem bekam ich eine commis- sion, ein Stadtbild jetzt zu malen, in oil für die sehr berühmte Autorin Kathleen Winsor (*Forever Amber*, 8-Millionen Auflage). Das darf ich nicht fliegen lassen, weil ja solche erfolgreiche & verwöhnte (vom Glück) Damen oft schnell die verwöhnte Meinung wechseln." (Furthermore, I received a commission to paint now a view of the city, in oil, for the very famous author Kathleen Winsor [*Forever Amber*, 8-million edition]. I can't let that go by, because such successful and spoilt [by fortune] ladies often quickly change their spoilt minds.) Grosz, *Briefe*, p. 446. *Forever Amber*, published in 1944, was Kathleen Winsor's first novel and became a huge popular success; because of its racy passages the book was "banned in Boston."

15. In a letter to Otto Schmalhausen of 30 March 1956, Grosz states that he made the sketches in the sketchbook from the balcony of her high-rise apartment. Grosz, *Briefe*, p. 496.

16. The present whereabouts of the painting are unknown. Ralph Jentsch, who is preparing the catalogue raisonné of Grosz's oil paintings, kindly directed me to a reproduction of a New York painting that may be either the one commissioned by Winsor or a variant Grosz may have painted for sale through his gallery, the Associated American Artists. Reproduced in Sotheby Parke Bernet, Inc., *A Collection of Watercolors and Drawings by Charles Demuth. American 19th & 20th Century Paintings, Drawings, Watercolors & Sculpture, Auction 3913* (New York, 1976), no. 215.

17. Grosz was quite familiar with the American art scene, partly through his affiliation with the Associated American Artists, a group he had joined in the 1940s to improve his exhibition opportunities. He joked about the mercantile conservatism of the AAA artists vis-à-vis Surrealism in a letter to Arnold Rönnebeck of 19 September 1943: "Wir sind jetzt alle mehr für die Aussenwelt hier bei AAA...." (We are all now more in favor of the external world here at AAA....) Grosz, *Briefe*, p. 321. In point of fact, for Grosz's two exhibitions in 1946 and 1948 the AAA's curator Pegeen Sullivan put the focus on his allegorical and fantastic recent works.

18. Grosz's letters are replete with sarcastic comments on the most recent developments in the New York art scene, including Abstract Expressionism and Jackson Pollock, who was a particular target of his attacks. Cf. Grosz, *Briefe*, p. 435.

19. Grosz to Hermann Borchardt, 4 December 1942. Grosz, *Briefe*, p. 310.

20. Grosz had a lifelong fascination with death and its representations; he often would pose as Death himself, from the Berlin Dada years to his last years in Huntington, where he would disquiet convivial outdoor gatherings with his fleeting appearances in a Death mask. Cf. Lothar Fischer, *George Grosz* (Reinbek, 1976), p. 120f.

21. For example, the painting *The Pit*, 1946. Ill. in Hess, *Grosz*, pl. 213.

22. Grosz to Otto Schmalhausen, 29 May 1950: "Der Zweifel und der grosse Weltekel nagt auch an mir (siehe Symbol der Ratten auf meinen Bildern)." (Doubt and disgust with the world eat me up as well [to wit, the symbol of rats in my pictures]. Grosz, *Briefe*, p. 444.

23. See letter to Elisabeth Lindner, 5 August 1948, in Grosz, *Briefe*, p. 412. Some forty-five years later Peter Grosz still vividly remembers the dump scene as "Dante's Inferno" (in conversation with the author, April 1993).

24. Grosz had done sketches of dead mice before; cf. Sketchbook 1950/3

25. For example, Flavell, *Grosz*, p. 254.

26. Peter Grosz in conversation with the author, April 1993.

27. George Grosz, "On My Drawings," 1944; here cited after Herbert Bittner, ed., *George Grosz* (New York, 1960), p. 29.

28. Ibid., p. 31.

29. Günther Anders, *George Grosz* (Zurich, 1961), p. 36: "Grosz entdeckte nämlich auf seiner Flucht vor der Politik ... die Natur" (my translation). Anders and Grosz met in New York in 1947 and were friendly for a brief period.

30. In his autobiography Grosz wrote, "The further away I drew from men the closer I grew to Nature, to landscape with its trees, shrubs, grass and leaves, with its flies, ants and turtles.... It was not an escape. It was a new beginning, a probing for a new approach." Grosz, *Autobiography*, p. 275.

31. Ill. in Hess, *Grosz*, p. 143.

32. George Grosz, "Unter anderem ein Wort für deutsche Tradition" (Among Other Things a Word in Favor of German Tradition), *Das Kunstblatt*, 1931: "Warum nicht an unsere Vorfahren anknüpfend eine 'deutsche' Tradition fortsetzen?" (my translation). Here cited after Uwe Schneede, ed., *Die Zwanziger Jahre. Manifeste und Dokumente Deutscher Künstler*, (Cologne, 1979), p. 280. Despite such zeitgeist-related emphasis on a national and Nordic tradition, Grosz's interest in Old Masters was not limited to Northern European art; his letters from America document his catholic taste, which embraced Italian or Spanish art with the same enthusiasm as Chinese brush drawings.

33. On the proscription and destruction of Grosz's art under the National Socialist regime see Stephanie Barron, ed., *"Degenerate Art": The Fate of the Avant-Garde in Nazi Germany*, exh. cat., Los Angeles County Museum of Art (Los Angeles, 1991), p. 242ff. The infamous *Degenerate Art* exhibition of 1937 featured many of Grosz's "Americanist" works, most notably the painting *The Adventurer*, 1916.

34. Grosz to Herbert Fiedler, 24 September 1936, Grosz, *Briefe*, p. 251.

35. In 1950 Grosz was working on a book about his teaching method and art—"not a straightforward, dry manual," he promised, but part diary, part textbook, which was to include a chapter on Chinese brush drawings. Grosz, *Briefe*, p. 441.

36. See, for example, his letter to Otto and Lotte Schmalhausen, 1 May 1936, Grosz, *Briefe*, p. 243f., or the letter to Ulrich Becher, 10 October 1939, ibid., p. 288.

37. The dating of Sketchbook 1951/1 is uncertain. It is inscribed with a Bayrisch-Zell address, suggesting that the mountain scenes were done during his month-long stay there in 1951, but Grosz also went to Bayrisch-Zell on a later trip in 1954.

38. Grosz to Otto Schmalhausen, 20 April 1953, Grosz, *Briefe*, p. 464.

39. Hans Sedlmayr, *Verlust der Mitte*, first ed. (Salzburg, 1948). Most of the book was written during the National Socialist era when Sedlmayr held the chair in art history at the University of Vienna. Sedlmayr's theses were sharply attacked for their conservatism at a symposium held in conjunction with the exhibition *Das Menschenbild in unserer Zeit*, Mathildenhöhe (Darmstadt, 1950). The symposium proceedings were published by Gerhard Evers, ed., *Darmstädter Gespräch* (Darmstadt, 1950).

40. Grosz to Hans Sahl, 30 July 1950, *Briefe*, p. 447. Grosz wrote to Sedlmayr on three occasions. On 15 July 1950 he conveyed his praise of *Verlust der Mitte* and expressed his hope that an American translation would be forthcoming: "Ihre Deutung der bildenden Kunst des 19. und 20. Jahrhunderts als Symbol der Zeit finde ich ganz hervorragend." [Your interpretation of the art of the nineteenth and twentieth centuries as symbol of the times seems outstanding to me.] The George Grosz Papers, Houghton Library, Harvard University, bMS Ger 206 (814). In 1958 Sedlmayr sent Grosz an inscribed copy of the American edition (*Art in Crisis: The Lost Center* [Chicago, 1958]), for which Grosz thanked him, including in his letter a review from the *New York Times Book Review* criticizing Sedlmayr's stance during the Nazi years.

41. Sedlmayr, *Verlust* p. 249f.

42. Quoted from the German edition, my translation. Ibid., p. 215 and pl. 58.

43. Grosz to Marc Sandler, 10 March 1950, Grosz Papers (801).

44. Grosz to Otto Schmalhausen, 4 November 1948: "Daran leidet unsere ganze neuere Kunst: zuviel Fantasie, Erfindung, anstatt Natur. Bei den ALTEN findet man BEIDES in einer vollkommenen Gemeinschaft. Wie sagt Leonardo: in einer Zeit der Kämpfe, in einer Zeit wo alles über einem zusammenbricht, muss der wirklich grosse Künstler fähig sein, eine einfache Birne nach der Natur zu malen—I agree, I agree." Grosz, *Briefe*, p. 417.

45. "Mit dieser friedlich-stummen Seinsart begnügt sich der Tod im Groszschen Universum nicht, vor dessen Gegenständen greift der übliche Ausdruck *nature morte* zu kurz, dieser muss durch den angemesseneren *nature assassinée* ersetzt werden. Womit gemeint ist, dass die Gegenstände in Grosz's Universum deshalb kalt, stumm und seelenlos wirken, weil sie kalt, seelenlos und stumm *gemacht* zu sein scheinen: weil sie so aussehen, als seien sie einer Vergewaltigung oder einem Morde zum Opfer gefallen." Anders, *Grosz*, p. 37 (my translation).

46. Grosz to Elisabeth Lindner, 16 August 1948: "... die Frau ist für mich Leben, Zukunft, Trägerin der Kommenden." Grosz, *Briefe*, p. 376.

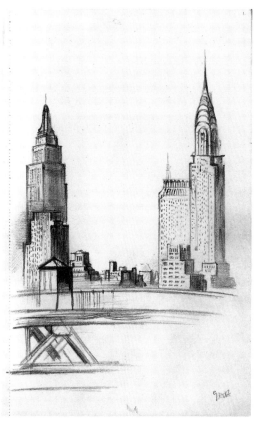

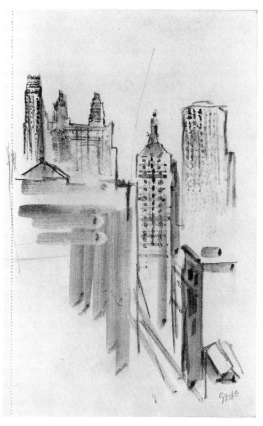

inside front cover

1 recto

2 recto

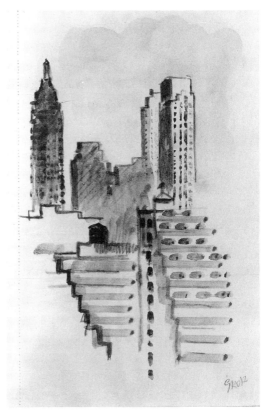

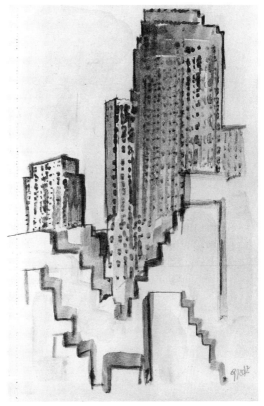

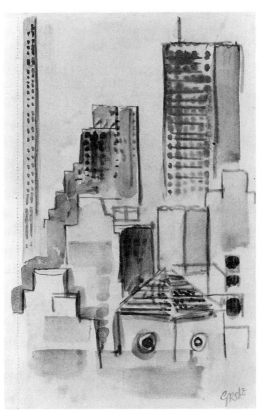

3 recto

4 recto

5 recto

6 recto

7 recto

8 recto

9 recto

9 verso and 10 recto

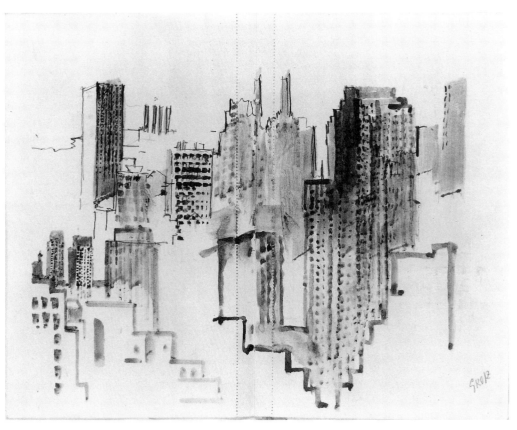

10 verso and 11 recto

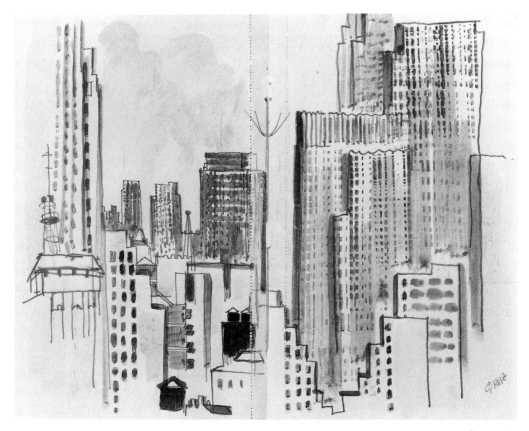

11 verso and 12 recto

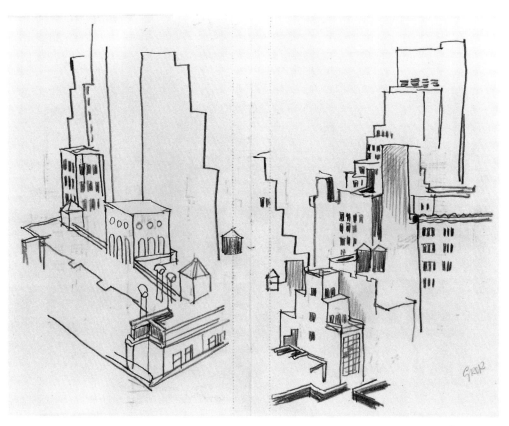

12 verso and 13 recto

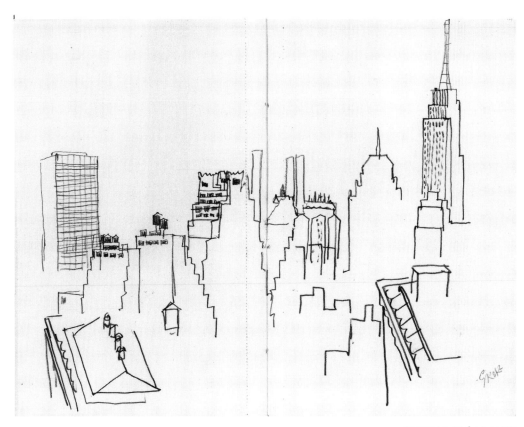

13 verso and 14 recto

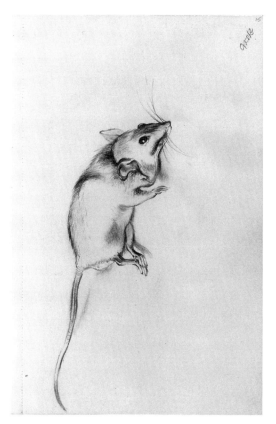

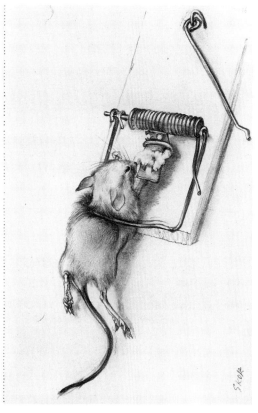

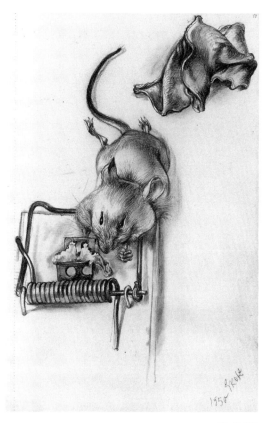

15 recto

16 recto

17 recto

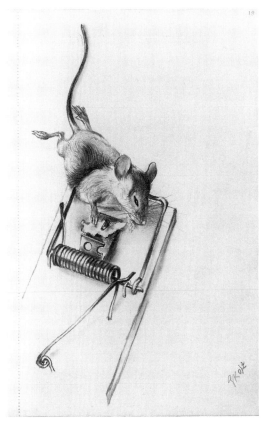

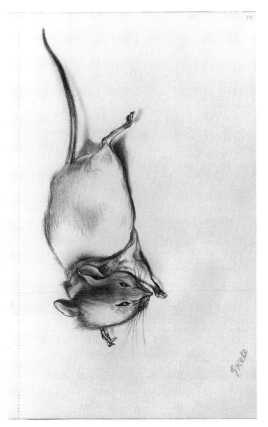

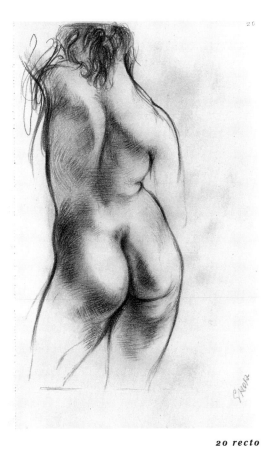

18 recto *19 recto* *20 recto*

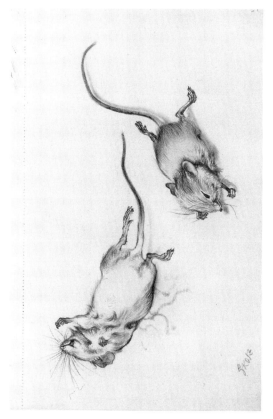

21 recto

22 recto

23 recto

24 recto

25 recto

26 recto

27 recto

28 recto

29 recto

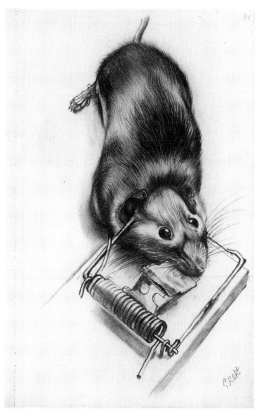

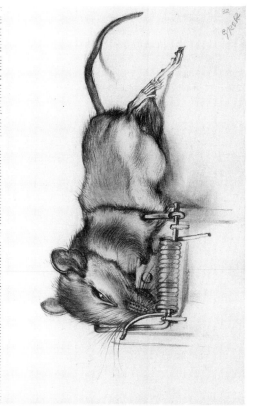

30 recto

31 recto

32 recto

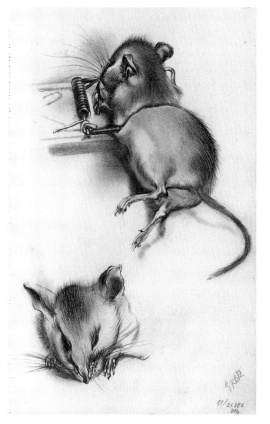

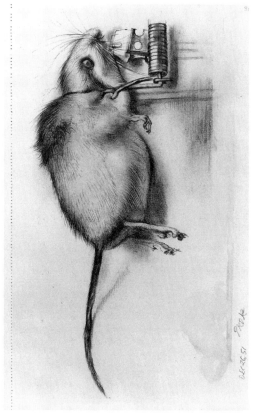

33 recto

34 recto

CATALOGUE OF SKETCHBOOKS

CATHERINA LAUER

Notes on the Catalogue of Sketchbooks

This summary catalogue lists all complete sketchbooks known to the compiler. No attempt has been made to reconstruct any dismembered sketchbooks or to trace missing pages that may have been removed from the sketchbooks catalogued here.

NUMBERING: Each complete sketchbook has been assigned a number in the form 1933/5, in which the first number indicates the year in which the sketchbook was used (or begun), and the second indicates the sketchbook's position within the sequence during that year. Sketchbooks whose position within the year cannot be determined accurately are listed first. (Exceptionally, the entry for Sketchbook 1912/8 gathers into one entry a large number of sheets gathered by the artist into clearly marked envelopes and deriving from dismembered sketchbooks of the year 1912, as explained in the entry.) The number in square brackets after this number is the number assigned by Arthur Nortman when he made an inventory of most of the extant sketchbooks in 1960–61. Revised dating and the inclusion of sketchbooks not covered by that inventory mean that these numbers, which are usually inscribed together with the stamp of the Estate of George Grosz on the inside back covers, are not necessarily sequential in this catalogue. All the sketchbooks belong to the Estate of George Grosz with the exception of 1916/2, 1917/2, 1932/4 (Akademie der Künste, Berlin); 1927/5, 1927/6, 1939/1, 1945/1, 1950/9, 1951/1 (Peter and Lilian Grosz, Princeton, N.J.); and 1950/7 (Fogg Art Museum, Harvard University Art Museums).

DATING: The second line of each entry gives the best possible dating of the use of the sketchbook, combining both internal information (dated drawings) and external informa-tion (related sketchbooks, letters, subject-matter, etc.). Datings that rely on the latter are indicated by "c."

DESCRIPTION: The sketchbook is then described as fully as the standard format allows. The sketchbooks have been divided into five types: Exercise book: paper-covered, thin book with smooth-surfaced pages and paper label on cover. Notebook: either paper- or cardboard-covered book with smooth-surfaced, lined or squared paper. Sketchbook: Book with heavy paper or cardboard cover and blank pages, often of slightly textured or laid paper. Sketch pad: vertical-format book with blank pages. Note pad: vertical-format book with lined or squared paper.

DIMENSIONS: Dimensions of both the cover and the pages are given.

NUMBER OF PAGES: For this catalogue, the word "page" is understood to mean both the recto and verso of a particular sheet. In addition to the total number of extant pages in each sketchbook, missing pages are counted or esti-mated, often tentatively. "Blank pages" have no drawings or inscriptions on either side. "Single-sided drawings" are pages with drawings on either the recto or the verso. "Double-sided drawings" are pages with drawings on both sides. Drawings on the inside front or back covers are not counted here, but are mentioned in the subject description. As pages with only written inscriptions are not counted, the total of blank, sin-gle- and double- sided drawings will not necessarily match the total number of pages.

INSCRIPTIONS: Inscriptions on the front and back covers, on the spine and on the first page recto are cited. If they

are by a hand clearly identifiable as not the artist's, they are so identified. Information on printed text and labels on sketchbook covers is often summarized in square brackets. All punctuation is transcribed exactly from the original with the exception of semicolons, which are used to separate the various elements.

TECHNIQUE: The techniques and media listed are those used for the drawings only, and not for the inscriptions. Media are listed in descending order of frequency.

SUBJECT: This section briefly summarizes the contents of each sketchbook, as a guide to scholars. The descriptions are not intended as definitive analyses and are, of course, subject to revision by future research. Words in quotation marks are translated and quoted from the sketchbook pages.

ABBREVIATIONS FOR REFERENCES: The following abbreviations are used:

AUTOBIOGRAPHY: George Grosz, *A Little Yes and a Big No: The Autobiography of George Grosz,* trans. Lola Sachs Dorin (New York, 1946)

DÜCKERS: Alexander Dückers, *George Grosz: Das druckgraphische Werk* (Frankfurt/Main, 1979)

FLAVELL: M. Kay Flavell, *George Grosz: A Biography* (New Haven and London, 1988)

HESS: Hans Hess, *George Grosz* (New Haven and London, 1985)

—CL

SUMMARY LIST OF SKETCHBOOKS

1905/1 [1]	C. FEBRUARY 1905 – NOVEMBER 1907	1916/1 [33]	3 FEBRUARY 1916	1925/1 [67]	7 JANUARY
		1916/2	APRIL	1925/2 [68]	7 JANUARY – 6 MARCH
1907/1 [2]	20 MAY – 14 DECEMBER	1916/3 [34]	C. JUNE – JULY	1925/3 [71]	6 MARCH – 18 APRIL
1907/2 [3]	15 DECEMBER 1907 – 30 OCTOBER 1908	1916/4 [35]	C. OCTOBER	1925/4 [63A]	18 APRIL – 10 JULY
		1916/5 [36]	C. NOVEMBER – DECEMBER	1925/5 [63B]	10 JULY – 13 JULY
1908/1 [4]	C. SEPTEMBER – OCTOBER			1925/6 [64]	13 JULY – 24 JULY
		1917/1 [37]	C. JUNE	1925/7 [62]	JULY – AUGUST
1909/1 [5]	C. JUNE – AUGUST	1917/2	UNTIL SEPTEMBER 1917	1925/8 [63]	C. JULY – AUGUST
1909/2 [6]	SEPTEMBER – OCTOBER	1917/3 [38]	SEPTEMBER 1917 – FEBRUARY 1918	1925/9 [69]	14 SEPTEMBER
1909/3 [7]	NOVEMBER			1925/10 [73]	C. SEPTEMBER – OCTOBER
		1918/1 [39]	6 MARCH – 5 AUGUST	1925/11 [70]	30 SEPTEMBER – 6 OCTOBER
1912/1 [8]	C. JANUARY	1918/2 [40]	5 AUGUST – 30 OCTOBER	1925/12 [61]	C. SUMMER 1925 AND SUMMER 1926
1912/2 [22A]	2 APRIL – 18 APRIL	1918/3 [41]	BEGUN 30 OCTOBER – C. NOVEMBER	1925/13 [65]	6 OCTOBER 1925 AND
1912/3 [9]	26 APRIL – 9 MAY				4 APRIL – 22 APRIL 1932
1912/4 [23]	2 MAY – 10 MAY	1922/1 [42]	AUGUST		
1912/5 [24]	SEPTEMBER – 14 OCTOBER	1922/2 [43]	C. 1922 UNTIL 15 FEBRUARY 1923	1926/1 [72]	UNTIL 30 JUNE
1912/6 [25]	9 NOVEMBER – 18 DECEMBER			1926/2 [66]	22 DECEMBER
1912/7 [25B]	1912–1913	1923/1 [46]	15 FEBRUARY – 28 MARCH		
1912/8 [10 – 21, 21A, 22] APRIL – JANUARY 1913		1923/2 [47]	28 MARCH – 30 MAY	1927/1 [76]	UNTIL 12 MARCH
		1923/3 [45]	30 MAY – 18 JUNE	1927/2 [74]	12 MARCH – MAY
1913/1 [26A]	BEGINNING OF MAY	1923/4 [50]	C. JUNE	1927/3 [74A]	MAY
1913/2 [25A]	C. MAY	1923/5 [49]	5 JUNE	1927/4 [74B]	MAY
1913/3 [26]	JUNE	1923/6 [44]	18 JUNE – 15 JULY	1927/5	C. AUGUST?
1913/4 [27]	AUGUST	1923/7 [48]	5 JULY – 30 OCTOBER	1927/6	C. AUGUST – SEPTEMBER
1913/5 [27A]	SEPTEMBER	1923/8 [53]	30 OCTOBER 1923 – 4 APRIL 1924	1927/7 [75]	OCTOBER
1913/6 [28B]	1913 – 14				
		1924/1 [54]	4 APRIL – 11 APRIL	1928/1 [91]	JANUARY
1914/1 [27B]	1914	1924/2 [57]	11 APRIL – 21 APRIL	1928/2 [77]	15 JANUARY
1914/2 [28]	SPRING 1914	1924/3 [54A]	21 APRIL – 28 APRIL	1928/3 [89]	JULY – SEPTEMBER
1914/3 [28A]	SPRING 1914	1924/4 [58]	24 APRIL – 1 MAY	1928/4 [90]	SEPTEMBER
		1924/5 [55]	28 APRIL – 5 MAY	1928/5 [86]	4 OCTOBER – 25 OCTOBER
1915/1 [29]	15 JULY	1924/6 [51]	3 MAY – 16 MAY	1928/6 [87]	25 OCTOBER – 31 OCTOBER
1915/2 [30]	OCTOBER – 13 NOVEMBER	1924/7 [56]	16 MAY – 25 MAY	1928/7 [88]	31 OCTOBER – 15 NOVEMBER
1915/3 [31]	13 NOVEMBER – 15 DECEMBER	1924/8 [52]	25 MAY – 10 JUNE	1928/8 [85]	16 NOVEMBER 1928 – 2 MARCH 1929
1915/4 [32]	15 DECEMBER 1915 – 31 JANUARY 1916	1924/9 [60]	JULY		
		1924/10 [59]	18 OCTOBER – 7 JANUARY 1925	1929/1 [78]	2 MARCH – 27 MARCH

1929/2 [80]	27 March –19 April	1932/14 [121]	21 July – August	1945/1	July – September
1929/3 [82]	19 April – 6 May	1932/15 [113]	24 July – August		
1929/4 [84]	6 May – 10 May	1932/16 [111]	August	1950/1 [166]	1950
1929/5 [81]	10 May – 5 July	1932/17 [114]	August	1950/2 [168]	1950
1929/6 [79]	5 July – 26 July	1932/18 [123]	August	1950/3 [159]	summer
1929/7 [83]	September – 4 November	1932/19 [110]	c. September	1950/4 [167]	summer
1929/8 [98]	8 December 1929 – 10 January 1930	1932/20 [115]	September	1950/5 [169]	summer
		1932/21 [117]	September	1950/6 [168A]	c. 1950 – 1951
1930/1 [95]	10 January – 18 January	1932/22 [124]	September	1950/7	1950 – 1951
1930/2 [92]	18 January – 22 March			1950/8 [160]	1950 – 1955 summer
1930/3 [93]	Begun 22 March	1933/1 [143]	c. 1933		
1930/4 [94]	12 May	1933/2 [134]	4 February	1951/1 [165?]	September 1951 and August 1956
1930/5 [100]	July	1933/3 [139]	15 February		
1930/6 [97]	17 October – 21 November	1933/4 [142]	30 March	1952/1 [170]	January
1930/7 [96]	21 November – 27 December	1933/5 [132]	20 April	1952/2 [161]	c. February 1952
1930/8 [99]	27 December 1930 – 10 March 1931	1933/6 [140]	8 May	1952/3 [171]	February
		1933/7 [141]	17 May	1952/4 [172]	1952–1953
1931/1 [104]	10 March – 25 April	1933/8 [138]	22 May		
1931/2 [105]	25 April – 16 August	1933/9 [137]	30 May – 5 July		
1931/3 [109]	13 June	1933/10 [135]	5 July	1954/1	1954
1931/4 [108]	summer	1933/11 [133]	1 September	1954/2 [173]	1954
1931/5 [100A]	16 August	1933/12 [136]	3 November 1933 – 22 January 1934	1954/3 [162]	c. May and October
1931/6 [107]	summer			1954/4 [163]	October
1931/7 [103]	summer	1934/1 [149]	Begun 22 January	1954/5 [164]	3 October
1931/8 [103A]	summer	1934/2 [155]	10 July		
1931/9 [102]	22 September – 26 October	1934/3 [154]	27 August	1955/1	1955
1931/10 [101]	26 October – 13 November	1934/4 [157]	1934 – 20 February 1935		
1931/11 [106]	20 November – 18 December			1956/1 [174]	1956
1931/12 [119]	December 1931 and	1935/1 [151]	20 February	1956/2 [175]	1956
	2 February – 14 April 1932	1935/2 [146]	Until 24 October	1956/3 [176]	1956
		1935/3 [150]	23 October – 12 November	1956/4 [177]	1956
1932/1 [125]	22 April – c. June	1935/4 [145]	13 November	1956/5 [180]	1956
1932/2 [118]	12 June	1935/5 [144]	1935 and summer 1939		
1932/3 [120]	22 June – 26 June			1957/1 [181]	1957
1932/4	26 June	1936/1 [156]	March – 29 April	1957/2 [183]	1957
1932/5 [126]	28 June	1936/2 [153]	Begun 29 April	1957/3 [184]	1957
1932/6 [127]	6 July			1957/4 [185]	1957
1932/7 [128]	6 July	1937/1 [148]	1937	1957/5 1957	
1932/8 [129]	7 July	1937/2 [152]	1937 – April 1938	1957/6 [182]	November – December
1932/9 [130]	9 July			1957/7 [188]	1957 – 1958
1932/10 [131]	c. 10–11 July	1938/1 [147]	3 May		
1932/11 [112]	12 July			1958/1 [187]	c. 1958
1932/12 [122]	July – August	1939/1	June – September	1958/2 [186]	January
1932/13 [116]	c. 17 July – August	1939/2 [158]	c. August		

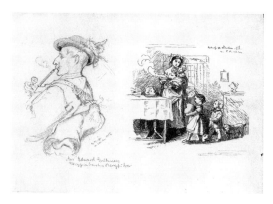

1905/1, 20 recto

1905/1 [1]

C. FEBRUARY 1905 – NOVEMBER 1907

Sketchbook with gray, cloth-covered cardboard covers, cloth ribbon closure [lost], pencil sleeve, and rounded corners. Stapled page block. Pages of very slightly textured, cream, wove paper with square corners.
Cover dimensions: 15.8 x 23.2 cm
Page dimensions: 14.9 x 22.7 cm
36 pages
1 missing page
7 blank pages
16 single-sided drawings
13 double-sided drawings
Inside front cover inscribed: George Grosz 1905; **imprinted:** Skizzenbuch für George Gross; **inscription on spine:** 0
Technique: Graphite and ink, one partially glazed watercolor gouache, and one prepared chalk drawing. Some graphite drawings treated with fixative.
Subject: Idyllic landscapes and images that seem to be copied from magazines or postcards. Studies of works by Adolf von Menzel and Eduard Grützner, as well as copies of picture stories like Wilhelm Busch's *Fritze*. In some instances images from his close surroundings, such as the tower of the city hall in Stolp, can be recognized. Two drawings on separate sheets of paper attached to sketchbook pages.

1907/1 [2]

20 MAY – 14 DECEMBER

Sketchbook with gray, cloth-covered cardboard covers, cloth ribbon closure, pencil sleeve, and rounded corners. Stapled page block. Pages of very slightly textured, cream, wove paper with square corners.
Cover dimensions: 10.1 x 17.9 cm
Page dimensions: 9.5 x 17.0 cm

33 pages
5 missing pages
1 blank page
30 single-sided drawings
1 double-sided drawing
Front cover inscribed: 1; 20. Mai 1907 - 14 Dezember 1907; **imprinted:** Skizzen-Buch; **inside front cover inscribed:** G. Gross; G. Groß 1907; 20. Mai 1907 - 14 Dezember 1907; **inscription on spine:** 1
Technique: Graphite and ink; occasionally watercolor and crayons; sometimes mixed media.
Subject: Studies of villages, landscapes, and people. Some images seem to resemble Grosz's close surroundings while others, such as his landscapes "Bei Neumühl," are likely to be copies. Two drawings depict features of industrialization, such as electrical wires and a chimney. Several still-life arrangements of books, fruit, and bottles.

1907/2 [3]

15 DECEMBER 1907 – 30 OCTOBER 1908

Sketchbook with gray, cloth-covered cardboard covers, pencil sleeve, and rounded corners. Sewn page block. Pages of very slightly textured, cream, wove paper with square corners.
Cover dimensions: 17.2 x 12.0 cm
Page dimensions: 16.3 x 11.3 cm
28 pages
2 missing pages
no blank pages
24 single-sided drawings
3 double-sided drawings
Front cover imprinted: Skizzenbuch; **inside front cover inscribed:** G. Gross 15 XII 07; **first page inscribed:** G. Gross 15.12.07 - 30. Oktober 1908; Stolp in Pommern; Offiziercasino Skizzen und Studien n. d. Natur; **inscription on spine:** 2
Technique: Graphite and ink; occasionally watercolor, gouache, and prepared chalk.
Subject: Graphite drawings of picturesque farmhouses and Grosz's dog Wittboi(s). Studies of the dog's head and expression. A graphite and gouache drawing of a bathhouse interior. Several studies of hands and a woman playing the piano.

1908/1 [4]

21 SEPTEMBER – 16 OCTOBER

Sketchbook with gray, cloth-covered cardboard covers, ribbon closure, pencil sleeve, and rounded corners. Stapled page block. Pages of slightly textured, cream, wove paper with square corners.
Cover dimensions: 15.7 x 23.5 cm
Page dimensions: 14.7 x 22.5 cm
32 pages

1908/1, 5 recto

2 missing pages
1 blank page
26 single-sided drawings
5 double-sided drawings
Inside front cover inscribed: Georg Gross 1908; Skizzen und Studien n. d. Natur vom 21. Dezember 1908 bis-16. Oktober 1908; **inscription on spine:** 3
Technique: Graphite; occasional use of ink, watercolor, and colored crayon.
Subject: Trees and farmhouses. Two studies of farm interiors and a graphite and gouache study of barrels and boxes in front of a brick wall, a highly finished drawing that has the quality of a still life. Two drawings of a windmill and a brick factory as well as several drawings of fish on a plate. The first three pages of the sketchbook contain outlines of men. According to Grosz's inscription "copied from nature," these are original drawings. His sketching appears more free.

1909/1 [5]

C. JUNE – AUGUST

Sketchbook with gray, cloth-covered cardboard covers, button closure [partly lost], pencil sleeve, and rounded corners. Stapled page block. Pages of slightly textured, wove paper of various colors with rounded corners. Colors range from cream and tan to blue and green.
Cover dimensions: 17.4 x 25.5 cm
Page dimensions: 16.4 x 24.8 cm
33 pages
3 missing pages
no blank pages
23 single-sided drawings
10 double-sided drawings
inside front cover inscribed: Skizzen G. Grosz; **inscription on spine:** 4

Technique: Graphite; occasionally watercolor, chalks, crayon, ink, and gouache are used, often in combination.

Subject: Numerous drawings of houses and gardens. Crayon and watercolor drawing of the church in Stolp. Sketches of horses, ducks, hens, as well as the artist's dog Wittboi(s). A watercolor of the head of the sleeping dog. Two drawings of sailboats, men at work, and people in the street.

1909/2 [6]

SEPTEMBER – OCTOBER

Sketchbook with gray, cloth-covered cardboard covers, cloth ribbon closure, pencil sleeve, and rounded corners. Stapled page block. Pages of slightly textured, cream, wove paper with square corners.

Cover dimensions: 12.9 x 20.3 cm
Page dimensions: 12.1 x 19.5 cm
38 pages
no missing pages
1 blank page
12 single-sided drawings
25 double-sided drawings
Front cover inscribed: 4; **imprinted:** Skizzen-Buch; **inside front cover inscribed:** George Gross Kögl. Kunstacademie [*sic*] Dresden. 1909. Sept; **inscription on spine:** 4a
Technique: Graphite; two drawings with black and brown inks; occasionally prepared chalk and crayon.
Subject: Depictions of people. Street cleaners, passersby, bicyclists, women with children, and men rafting. Drawings of painters with sketchbooks presumably portray fellow students at the Royal Art Academy in Dresden. One of the drawings is inscribed "Dungebauer malend im Freien" (Dungebauer painting outdoors). Three landscapes.

1909/3 [7]

NOVEMBER

Sketchbook with gray, cloth-covered cardboard covers, cloth ribbon closure [lost], pencil sleeve, and square corners. Stapled page block. Pages of slightly textured, cream, wove paper with square corners.

Cover dimensions: 12.1 x 19.8 cm
Page dimensions: same
30 pages
no missing pages
no blank pages
2 single-sided drawings
27 double-sided drawings
Front cover inscribed: 5./Nov. 1909; **imprinted:** Skizzen; **inside front cover inscribed:** Georg Gross Drsd. Nov. 09.; [illeg.] Gummi; Bleistift. No. 3.; 1 Carton. **inscription on spine:** 5
Technique: Graphite; occasionally charcoal and crayon. Some

drawings treated with fixative. Techniques often used in combination.

Subject: People in the streets and sitting at coffee tables. Drawing of a person singing and another accompanying on the piano. (Possibly a cabaret scene, and in this context the drawings of people sitting at coffee tables could be the audience.) Detailed portrait of his friend Kittelsen, whom he mentions in his Autobiography, pp. 82–85. Overall, Grosz's drawing style appears more energetic and expressive. Drawing on inside front and back covers.

1912/1 [8]

c. JANUARY

Sketchbook with gray, cloth-covered cardboard covers, ribbon closure [lost], pencil sleeve, and rounded corners. Stapled page block. Pages of smooth-surfaced, cream, wove paper with square corners.

Cover dimensions: 17.6 x 25.8 cm
Page dimensions: 16.8 x 25.0 cm
33 pages
5 missing pages
no blank pages
1 single-sided drawing
32 double-sided drawings
Front cover imprinted: Skizzenbuch [corner design in Art Nouveau style]; **inside front cover inscribed:** 1912 Dresden und Berlin [by another hand]
Technique: Graphite, ink [applied with pen or brush], crayon, prepared chalk, gouache, pastel, and watercolor; often mixed media.
Subject: Cityscapes and people. Gulliver as a giant, man holding zoetrope, satirical sketches, and abstracted cityscapes. Various materials and techniques; often the same image is rendered in a different technique. Bicyclists at the "Sechstagerennen" (six-day bicycle race) and slender figures of "Pupenjungen" (Berlin slang for homosexuals), as well as a train and passengers. Butcher pushing people through a meat-slicer. Several ideas for pictures are formulated in writing. Drawings on inside front and back covers. [See essay by Peter Nisbet in this volume.]

1912/2 [22A]

2 APRIL – 18 APRIL

Sketchbook with blue cardboard covers, black cloth spine, and square corners. Sewn page block. Perforated pages of thin, smooth-surfaced, cream, wove paper with square corners.

Cover dimensions: 17.0 x 11.0 cm
Page dimensions: same
64 pages
12 missing pages
no blank pages

32 single-sided drawings
30 double-sided drawings
Front cover inscribed: 2. April bis 18 April/ 1912.; 28; 2. Berliner Skizzenbuch.; **inside front cover inscribed:** George Grosz Notizen vom 2 April 1912 bis. 18 April 1912. Südende/Berlin Lichterfelderstr. 36. III; **inside back cover inscribed:** Skizzen nach Radierung von Großmann [?]
Technique: Graphite; occasionally prepared chalk and crayon.
Subject: People in the streets—men, women and children, policemen, street vendors, and bellboys. Drawing style of figures is reminiscent of Feininger. Man carrying a poster-size sign inscribed "Ki-Ko Kroll." Several drawings of people carry inscriptions of Berlin train stations, in particular, the Potsdamer Bahnhof. Items of modern technology such as steam engines and a crane. Drawing on inside back cover.

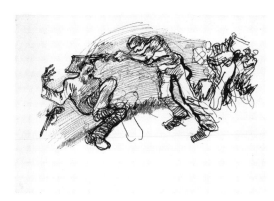

1912/3, 23 recto

1912/3 [9]

c. 26 APRIL – 9 MAY

Sketchbook with gray, cloth-covered cardboard covers, cloth ribbon closure [lost], pencil sleeve, and rounded corners. Stapled page block. Pages of smooth-surfaced, cream, wove paper with square corners.

Cover dimensions: 19.2 x 29.0 cm
Page dimensions: 18.6 x 28.0 cm
23 pages plus one tipped-in
c. 8 missing pages
no blank pages
7 single-sided drawings
17 double-sided drawings
Front cover imprinted: Skizzenbuch [corner design in Art Nouveau style]; **inside back cover inscribed:** Heymlich
Technique: Black and blue ink; occasionally crayon and pastel.
Subject: Narrative Wild West scenes. Fights between cowboys

and Indians are the dominant theme (possibly imaginative illustrations to novels by Karl May and J. F. Cooper). A train robbery, man committing suicide, and lake views with block house and canoe. Several drawings of a Robinson Crusoe episode, and one drawing of Gulliver as a giant. The composition and organization are carefully planned and differ strongly from those of other sketchbooks.

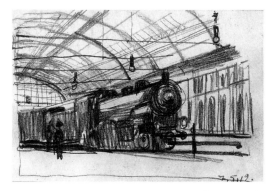

1912/4, 32 recto

1912/4 [23]

2 MAY – 10 MAY

Notebook with black-coated cloth covers and rounded corners. Stapled page block, red-colored sides. Pages of smooth-surfaced, cream, wove paper with rounded corners.

Cover dimensions: 20.3 x 12.8 cm
Page dimensions: same
46 pages
no missing pages
no blank pages
46 single-sided drawings
no double-sided drawings
inside front cover inscribed: Georg Grosz./; 2. Mai 1912 bis 10 Mai 1912; 31.; (5. Berlin)
Technique: Graphite, prepared chalk and ink.
Subject: Street scenes, including a busy street corner where a policeman directs traffic. Advertisement columns appear several times. Two men wearing long overcoats and top hats carrying a coffin, as well as three men working on a scaffold. Seated men at the Café Josty. A steam engine in a train station. Several drawings render details such as the lamps and the glass-and-steel structure of the station.

1912/5 [24]

SEPTEMBER – 14 OCTOBER

Exercise book with blue paper covers and square corners. White

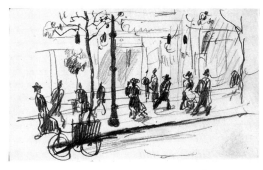

1912/5, 19 recto

paper label attached to front cover. Sewn page block. Pages of smooth-surfaced, cream, wove paper.

Cover dimensions: 17.1 x 10.2 cm
Page dimensions: same
32 pages
no missing pages
no blank pages
31 single-sided drawings
no double-sided drawings
Front cover label inscribed: September bis 14.10.12; Berlin.; 1912; **on cover:** Grosz
Technique: Graphite; some prepared chalk, traces of crayon.
Subject: Several character studies, street vendors, and beggars. A seated, middle-aged man wearing glasses and woman wearing an enormous hat are reading newspapers. In contrast to two drawings that feature horse-drawn cabs, on the last page of the sketchbook is a speeding train.

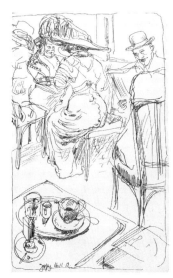

1912/6, 11 recto

1912/6 [25]

9 NOVEMBER – 18 DECEMBER

Notebook with black-coated cloth covers and rounded corners. Stapled page block and red-colored sides. Pages of smooth-surfaced, cream, wove paper with rounded corners.

Cover dimensions: 20.3 x 12.8 cm
Page dimensions: same
46 pages
missing pages [?]
2 blank pages
39 single-sided drawings
5 double-sided drawings
inside front cover inscribed: Grosz. Südende. Lichterfelder Str. 36.; 9. November bis 18. Dezember 1912
Technique: Blue ink, frequently washed; occasionally graphite and prepared chalk.
Subject: Café scenes at the Café Josty. People reading, talking, and drinking coffee. Bedroom with furniture and items of daily life. Bathroom interior and a washstand. A set lunch or dinner table with still-life arrangement of plates, glasses, and other utensils. Office interior and people waiting at a train station. One drawing features the student Karl Hubbuch sketching a seated dummy. All drawings are executed in a fluid style.

1912/7 [25B]

C. 1912 – 1913

Exercise book with blue paper covers and square corners. Sewn page block. Pages of smooth-surfaced, cream, wove paper with square corners.

Cover dimensions: 17.4 x 10.3 cm
Page dimensions: same
25 pages
1 missing page
no blank pages
23 single-sided drawings
2 double-sided drawings
No cover inscriptions; **first page inscribed:** 1912-1913 [by another hand]
Technique: Graphite.
Subject: Café scenes. Men and women sitting at tables, drinking coffee or reading papers. A variety of different characters are rendered, such as a waiter, well-dressed men and women, and a skinny child sitting alone at an empty table. Several portraits of men and women.

1912/8 A - N[10 - 21, 21A, 22]

APRIL – JANUARY 1913

This catalogue number encompasses fourteen envelopes, all inscribed by the artist, into which he gathered single pages. The pages were mostly taken from sketchbooks, and may include

some from sketchbooks which were completely dismembered. These drawings range in size from 20.5 x 14.2 to 11.4 x 11.8 cm. Inscriptions on the envelopes and drawings indicate a date of 1912-13. The entries below summarize the contents of these envelopes as they are at present. Some drawings have clearly been removed at various points.

A) [10]

Envelope inscribed: April 1912 Szenen und Notizen. Vom Potsdamer Platz. Zeitungsverkäufer. und vom Potsdamer Bahnhof. außerdem Café Josty.
Contains 17 pages of wove paper with graphite drawings.
14 single-sided drawings
3 double-sided drawings
Subject: Children, promenading men and women, and policemen. Two seated men, one of them watching a woman who walks by, two men and a woman sitting at a table.

B) [11]

Envelope inscribed: Landschaften/Architekturen/April/Mai/Juni 12. Juli.
Contains 39 pages of wove paper with graphite drawings and one ink drawing.
35 single-sided drawings
4 double-sided drawings
Subject: Studies of people. People reading, man watching a Zeppelin. Man selling newspapers (drawing inscribed B.Z. which is an abbreviation of *Berliner Zeitung*). Train station with technical devices such as an emergency brake and an antique pistol. Female religious figure. Two studies of men looking at a peep show.

C) [12]

Envelope inscribed: Mai und Juni April 1912. Enthält alle mögliche [crossed out] [illeg.] (Eisenbahnnotizen) außerdem verschiedenes anderes. Droschken, Wagen, Omnibus. u./a.
Contains 6 pages of wove paper with graphite drawings.
5 single-sided drawings
1 double-sided drawing
Subject: Drawings of men in the streets. Includes well-dressed men with hats and walking sticks as well as working-class people. Two drawings of technical devices such as beer taps and lamps.

D) [13]

Envelope inscribed: Mai 1912. Einzelstudien. Arbeiter. Aus dem Café Josty. und anderes.
Contains 18 pages of wove paper with graphite drawings and one prepared chalk drawing.
17 single-sided drawings
1 double-sided drawing

Subject: Steam engines and train interiors; among others, train at a train station, and two drawings of lamps. Several studies of horses and dogs.

E) [14]

Envelope inscribed: Mai 1912 Figuren/ Arbeiter, Proletariatsfrauen/ Kinder und andere Typen.
Contains 27 pages of squared, wove paper with graphite and prepared chalk drawings. One ink drawing.
27 single-sided drawings
no double-sided drawings
Subject: People in the streets, including children, men and women walking, and workers.

F) [15]

Envelope inscribed: Mai - Juni. 1912. Figuren. Café Josty. und andere. Potsdamer Bahnhof.
Contains 32 pages of wove paper with graphite and prepared chalk drawings.
31 single-sided drawings
1 double-sided drawing
Subject: Promenading people. According to Grosz's inscriptions, several drawings of seated people feature customers at the Café Josty. People reading or writing, a woman on the telephone, and coat rack. Also a seated nun, men carrying a heavy object, and a train at a station.

G) [16]

Envelope inscribed: Juni 1912. Einzelfiguren. Bettler. Kinder Frauen. Arbeiter.
Contains 25 pages of squared, wove paper with graphite and prepared chalk drawings. One black ink drawing.
25 single-sided drawings
no double-sided drawings
Subject: People in the streets. Man glancing at a woman from behind. The woman's high-heeled boots and dangling handbag possibly identify her as a prostitute. Several other drawings render women in similar outfits. Man pushing a large cart, and men lined up in front of a peep show.

H) [17]

Envelope inscribed: Juli. 1912. unter anderem "Notizen" aus Fürstenwalde und [illeg.].
Contains 21 pages of squared, wove paper with graphite drawings.
21 single-sided drawings
no double-sided drawings
People in the streets. Man with knapsack and hiking gear in a crowd of people. Men and women sitting on a bench, woman wearing an apron. Lamps, spigot, and a bouquet of roses in a vase. A steam engine and sailboats are also included.

I) [18]

Envelope inscribed: Thorn. Juli. 1912. und August.
Contains 18 pages of wove paper with graphite drawings. Two ink drawings.
18 single-sided drawings
no double-sided drawings
Uniformed men: carrying a bucket, attending horses, or carrying a flag. One of the figures is depicted from a birds-eye perspective. Domestic items such as an iron, a clock, and a basket. Three studies of a dog.

J) [19]

Envelope inscribed: August. 12. Thorn. Hunde.
Contains 23 pages of squared, wove paper with graphite drawings.
23 single-sided drawings
no double-sided drawings
Subject: Dogs in different poses with various expressions.

K) [20]

Envelope inscribed: Ende August. und September. 1912. Grosz.
Contains 16 pages of wove paper with graphite drawings.
16 single-sided drawings
no double-sided drawings
Subject: Workers and two drawings of children. Man glancing at a woman who is leaning forward. Steam engine, cab and cab driver.

L) [21]

Envelope inscribed: Oktober 1912.
Contains 13 pages of squared, wove paper with graphite and prepared chalk drawings.
13 single-sided drawings
no double-sided drawings
Subject: Women from behind, including a woman pushing a pram. Man sitting at a coffee table, street cleaners, a carriage and driver, and two people in a row boat. Two drawings of horses and dogs.

M) [21A]

Envelope inscribed: Berlin. Naturnotizen./ 8. Mai 12. November 1912.
Contains 16 pages of wove paper with graphite and blue ink drawings.
13 single-sided drawings
3 double-sided drawings
Subject: Men and women sitting at tables, one of these drawings from a birds-eye perspective. A man sitting at a table, writing (possibly a self-portrait). Page from a theater program with drawing of theater interior and spectators.

N) [22]

Envelope inscribed: Thorn Dez. 1912 Jan. 1913. Hundenotizen
Contains 8 pages of wove paper with graphite drawings and
one blue ink drawing.
6 single-sided drawings
2 double-sided drawings
Subject: Some dog studies. Woman ironing, drawings of men
(one of them reclining in an armchair).

1913/1, 8 verso

1913/1 [26A]

c. MAY

Exercise book with blue paper covers and square corners.
White paper label attached to front cover. Sewn page block
now disintegrated. Pages of smooth-surfaced, cream, wove
paper with square corners.
Cover dimensions: 16.1 x 10.2 cm
Page dimensions: same
13 pages
several missing pages
no blank pages
5 single-sided drawings
8 double-sided drawings
Front cover label inscribed: Notizbuch. 1913. Berlin
Technique: Graphite.
Subject: Pornographic imagery. Numerous erect penises,
detached from the male body, represented as independent
figures, or aberrations of the human body. In several cases,
Grosz attached male genitals to mechanical devices: penises

are propelled by metal springs and occasionally associations
are made between male genitals and cannons or guns. While
two sketches depict penises aimed at or penetrating nude
women, others feature sadistic or masochistic imagery. Several
male portraits and a breakfast still life appear in between.

1913/2 [25A]

BEGINNING OF MAY

Exercise book with blue paper covers and square corners.
White paper label attached to front cover. Sewn page block.
Pages of smooth-surfaced, cream, wove paper with square
corners.
Cover dimensions: 16.4 x 10.1 cm
Page dimensions: same
27 pages
1[?] missing page
no blank pages
27 single-sided drawings
no double-sided drawings
Front cover and label inscribed: Grosz; Anfang Mai 1913 - [illeg.]
7. Linden Kabarett; **inside front cover:** [Berlin retailer's stamp]
Technique: Graphite and prepared chalk.
Subject: Actors and musicians. According to Grosz's inscrip-
tion, the book illustrates an evening at the Linden Cabaret.
While most drawings focus on the performing artists, there are
also studies of the audience watching the stage. One page fea-
tures studies of a female nude. Two sketches of insects on front
label.

1913/3 [26]

JUNE

Exercise book with blue paper covers and square corners.
White paper label attached to front cover. Sewn page block.
Pages of smooth-surfaced, cream, wove paper with square
corners.

1913/3, 1 recto

Cover dimensions: 16.1 x 10.2 cm
Page dimensions: same
28 pages
no missing pages
no blank pages
28 single-sided drawings
no double-sided drawings
Front cover label inscribed: Notizen; Berlin Juni 1913
Technique: Graphite and one prepared chalk drawing.
Subject: Coffee tables and chairs. Detailed drawing of a break-
fast-table, still-life arrangement. Drawings of busy garden
restaurants (*Biergärten*), and detailed studies of people form
the majority of drawings. Nude back of a woman.

1913/4 [27]

AUGUST

Sketchbook with blue cardboard covers, black cloth spine, and
square corners. Sewn page block. Perforated pages of smooth-
surfaced, thin, cream, wove paper with square corners.
Cover dimensions: 26.8 x 21.4 cm
Page dimensions: same
78 pages plus one tipped-in
no missing pages
no blank pages
1 single-sided drawing
78 double-sided drawings
Inside front cover inscribed: Paris, 1913. August; **inside back
cover:** [Paris retailer's stamp]
Technique: Graphite, crayon, and ink drawings.
Subject: Academic studies of the female nude in various poses.
In contrast to Grosz's street scenes, which mostly illustrate
women from behind, most of these studies present the models
frontally or in three-quarter view. According to the date, it can
be assumed that the drawings were executed in the studio of
Colarossi in Paris. Drawing on inside back cover.

1913/5 [27A]

SEPTEMBER

Sketchbook with blue cardboard covers, black spine, and
square corners. Sewn page block. Perforated pages of smooth-
surfaced, cream, wove paper with square corners.
Cover dimensions: 21.9 x 18.0 cm
Page dimensions: same
72 pages
3 missing pages
no blank pages
23 single-sided drawings
49 double-sided drawings
inside front cover inscribed: Paris. 1913. September; **back
cover:** [Paris retailer's stamp]

Technique: Graphite.
Subject: Drawings of the female nude. See 1913/4 [27].

1913/6 [28B]

c. 1913–1914 [*old school sketchbook reused; dated by Peter Grosz*]

Sketchbook with blue paper covers and square corners. Sewn page block. Pages of textured, tan, wove paper with square corners.
Cover dimensions: 22.9 x 19.0 cm
Page dimensions: same
10 pages
no missing pages
no blank pages
6 single-sided drawings
4 double-sided drawings
Front cover imprinted: Zeichenheft für den Zeichenunterricht in den Volksschulen. Heft 2., Schüler:; geb.:; Schule:; in:; **the imprinted cover is inscribed:** Gross Ehrenfried. Grosz; 12. Dez. 1900./ 27. Gemeindeschule.; Berlin
Technique: Ink.
Subject: Female nudes. The first pages depict young women in attractive poses; the following sketches show a middle-aged woman with slightly sagging breasts, aging body, and angular face. The drawings of the middle-aged nude have rough shading, which emphasizes the sagging, aging body.

1914/1 [27B]

SEPTEMBER

Exercise book with blue paper covers and square corners. White paper label attached to front cover. Sewn page block. Pages of smooth-surfaced, cream, wove paper with square corners.
Cover dimensions: 16.1 x 10.2 cm
Page dimensions: same
24 pages
2 missing pages
4 blank pages
20 single-sided drawings
no double-sided drawings
Front cover label inscribed: 1914. Groß
Technique: Graphite, prepared chalk; one crayon and one prepared chalk drawing.
Subject: Several portraits of men and women, among them the study of two men engaged in conversation. One of the men, who is rather stout, has a sardonic expression on his face while he is looking at his counterpart. A single drawing depicts chairs and tables in a restaurant.

1914/2 [28]

SPRING 1914

Sketchbook with heavy brown paper covers and square corners. Sewn page block now disintegrated. Tan label with dark brown edging attached to front cover. Pages of smooth-surfaced, cream, wove paper with square corners.
Cover dimensions: 23.1 x 18.5 cm
Page dimensions: same
5 pages
several missing pages
no blank pages
5 single-sided drawings
no double-sided drawings
Front cover label inscribed: Dolly Wibach Heft I; Frühjahr 1914 K.G.M.; [label with manufacturer's information]
Technique: Ink and chalk.
Subject: A female nude in different poses. According to Grosz's front-cover-label inscription, the model is Dolly Wibach. Apart from the use of ink here, these sketches are quite similar in style to his Paris drawings of 1913. See 1913/4 [27] and 1913/5 [27A] in comparison.

1914/3 [28A]

c. SPRING 1914

Sketchbook with heavy brown paper covers and square corners. Tan label with dark brown edging attached to front cover. Sewn page block. Pages of slightly textured, cream, wove paper with square corners.
Cover dimensions: 23.1 x 18.5 cm
Page dimensions: same
10 pages
no missing pages
no blank pages

1914/3, 5 recto

10 single-sided drawings
no double-sided drawings
Front cover label with manufacturer's information; inscribed: Dolly Wibach Heft II. 1914
Technique: Ink and chalk.
Subject: Drawings of a female nude in different poses. Technique, style, and subject are the same as 1914/2 [28].

1915/1 [29]

15 JULY

Exercise book with blue paper covers and square corners. White paper label attached to front cover. Sewn page block. Pages of smooth-surfaced, cream, wove paper with square corners.
Cover dimensions: 16.2 x 10.1 cm
Page dimensions: same
28 pages
half a page ripped from the first page
no blank pages
9 single-sided drawings
17 double-sided drawings
Front cover label inscribed: Grosz 15. Juli 1915. Southend
Technique: Graphite; occasionally crayon.
Subject: Human types, pornographic imagery, and distorted female bodies. "Man after operation": elegantly dressed man, smiling, top half of his skull is opened and attached to the back of his head with a hinge, and tube hooked up to the man's nose. (Peter Grosz suggests that this drawing might relate to Grosz's serious sinus condition, for which he was eventually exempted from his military duties.) Crude drawing style characteristic of Grosz's wartime production. A number of pages are filled with distressed notes such as "that I hate myself," or "I can love no woman." First page has brief media inventory.

1915/2 [30]

OCTOBER – 13 NOVEMBER

Exercise book with blue paper covers and square corners. White paper label attached to front cover. Pages of smooth-surfaced, cream, wove paper with square corners.
Cover dimensions: 16.4 x 10.4 cm
Page dimensions: same
30 pages
no missing pages
no blank pages
25 single-sided drawings
5 double-sided drawings
Front cover label inscribed: Ok. 15 bis 15. Nov. 15; Krankenjournal des Dr. William King Thomas U.S.A.; **inside front cover inscribed:** 1915 [by another hand]
Technique: Graphite and ink; occasionally crayon.

Subject: Soldiers, profiteers, women portrayed as prostitutes. Grosz presents the common man in soldier's uniform, thus focusing on the individual rather than on the stereotype. Some soldiers appear as victims. Acerbic drawing of soldiers shooting with cannons at a peace angel descending from heaven. Woman stripping in an office in front of two men, doctor examining a man's genitals, and a suicide scene. [See essay by Beth Irwin Lewis in this volume.]

1915/3 [31]

13 NOVEMBER – 15 DECEMBER

Exercise book with pink and white paper covers and square corners.
White paper label attached to front cover. Sewn page block. Pages of smooth-surfaced, cream, wove paper with square corners.
Cover dimensions: 16.1 x 10.1 cm
Page dimensions: same
23 pages
1 missing page
no blank pages
18 single-sided drawings
5 double-sided drawings
Front cover label inscribed: Krankenjournal des Dr. William King Thomas U.S.A.; 13. Nov. 1915/bis./15.12.15
Technique: Graphite; occasionally prepared chalk and ink.
Subject: Male portraits, women portrayed as prostitutes, and items of daily life. Bathroom interior, washstand, a basin, dogs, and a teddy bear as well as a cityscape and a cabaret

scene. A drawing of a woman with high-heeled shoes and a muff is carefully shaded and gives the figure a plasticity unseen in other sketchbook drawings of that time. Notes on inside back cover.

1915/4, 29 recto

1915/4 [32]

15 DECEMBER 1915 – 31 JANUARY 1916

Exercise book with blue paper covers and square corners. White paper label attached to front cover. Sewn page block. Pages of smooth-surfaced, cream, wove paper with square corners.
Cover dimensions: 16.4 x 10.3 cm
Page dimensions: same
30 pages
no missing pages
no blank pages
18 single-sided drawings
10 double-sided drawings
Front cover label inscribed: Krankenjournal des Dr. William King Thomas. U.S.A.; 15. Dez. 1915 jusqu'à Montag [?] 31.1.16
Technique: Graphite.
Subject: Dogs, cityscapes and people walking in the streets. Drawings of children, a three-faced representation of the Trinity and two drawings of Egyptian figures. An outline of a stout man in the nude, "bathroom graffiti," a woman rendered as a prostitute, and several portraits. Shopping lists, calculations, advertisements, and a poem about Walt Whitman.

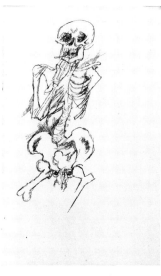

1916/1, 4 recto

1916/1 [33]

3 FEBRUARY

Exercise book with blue paper covers and square corners [corners worn]. White paper label attached to front cover. Sewn page block. Pages of smooth-surfaced, cream, wove paper with square corners.
Cover dimensions: 16.4 x 10.3 cm
Page dimensions: same
24 pages
no missing pages
no blank pages
16 single-sided drawings
7 double-sided drawings
Front cover label inscribed: Krankenjournal des Dr. William King Thomas U.S.A. Ottawa 3 Feb./
Technique: Graphite; occasionally ink.
Subject: People and Berlin cityscapes: smokestacks, railroad signals, towers, skylines. Voyeuristic view through a window curtain onto a street. Next to it, several depictions of men with brutal or agonized looks. Acrobats and skeleton smoking a cigarette. Several pages are filled with laundry lists and addresses, and on one page are the English lyrics of the song "It's a Long Way to Tipperary."

1916/2

APRIL 1916

Exercise book with blue light cardboard covers and rounded corners. White paper label attached to front cover. Stapled

1915/3, 4 recto

page block. Pages of smooth-surfaced, cream, wove paper with rounded corners, some loose pages.
Cover dimensions: 16.4 x 10.4 cm
Page dimensions: same
28 pages
no missing pages
no blank pages
17 single-sided pages
11 double-sided pages
Paper label inscribed: Krankenjournal des Dr. William K. Thomas Boston U.S.A.; April 1916
Technique: Graphite
Subject: Presumably similar content as other "Krankenjournal" exercise books of 1915 and 1916. (Cataloguing information for this sketchbook kindly provided by Gudrun Schmidt, Akademie der Künste, Berlin.)

1916/3 [34]

C. JUNE – JULY

Exercise book with blue paper covers and square corners [corners worn]. White paper label attached to front cover. Sewn page block. Pages of smooth-surfaced, cream, wove paper with square corners.
Cover dimensions: 16.4 x 10.3 cm
Page dimensions: same
34 pages
no missing pages [?]
no blank pages
14 single-sided drawings
13 double-sided drawings
Front cover label inscribed: Krankenjournal of Dr. William King Thomas. Montreal/Canada/Berlin/ 32/32/32/32/32x32;
inside front cover inscribed: 1916 [by another hand]
Technique: Graphite.
Subject: Lusting male aggressors and women as objects of desire. Among others: man approaching a voluptuous nude woman. Woman (drawn with soft, rounded lines) has a naïve expression on her face, the man (rendered with angular lines) is aggressively fixing her with his gaze. Buildings, advertisements. Lengthy letter addressed to a "female sculptor," asking for money. The letter includes artists' nicknames (most of them invented by the poet Else Lasker-Schüler, not all of them identified). Among others Lasker-Schüler's pseudonym "Prinz Jussuf" and her fictional character "Konsul Abigel" appear. One of her poems that describes Grosz is also copied. The poem appeared in *Neue Jugend* 8 (August 1916): 154.

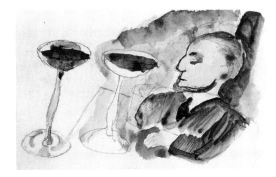

1916/4, 4 verso

1916/4 [35]

C. OCTOBER

Exercise book with black paper covers and square corners [corners worn]. White paper label attached to front cover. Sewn page block. Pages of smooth-surfaced, cream, wove paper with square corners.
Cover dimensions: 16.5 x 10.2 cm
Page dimensions: same
10 pages
no missing pages
no blank pages
4 single-sided drawings
3 double-sided drawings
Front cover label inscribed: Dr. William King Thomas Krankenjournal
Technique: Graphite; occasionally watercolor, ink, and crayon.
Subject: Houses in sketchy, Dada drawing style. Graphite-and-watercolor portrait of a man sitting at a table, gazing into the distance. Two disproportionately large wine glasses appear in front of the seated figure, possibly a self-portrait. Several pages of the book are filled with addresses and one page has a short thank-you note to Grosz's patron Mr. Falk. Several addresses of Haussmann, Pfemfert, and Mynona (Dr. Friedländer).

1916/5 [36]

C. NOVEMBER – DECEMBER

Exercise book with blue paper covers and square corners [corners worn]. White paper label attached to front cover. Sewn page block. Pages of smooth-surfaced, cream, wove paper with square corners.
Cover dimensions: 16.4 x 10.3 cm
Page dimensions: same
31 pages

1 missing page
1 blank page
19 single-sided drawings
6 double-sided drawings
Front cover label inscribed: Krankenjournal des Dr. William K. Thomas.; Krankenjournal des Dr. William King Thomas
Technique: Graphite; occasionally watercolor with graphite.
Subject: Portraits, some of which are titled "Café Josty." Several watercolors of figures, among others a ghostlike figure with green face and red eyes, dressed in a white suit. Four drawings of performing jugglers. Shopping lists, addresses, and notes. List with titles of Grosz poems and a second list with titles and prices of six ink drawings and three lithographs. The second list is headed "drawings / Golz" and resembles, in part, titles of images that appeared in the first and second Grosz print portfolios.

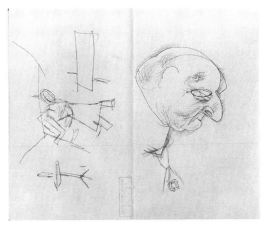

1916/5, 11 verso and 12 recto

1917/1 [37]

C. JUNE

Exercise book with black paper covers and square corners [corners worn]. White paper label attached to front cover. Sewn page block. Pages of smooth-surfaced, cream, wove paper with square corners.
Cover dimensions: 17.0 x 10.2 cm
Page dimensions: same
16 pages
no missing pages
no blank pages
6 singled-sided drawings
6 double-sided drawings
Front cover label inscribed: Dienstag 4 Uhr [illeg. addresses

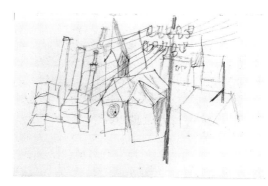

1917/1, 7 recto

and phone numbers]; [back inside cover holds corner of perforated, gum-adhesive stamp margin with orange printing]
Technique: Graphite.
Subject: Street signs, notes, and cityscapes. The dividing line between drawing and written information becomes almost inseparable. Several drawings of street signs could be preliminary studies for *The City* of 1916-17. Portrait of a man with an enormous nose, inscribed "bei Kempinski" (famous Berlin hotel and café), one outside view of a café or bar. A male head with the features of a skull. The ambiguous impressions of death and life are further enhanced by dark glasses and the outline of a hat.

1917/2

UNTIL SEPTEMBER

Exercise book with blue-gray cardboard covers and rounded corners. White paper label attached to front cover. Stapled page block. Pages of smooth-surfaced, cream, wove paper with blue lines and rounded corners.
Cover dimensions: 16.7 x 10.3 cm
Page dimensions: same
21 pages
no missing pages
no blank pages
3 single-sided drawings
17 double-sided drawings
Front cover label inscribed: Grosz/ bis September 1917; Dr. W.K. Thomas
Technique: Graphite.
Subject: People in the streets, character studies of petit bourgeois, dogs. Men drinking wine, one of them accompanied by a prostitute. Man walking through landscape with windmill, castle, church, and cemetery. Still-life arrangements, a tree, and various addresses. Cf. facsimile edition as George Grosz, *Skizzenbuch 1917*, ed. Karl Riha (Siegen, 1987).
(Cataloguing information kindly provided by Gudrun Schmidt, Akademie der Künste, Berlin.)

1917/3 [38]

SEPTEMBER 1917 – FEBRUARY 1918

Exercise book with blue paper covers and square corners [corners worn]. White paper label attached to front cover. Sewn page block. Pages of smooth-surfaced, cream, wove paper with blue lines and square corners.
Cover dimensions: 16.4 x 10.4 cm
Page dimensions: same
31 pages
1 missing page
no blank pages
20 single-sided drawings
7 double-sided drawings
Front cover label inscribed: Grosz/ Mannheim September 1917 bis 1918 Febr.; Lützow 3254
Technique: Graphite.
Subject: Contemporary and baroque building facades, industrial steel structures, interiors, portraits. Several male portraits show individuals with dark, swollen noses. Bar scene. Portrait of a petit bourgeois, lusting for beer. The man's head is filled with imaginative beer bottles, one of which is ornamented with a woman's breast. Depiction of a woman as Circe, with malicious smile and seductive look, appears in the middle of a letter addressed to his patron Mr. Falk. In the letter Grosz apologizes for not sending new drawings since he was unable to work in his studio due to a lack of coal. Addresses, calculations, a fragmentary poem, the title of a book on Hieronymus Bosch, and various notes.

1917/3, 7 recto

1918/1 [39]

6 MARCH – 5 AUGUST

Exercise book with black paper covers and square corners [worn].
White paper label attached to front cover. Sewn page block. Pages of smooth-surfaced, cream, wove paper with square corners.

1918/1, 8 recto

Cover dimensions: 16.7 x 10.3 cm
Page dimensions: same
14 pages
no missing pages
no blank pages
3 single-sided drawings
10 double-sided drawings
Front cover inscribed: 6 März 18 - 5.8.18; **Front cover label inscribed:** 6. März 18 bis [no date given]; Steglitz 597 Steglitz 450
Technique: Graphite; traces of oil and crayon.
Subject: Studies for a drawing in the sketchbook titled "Sei gegrüsst du mein schönes Sorrent." The shape of a male's head is developed from two buttocks. In contrast to this self-indulgent, stout figure, Grosz introduces a male type with angular face, thin lips, and a penetrating, brutal gaze. Advertisements and street signs. "Kaiser" coal advertisement attached to front inside cover. Image copied on sketchbook page, same advertisement appears in his painting *Funfair*, 1928-29.

1918/2 [40]

5 AUGUST – 20 OCTOBER

Exercise book with black paper covers and square corners [worn]. White paper label attached to front cover. Sewn page block. Pages of smooth-surfaced, cream, wove paper with square corners.
Cover dimensions: 16.8 x 10.3 cm
Page dimensions: same
16 pages
no missing pages
no blank pages
5 single-sided drawings
10 double-sided drawings
Front cover inscribed: 5.8.18; **Front cover label inscribed:** George Grosz; 5 August 18. bis 30 Oktober 1918.; [inside front cover has perforated, gum-adhesive stamp margin of top left corner with orange printing]

Technique: Graphite.

Subject: Building facades, two drawings of interiors (presumably living rooms). Three sketches of landscapes as well as towers, lamps, railway signals, and train. Three drawings of clowns. "Fred 29 Jahre tätowiert" (Fred 29 years old tattooed) a man with penetrating look and malicious smile, possibly a pimp or a profiteer. Various pages are filled with addresses, appointments, and calculations.

1918/3 [41]

BEGUN 30 OCTOBER – C. NOVEMBER

Exercise book with blue paper covers and square corners [corners worn]. White paper label and small cream-and-red paper label with the image of three men attached to front cover. Sewn page block. Pages of smooth-surfaced, cream, wove paper with blue lines and square corners.

Cover dimensions: 16.4 x 10.3 cm
Page dimensions: same
15 pages
1 missing page
no blank pages
8 double-sided drawings
Front cover label inscribed: Grosz; 30 Oktober 18
Technique: Graphite.
Subject: Trams, building facades, among others the entrance to a delicatessen. Several male portraits and a single drawing of a woman's nude upper body. The first and last pages of the book are filled with addresses, notes, and calculations. A small, erect penis appears next to the address of a woman named Elly. Telephone numbers on front label.

1922/1 [42]

AUGUST

Exercise book with blue paper covers and square corners. White paper label attached to front cover. Stapled page block. Pages of smooth-surfaced, cream, wove paper with square corners.

Cover dimensions: 16.8 x 10.5 cm
Page dimensions: same
32 pages
no missing pages
no blank pages
14 single-sided drawings
17 double-sided drawings
Front cover label inscribed: Notizen von der Reise durch Norwegen an Bord "Kong Harald" Vardö. und Fischerboot Uberfahrt nach Murmansk August 1922
Technique: Graphite.
Subject: Drawings relating to Grosz's journey to Russia via Norway. Notes on the first two pages express extreme bore-

1922/1, 10 verso

dom. Several drawings of facilities on board such as bunk beds, stove, etc. People, interiors, detailed studies of lamps and chairs. A mountain range, a house on the water, a ship in a harbor, and a village street are the only examples of landscapes or scenery. Several drawings of cows and seagulls.

1922/2 [43]

C. 1922 – 15 FEBRUARY 1923

Exercise book with blue paper covers and square corners. White paper label attached to front cover. Stapled page block [block has been opened]. Pages of smooth-surfaced, cream, wove paper with square corners.

Cover dimensions: 16.8 x 10.5 cm
Page dimensions: same
28 pages
missing pages [?] [upper quarter of center page cut out]
no blank pages
23 single-sided drawings
3 double-sided drawings
Front cover inscribed: no 1.; 1.; Notizen bis [stamped]: 15. Feb. 1923
Technique: Graphite and prepared chalk.
Subject: People, occasionally identifiable as widow, cleaning woman, etc. Stout man smoking pipe and reading the socialist newspaper *Vorwärts*, a crowned woman in revealing dress (possibly a carnival queen). The first and last page probably date back to Grosz's 1922 trip to Russia, since his departure time from Moscow and several addresses of Russians are

1922/2, 10 recto

included. Grosz may have collected the latter at the Moscow conference. Notes on front cover label.

1923/1 [46]

15 FEBRUARY – 28 MARCH

Exercise book with blue paper covers and square corners. White paper label attached to front cover. Sewn page block. Pages of smooth-surfaced, cream, wove paper with square corners.

Cover dimensions: 16.4 x 10.4 cm
Page dimensions: same
32 pages
no missing pages

1923/1, 32 recto

1 blank page

23 single-sided drawings

8 double-sided drawings

Front cover inscribed: No 2; 2.; **front cover label stamped:** Tel. Uhland 8102; 15. Feb. 1923 - 28. März 1923

Technique: Prepared chalk and graphite.

Subject: People, especially portraits of women. Grosz focuses, in particular, on fox-fur collars on women's dresses. The last page of the book has various sketches for the Malik Verlag logo. Examples vary from figurative to abstract designs.

1923/2 [47]

28 MARCH – 30 MAY

Notebook with flecked, brown paper-covered cardboard covers, black cloth spine, and square corners.

Stapled page block with blue, dotted sides. Pages of smooth-surfaced, cream, wove paper with square corners.

Cover dimensions: 16.7 x 10.3 cm

Page dimensions: same

24 pages

no missing pages

no blank pages

15 single-sided drawings

9 double-sided drawings

Front cover inscribed: no 3.; 3; **inside front cover stamped:** 28. März 1923 - 30. Mai 1923; **inside back cover:** [German retailer's stamp]

Technique: Graphite and prepared chalk.

Subject: Drawings of people, including a man in hiking gear and a soldier. The last page features a child on a scooter. Several drawings of bottles and glasses, such as a bottle of champagne in a cooler. Small drawing, notes, and address on inside back cover.

1923/3 [45]

30 MAY – 18 JUNE

Exercise book with blue paper covers and square corners. Back cover cut and attached to rigid cardboard support. White paper label attached to front cover [removed]. Sewn page block.

Pages of smooth-surfaced, cream, wove paper with square corners.

Cover dimensions: 16.4 x 10.3 cm

Page dimensions: same

32 pages

no missing pages

1 blank page

27 single-sided drawings

4 double-sided drawings

Front cover inscribed: No 4.; **front cover stamped:** 30. Mai 23 - 18. Juni 1923

Technique: Graphite.

Subject: Courtroom. Seated figures on high benches listening and watching attentively. Standing and walking figures, such as a policeman. Compare drawings to 1923/5 [49] and 1923/4 [50]. An advertisement for "Sarg Magazin" (Coffin Magazine) appears.

1923/4 [50]

C. JUNE

Exercise book with blue paper covers and square corners. White paper label attached to front cover. Sewn page block. Pages of smooth-surfaced, cream, wove paper with square corners.

Cover dimensions: 20.8 x 15.7 cm

Page dimensions: same

16 pages

no missing pages

11 blank pages

4 single-sided drawings

1 double-sided drawing

Front cover label inscribed: Zirkus Busch Prozess; 2.; [1923 by another hand]

Technique: Prepared chalk.

Subject: Circus Busch trial. The first page depicts attorney Dr. Herzfeld on his stand and gazing fixedly at someone or something. Grosz noted "KPD" attorney next to the drawing (KPD standing for German Communist Party). Person listening. Representational interiors with Corinthian column and stained glass windows.

1923/5 [49]

5 JUNE

Exercise book with blue paper covers and square corners. White paper label attached to front cover. Sewn page block. Pages of smooth-surfaced, cream, wove paper with square corners.

Cover dimensions: 20.9 x 15.8 cm

Page dimensions: same

15 pages

1 missing page

15 single-sided drawings

no double-sided drawings

Front cover label inscribed: Stuhl [?], Lampe, Aufsatz und Circus Busch Prozess; Notizen 5.6.23; 3

Technique: Graphite and prepared chalk.

Subject: Portraits of individuals at court. Several drawings are inscribed with names and titles such as "Ein Richter" (a judge), "Zeuge Frank" (Witness Frank), or "Der Wachtmeister" (policeman). Grosz's interest in the trial is not clear. An exception to this series of people at court is the first page, with an elaborate drape and two lamps.

1923/6 [44]

18 JUNE – 15 JULY

Exercise book with blue paper covers and square corners. Back cover cut and attached to rigid cardboard support. White paper label attached to front cover [removed]. Sewn page block. Pages of smooth-surfaced, cream, wove paper with square corners.

Cover dimensions: 16.4 x 10.4 cm

Page dimensions: same

32 pages

no missing pages

no blank pages

31 single-sided drawings

no double-sided drawings

Front cover inscribed: No. 5; **front cover stamped:** 18. Jun. 23 - 5. Juli 1923

Technique: Graphite; occasionally prepared chalk, and watercolor.

Subject: Sketches of people and performing acrobats. In general, faces do not have any detail. Watercolors of a maid with notes describing her dress, and an acrobat. The first page contains a letterhead addressed to the state prosecutor, followed by a defense that seems to include a list of legal paragraphs. The note likely relates to Grosz's upcoming trial in February 1924, when he had to defend himself against charges of obscenity regarding his portfolio *Ecce Homo*.

1923/7 [48]

5 JULY – 30 OCTOBER

Exercise book with black, textured, paper-covered cardboard covers, and square corners. Tan label with brown edging attached to front cover. Stapled page block. Pages of smooth-surfaced, cream, wove paper with purple lines and square corners.

Cover dimensions: 16.5 x 10.2 cm

Page dimensions: same

24 pages

no missing pages

no blank pages

12 single-sided drawings

10 double-sided drawings

Front cover label inscribed: No 6; **front cover label stamped:** 5. Juli 1923 - 30. Okt. 23; **inside front cover stamped:** 5. Juli 1923; 30. Okt. 1923

Technique: Graphite; occasionally crayon and watercolor.

Subject: Drawings of people often supplemented with notes regarding texture and color of clothes. Several mechanical and technical devices such as a door lock, telephone, coat rack and hangers, lamps, and doorbell. Some drawings of women with fox-fur collars and two watercolor sketches of women's dresses. Inside front and back covers and last pages contain addresses, appointments, and measurements.

1923/7, 22 recto

1923/8 [53]

30 OCTOBER 1923 – 4 APRIL 1924

Exercise book with black, textured, paper-covered cardboard covers, and square corners. Tan paper label with brown edging attached to front cover. Stapled page block. Pages of smooth-surfaced, cream, wove paper with purple lines and square corners.

Cover dimensions: 16.6 x 10.3 cm
Page dimensions: same
24 pages
no missing pages
no blank pages
6 single-sided drawings
17 double-sided drawings
Front cover label inscribed: no 7; [stamped] 30. Okt. 23 [inscribed] - 4 April 24 Paris; Mappe; **inside front cover inscribed:** 7.; [stamped] 30. Okt. 23
Technique: Graphite and prepared chalk; occasionally crayon.
Subject: Portraits, drawings of women, some seated, others walking. Drawing of a woman with dark shadows around her eyes and mouth (possibly a prostitute). A priest, and a mean-looking French policeman, as well as items of daily life such as a basin, a hot-water bottle, dishes, and a bottle of champagne. Two architectural studies of the Eiffel Tower and arcades. The last page and the inside front and back covers are filled with addresses, phone numbers, shopping list, and calculations.

1924/1 [54]

4 APRIL – 11 APRIL

Two exercise books with blue paper covers and square corners glued together. Back cover of first book and front cover of second book are cut and adhered; cardboard support attached to the second book's back inside cover. Gray/white paper label with brown edging attached to front cover. Stapled page blocks. Pages of smooth-surfaced, cream, wove paper with square corners.

Cover dimensions: 16.2 x 10.0 cm
Page dimensions: same
32 pages [16 pages per exercise book]
no missing pages
no blank pages
first exercise book: 11 single-sided drawings and 5 double-sided drawings; second exercise book: 8 single-sided drawings and 8 double-sided drawings
Front cover inscribed: 4.4.24; No 8 Paris.; **label inscribed:** No 8; 4. April 24 - Paris 11.4.24
Technique: Graphite; one prepared chalk drawing.
Subject: Circus performance. Clowns, musicians, animal trainers, man throwing a lasso, performing horses and dogs. Café or restaurant scenes, bed and chair. Drawing of a priest walking.

1924/2 [57]

11 APRIL – 21 APRIL

Exercise book with blue paper covers and square corners. Back cover cut and attached to rigid cardboard support. Gray paper label with brown edging attached to front cover. Stapled page block. Pages of smooth-surfaced, cream, wove paper with square corners.

Cover dimensions: 16.1 x 10.0 cm
Page dimensions: same
16 pages
no missing pages
no blank pages
9 single-sided drawings
7 double-sided drawings
Front cover inscribed: 8. [crossed out] 9.; **label inscribed:** Paris 11.4.24; 21.4.24
Technique: Graphite.
Subject: Men, women, and several children. According to an inscribed drawing the images originated at the Luxembourg Gardens. Many people depicted are seated, watching or reading. Women pushing baby carriages, and drawing of a French policeman. Grosz frequently used soft graphite shading.

1924/3 [54A]

21 APRIL – 28 APRIL

Exercise book with blue paper covers and square corners. White paper label attached to front cover. Back cover cut and attached to rigid cardboard support. Sewn page block. Pages of smooth-surfaced, cream, wove paper with square corners.

Cover dimensions: 16.4 x 10.3 cm
Page dimensions: same
31 pages
1 missing page
1 blank page
29 single-sided drawings
1 double-sided drawing
Front cover inscribed: 9. [crossed out]; 10; **label inscribed:** Paris 21.4.24 - 28.4.24
Technique: Graphite; occasionally crayon and prepared chalk.
Subject: Drawings of people. Elegantly-dressed women, workers, children, chauffeurs, etc. Female busts for window displays, ornamented chair backs, as well as some detailed studies of coat racks.

1924/4, 1 recto

1924/4 [58]

24 APRIL – 1 MAY

Exercise book with blue paper covers and square corners [worn].

Back cover cut and attached to rigid cardboard support. White paper label attached to front cover. Pages of smooth-surfaced, cream, wove paper with square corners.

Cover dimensions: 20.9 x 16.8 cm
Page dimensions: same
14 pages
at least 2 missing pages

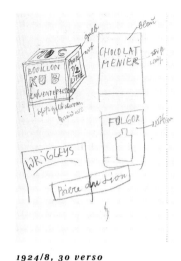

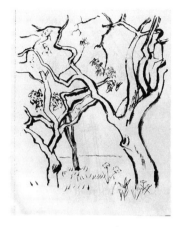

1924/7, 19 recto

1924/8, 30 verso

1924/9, 4 recto

1924/6, 23 recto

1 blank page
14 single-sided drawings
no double-sided drawings
Front cover label inscribed: Paris 24 April Mai; 1
Technique: Graphite and prepared chalk; one watercolor.
Subject: Building facades, café exteriors and one interior. Coffee tables and chairs. Two detailed drawings of windows. Installation of a carousel, architecture, advertisement signs, one in watercolor. Two drawings of a man.

1924/5 [55]

28 APRIL – 5 MAY

Sketchbook with green paper-covered cardboard covers, black cloth spine, and square corners. Sewn page block. Perforated pages of smooth-surfaced, cream, wove paper with square corners.
Cover dimensions: 15.3 x 11.5 cm
Page dimensions: same
34 pages
4 missing pages
no blank pages
no single-sided drawings
34 double-sided drawings
Front cover inscribed: 11. Paris; 28.4.24 - 3.5.24
Technique: Graphite and prepared chalk.
Subject: People. Person walking through park, children riding scooters, man asleep on park bench, men and women reading or walking. Drawing of woman with watchful eyes and an elderly woman with half-opened, toothless mouth. Voyeuristic view of a girl's bloomers.

1924/6 [51]

3 MAY – 16 MAY

Sketchbook with blue cardboard covers, black cloth spine, and square corners. Stapled page block. Perforated pages of smooth-surfaced, cream, wove paper with square corners.
Cover dimensions: 17.3 x 13 cm
Page dimensions: same
60 pages
5-6 missing pages
no blank pages
52 single-sided drawings
8 double-sided drawings
Front cover inscribed: 12 Paris; 3.5.24 - 16.5.24
Technique: Graphite; occasionally prepared chalk and crayon; one watercolor.
Subject: Promenading women, children, a gardener, as well as French policemen. (Detailed notes on the colors of the policeman's uniform.) Several drawings of circus artists including acrobats, people on horseback, and a magician. Two drawings of a coffee machine, building facades and street scenes. Advertisements with focus on typography. An address on inside back cover.

1924/7 [56]

16 MAY – 25 MAY

Sketchbook with green cardboard covers, black cloth spine, and square corners. Sewn page block. Perforated pages of smooth-surfaced, cream, wove paper with square corners.
Cover dimensions: 15.3 x 11.5 cm
Page dimensions: same

35 pages
1 missing page
no blank pages
25 single-sided drawings
10 double-sided drawings
Front cover inscribed: 13. Paris; 16.5.24 - 25.5.24
Technique: Graphite, prepared chalk, and crayon drawings.
Subject: People, head studies, mostly in profile and semi-profile, men and women reading. Focus on women's dresses, in particular their color combinations. Several detailed drawings of French policemen. Advertisement signs, building facades, trees, and pigeons.

1924/8 [52]

25 MAY – 10 JUNE

Sketchbook with light brown cardboard covers, black cloth spine, and square corners. Sewn page block. Perforated pages of slightly textured, cream, wove paper with square corners.
Cover dimensions: 17.6 x 12.6 cm
Page dimensions: same
30 pages
8 missing pages
1 blank page
25 single-sided drawings
3 double-sided drawings
Front cover inscribed: 14.; 25.5. 1924. - [stamped] 10. Juni 1924;
inside front cover inscribed: Paris
Technique: Graphite; some crayon drawings.
Subject: Rough sketches of women and two more detailed drawings of men. Emphasis on women's hats and silhouette

rather than faces. Portrait of a chef and two clowns. Image of a male head reminiscent of a skull with dark glasses and hat. Several chairs, a baby carriage as well as advertisements, some of which appear on the inside back cover.

1924/9 [60]

JULY

Sketchbook with blue cardboard covers, black cloth spine, and square corners. Sewn page block. Perforated pages of smooth-surfaced, thin, cream, wove paper with square corners.
Cover dimensions: 32.6 x 26.0 cm
Page dimensions: same
60 pages (4 loose pages)
c. 6 missing pages
no blank pages
60 single-sided drawings
no double-sided drawings
Front cover inscribed: 1924 July Adelsbach; **inside front cover inscribed:** Adelsbach Juli 1924
Technique: Crayon, graphite, ink, and prepared chalk; one watercolor.
Subject: Summer holiday in Adelsbach near Salzbrunn in Silesia (today Poland). Images of farm animals and landscapes. Drawings of cows and pigs, horses, ducks, and chickens. A few ink drawings of trees, carefully shaded drawing of a cloth hanging over a chair. This particular drawing technique enhances the object's plasticity and connects to Grosz's very late work, such as the drawings of Cape Cod.

1924/10 [59]

18 OCTOBER 1923 – 7 JANUARY 1924

Sketchbook with gray cardboard covers, black cloth spine, and rounded corners. Sewn page block. Pages of smooth-surfaced, thick, cream, wove paper with square corners.
Cover dimensions: 15.8 x 13.3 cm
Page dimensions: 14.8 x 12.7 cm
16 pages
no missing pages
no blank pages
no single-sided drawings
16 double-sided drawings
Front cover inscribed: 16; **front cover stamped:** 18. Okt. 24 - 7. Jan. 1925; inside back cover: [Berlin retailer's sticker]
Technique: Graphite; one crayon drawing.
Subject: Drawings of customs office. Officials sitting at a desk, talking to a courier, someone opening a suitcase forcibly with a knife. Detailed drawings of bills stuck to a lamp, a telephone, etc. Descriptions supplement the drawings and identify various objects. Several drawings feature people, an abandoned table with papers, and a hat.

1925/1 [67]

UNTIL 7 JANUARY

Exercise book with black textured paper-covered cardboard covers, and square corners. Tan label with brown edging attached to front cover. Stapled page block. Pages of smooth-surfaced, cream, wove paper with purple lines and square corners.
Cover dimensions: 16.6 x 10.3 cm
Page dimensions: same
24 pages
no missing pages
1 blank page
19 single-sided drawings
5 double-sided drawings
Front cover label inscribed: 17; front cover label **imprinted:** - 7. Jan. 1925; [perforated, gum-adhesive, fraction of bottom stamp margin with ochre imprint on front inside cover]
Technique: Graphite.
Subject: Men, women, and children dressed in warm clothes. Children with schoolbags and child in a baby carriage. Drawings have little detail but are supplemented by various comments regarding the colors of the clothes.

1925/2 [68]

7 JANUARY – 6 MARCH

Two exercise books with blue paper covers and square corners. Last page of the first book and first page of the second book are cut and adhered. Rigid cardboard support attached to back inside cover of second sketchbook. Gray paper label with brown edging attached to front cover. Stapled page blocks. Pages of smooth-surfaced, cream, wove paper with square corners.
Cover dimensions: 16.3 x 10.1 cm
Page dimensions: same
first book 14 pages
second book 18 pages
no missing pages
no blank pages
26 single-sided drawings
6 double-sided drawings
Front cover label inscribed: 18; [stamped] 7 Jan. 25 [-] 6 Mrz. 25; **first page stamped:** 7 Jan. 25 - 6 Mrz. 26
Technique: Graphite and watercolor.
Subject: Dancing figures (possibly a cabaret or burlesque show). A seminude woman performing. Butcher's window display, woman and child walking a dog. Second book contains drawings of nurses of a religious order, numerous baby carriages, and promenading men and women. Watercolor drawings of women, among them one carrying a basket, and a nurse walking with a child. Drawing on cardboard support.

1925/3 [71]

6 MARCH – 18 APRIL

Sketchbook with gray cardboard covers, black cloth spine, and rounded corners. Sewn page block. Pages of slightly textured, cream, wove paper with square corners.
Cover dimensions: 17.7 x 12.6 cm
Page dimensions: 17.0 x 12.0 cm
19 pages
1 missing page
no blank pages
6 single-sided drawings
13 double-sided drawings
Front cover inscribed: 19; 578, 81; **inside front cover and first page stamped:** 6 - Mrz. 25 18. Apr. 25
Technique: Graphite; one prepared chalk, one ink drawing.
Subject: People in the street. Several sketches of men. Stout woman enjoying a meal, series of a street cleaner pushing a cart, and an abandoned cart at a curb.

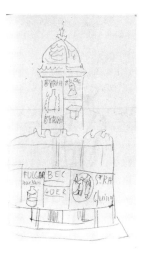

1925/4, 46 recto

1925/4 [63A]

18 MARCH – 10 JULY

Sketchbook with tan cardboard covers and rounded corners. Stapled page block. Perforated pages of smooth-surfaced, cream, wove paper with rounded corners.
Cover dimensions: 17.3 x 11.8 cm
Page dimensions: same
70 pages
no missing pages
1 blank page
61 single-sided drawings

7 double-sided drawings
Front cover inscribed: 20; [stamped] 18. Apr. 25; [manufac-
turer's logo and other information]; **inside front cover
inscribed:** 20; [stamped] 18. Apr. 25; [inscribed] 10 Juli 25;
inside front cover: [Berlin retailer's sticker]
Technique: Graphite; one watercolor.
Subject: Nurses and a doctor, numerous studies of women's
dresses, workers, people at the beach, and ships. Children
playing and a woman knitting. Advertisement column.
Address and notes on back cover.

1925/5 [63B]

10 JUNE – 13 JULY

Sketchbook with green cardboard covers, black cloth spine,
and square corners. Sewn page block. Perforated pages of
smooth-surfaced, cream, wove, paper with square corners.
Cover dimensions: 18.0 x 12.6 cm
Page dimensions: same
27 pages
11 missing pages
no blank pages
18 single-sided drawings
9 double-sided drawings
Front cover inscribed: 21 Boulogne s/mer; **inside front cover
inscribed:** 21. Boulogne s/mer Hotel aux Bains 10 Juli 1925 - 13
Juli 1925
Technique: Graphite; some prepared chalk.
Subject: People at the beach: in sun chairs, standing, sitting,
or lying down. Sketches of people in bathing suits, a man car-
rying a large camera and tripod, and people riding on a don-
key. A boy with a crutch.

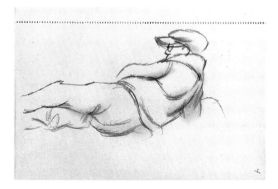

1925/5, 4 recto

1925/6, 5 recto

1925/6 [64]

13 JULY – 24 JULY

Sketchbook with green cardboard covers, black cloth spine,
and square corners. Sewn page block. Perforated pages of
smooth-surfaced, cream, wove paper with watermarks and
square corners.
Cover dimensions: 21.5 x 13.4 cm
Page dimensions: same
28 pages
10 missing pages
no blank pages
11 single-sided drawings
17 double-sided drawings
Front cover inscribed: 22 Boulogne s/mer; **inside front cover
inscribed:** Boulogne s/mer 13 Juli 1925 bis 24 Juli 1925
Technique: Graphite; some prepared chalk.
Subject: People at the beach. Playing children, promenading
men and women, a priest, and a policeman. Detailed drawings
of beach chairs and a cabana. Sketches of donkeys, bicyclists,
and a ship. Head of a woman with vampire teeth hovering
above a stout, well-dressed man

1925/7 [62]

JULY – AUGUST

Sketchbook with green cardboard covers and square corners.
Sewn page block. Perforated pages of smooth-surfaced, cream,
wove paper with square corners.
Cover dimensions: 30.7 x 24.0 cm
Page dimensions: same
33 pages
c. 13 missing pages
no blank pages
24 single-sided drawings
9 double-sided drawings
Front cover inscribed: Boulogne 1925 Ile de Brehat [*sic*]; **inside
front cover inscribed:** Boulogne 1925 Juli; Ile de Bréhat Aug 1925

1925/7, 25 recto

Technique: Graphite.
Subject: Cows and sheep. Detailed studies of rock formations
with soft shading techniques bring to mind Grosz's boulder
drawings of the 1940s and 1950s. Sketches of village houses and
drawing of a man and woman at work.

1925/8 [63]

c. JULY – AUGUST

Stapled sketchbook block, covers lost. Perforated pages of
smooth-surfaced, thin, cream, wove paper with square corners.
Page block dimensions: 27.0 x 21.0 cm
63 pages
no missing pages
no blank pages
63 single-sided drawings
no double-sided drawings
Inscribed by another hand: 1925 Boulogne—Ile de Bréhat
[description and count of drawings]
Technique: Graphite and prepared chalk; two ink drawings.
Subject: Pigs and cows, a few houses, and a standing figure.
Two drawings of interiors. See 1925/7 [62].

1925/9 [69]

14 SEPTEMBER

Sketchbook with blue cardboard covers, black cloth spine, and
square corners. Sewn page block. Perforated pages of smooth-
surfaced, cream, wove paper with square corners.
Cover dimensions: 20.6 x 12.9 cm
Page dimensions: same
49 pages
17 missing pages
no blank pages

49 single-sided drawings
no double-sided drawings
Front cover inscribed: 6. [crossed out] 25; **inside front cover inscribed:** 14 Sept. 1925; [Paris retailer's sticker]
Technique: Graphite.
Subject: French policemen, promenading men and women. A few drawings of workers and some seated figures.

1925/10 [73]

c. SEPTEMBER – OCTOBER

Sketch pad with green cardboard covers, gray-green cloth spine, and square corners. Sewn page block. Perforated pages of smooth-surfaced, cream, wove paper with square corners.
Cover dimensions: 13.5 x 9.8 cm
Page dimensions: same
29 pages
7 missing pages
1 blank page
16 single-sided drawings
12 double-sided drawings
inside front cover inscribed: 1925; [Paris retailer's stamp]
Technique: Graphite.
Subject: Combination of drawing and writing. Advertising signs, slogans, and window displays. A few portraits, drawing of a facade inscribed "Les Halles," architecture with shape of Sacre Coeur. Several pages are filled with drawings, addresses, and calculations, including front and back inside covers.

1925/11 [70]

30 SEPTEMBER – 6 OCTOBER

Sketchbook with green cardboard covers, gray-green cloth spine, and square corners. Sewn page block. Perforated pages of smooth-surfaced, cream, wove paper with square corners.
Cover dimensions: 17.7 x 12.6 cm
Page dimensions: same
36 pages
10 missing pages
no blank pages
36 singled-sided drawings
no double-sided drawings
Front cover inscribed: 27; **inside front cover inscribed:** 30 September 1925 - 6 Oktober 25 Paris; [Paris retailer's stamp]
Technique: Graphite.
Subject: With the exception of a baby carriage and a scooter the sketchbook focuses entirely on people. Several girls with braids and small children. Man with clubfoot, a person in a wheel chair, a woman's hat with an extraordinarily large bow. Woman with feather boa, sailor with piercing look.

1925/12, 19 recto

1925/12 [61]

c. SUMMER 1925 AND SUMMER 1926

Sketchbook with blue cardboard covers and square corners. Sewn page block. Perforated pages of smooth-surfaced, thin, cream, wove paper with square corners.
Cover dimensions: 32.8 x 26.4 cm
Page dimensions: same
57 pages [4 loose pages]
c. 11 missing pages
57 single-sided drawings
no double-sided drawings
Front cover inscribed: 1926 Leba [coast town on the Baltic Sea near Danzig, today Poland]; **inside front cover inscribed:** Ile de Bréhat 1925; [illeg. name]; descriptions of drawings in another hand
Technique: Graphite.
Subject: Drawings of Grosz's newborn son, Peter. Studies of fishing boats and landscapes. People, including sailors and children. Throughout the sketchbook Grosz used a very soft shading technique.

1925/13 [65]

BEGUN 6 OCTOBER 1925 AND 4 APRIL – 22 APRIL 1932

Sketchbook with green cardboard covers, gray-green cloth spine, and square corners. Sewn page block. Perforated pages of smooth-surfaced, cream, wove paper with square corners.
Cover dimensions: 17.8 x 12.7 cm
Page dimensions: same
45 pages
1 missing page
1 blank page

35 single-sided drawings
9 double-sided drawings
Front cover inscribed: 76; 76 1932; 28 Paris 1925; **inside front cover inscribed:** Paris 6 Oktober 1925 - No. 76 14 April 1932; 22 April 1932; [Paris retailer's stamp]
Technique: Graphite.
Subject: Paris 1925 and Berlin 1932. Numerous street scenes, men playing brass instruments, people walking, drawings of old women with wrinkled faces. Carefully shaded portrait of a woman reading, automobiles, advertisements, doors, seats, and drain cover. Horse-drawn cart with barrels and "Berliner Kindl" beer advertisement. Drawing and notes on inside back cover.

1926/1 [72]

UNTIL 30 JUNE

Sketchbook with gray cardboard covers, black cloth spine, and rounded corners. Sewn page block. Pages of slightly-textured, cream, laid paper with square corners.
Cover dimensions: 17.7 x 12.6 cm
Page dimensions: 17.0 x 12.0 cm
19 pages
1 missing page
no blank pages
8 single-sided drawings
11 double-sided drawings
Front cover inscribed: 31; **inside front cover inscribed:** 31; bis [stamped] 30. Juni 1926
Technique: Graphite and prepared chalk.
Subject: Primarily drawings of people. People carrying heavy loads—among others, a man carrying a barrel organ. Several notes supplement this drawing. A nude figure, part of the instrument's decoration, is especially mentioned. Individualistic portraits such as a young man with freckles and large nose. Voluptuous young woman with naïve expression holding a guitar. Cars and advertisements.

1926/2 [66]

22 DECEMBER

Sketchbook with gray cardboard covers, black cloth spine, and rounded corners. Sewn page block. Pages of slightly textured, cream, laid paper with square corners.
Cover dimensions: 12.8 x 20.4 cm
Page dimensions: 12.0 x 20.1 cm
20 pages
no missing pages
no blank pages
10 single-sided drawings
10 double-sided drawings
Front cover inscribed: 34; inside front cover stamped: 22. Dez. 26
Technique: Graphite; one crayon-and-pastel drawing.

1926/2, 5 recto

1927/1, 59 verso

62 pages
no missing pages
no blank pages
48 single-sided drawings
14 double-sided drawings
Front cover inscribed: 36 Berlin-Marseille May 1927; **imprinted:** Monachia-Block [logo and other manufacturer's information]
Technique: Graphite.
Subject: People in the streets as well as acrobats, a bartender, and a musician. Series of sketches of people in historic military uniforms. Man with pig face smoking cigar. Passport office and building facades, and advertisements. Among others, "Mareks Wanzengas" (Marek's bug gas) features a skeleton holding a scythe illustrating the product's fatal effect.

Subject: People walking. Women carrying flowers or parcels, a man with guitar, girl with braids and beret. Cigar boxes, tambourines, rapier, and shoe advertisement.

1927/1 [76]
UNTIL 12 MARCH

Sketchbook with blue cardboard covers, black cloth spine, and square corners. Sewn page block. Perforated pages of smooth-surfaced, cream, wove paper with square corners.
Cover dimensions: 16.9 x 10.6 cm
Page dimensions: same
78 pages
no missing pages
3 blank page
53 single-sided drawings
21 double-sided drawings
Front cover inscribed: 13. [crossed out] 35; **inside front cover inscribed:** bis 12 März 1927; [Paris retailer's sticker]
Technique: Graphite and crayon.
Subject: Window displays. Among others, bakery arrangements, pyramids of toilet paper next to soaps and brooms, bottles. Building entrances, cars, scenic views, and numerous drawings of people. Among others, a butcher, a nurse, and a man in uniform (possibly a chauffeur). Portraits, railway signals, a clock, and a deer's skull.

1927/2 [74]
12 MARCH – MAY

Sketch pad with tan cardboard covers and rounded corners. Stapled page block. Perforated pages of smooth-surfaced, cream, wove paper with rounded corners.
Cover dimensions: 20.7 x 14.0 cm
Page dimensions: 20.6 x 13.8 cm

1927/2, 39 verso

1927/3 [74A]
MAY

Sketchbook with green cardboard covers, gray-green cloth spine, and square corners. Sewn page block. Perforated pages of smooth-surfaced, cream, wove paper with square corners.
Cover dimensions: 18.0 x 12.7 cm
Page dimensions: same
35 pages
3 missing pages
no blank pages
27 single-sided drawings
7 double-sided drawings
Front cover inscribed: 37 Marseille May 1927; **inside front cover inscribed:** Grosz May 1927; Marseille Pointe Rouge avenue des [illeg.] Villa des [illeg.]; [Paris retailer's stamp]
Technique: Graphite.
Subject: Bullfight. Men sitting casually on steps or leaning against railings. Sailors, view into arena, bullfighters and bulls. Bar entrances, advertisements, as well as scenic sketches.

1927/4 [74B]
MAY

Exercise book with black-coated cloth covers and rounded corners. Sewn page block. Pages of smooth-surfaced, cream, wove, squared paper with rounded corners.
Cover dimensions: 16.8 x 11.0 cm
Page dimensions: same
91 pages
3 missing pages
1 blank page
65 single-sided drawings
24 double-sided drawings
inside front cover inscribed: 38 Marseille Pointe Rouge Mai 1927
Technique: Graphite and prepared chalk; one purple ink drawing.
Subject: People and advertisements, focusing on typography. Bar signs, bar and restaurant entrances. Several studies for the paint-

ing *Bar in Pointe Rouge* (1927) [see Hess p. 148]. Various segments that appear in the painting are developed in the sketchbook: entrance, bar sign, flag, table, chair, and donkey. Harbor scenes, lighthouses, and building facades. Several pages (including inside front and back covers) are filled with notes, calculations, and addresses.

1927/5

c. AUGUST

Cover missing. Sewn page block. Pages of smooth-surfaced, cream, wove paper with square corners.
Page dimensions: 33.1 x 45.0 cm
6 pages
no blank pages
6 single-sided drawings
no double-sided drawings
no inscriptions
Technique: Graphite.
Subject: According to Peter Grosz, these figure drawings originated in Marseilles. Most men wear caps and some women wear aprons. Little focus on faces and facial expressions. Several images appear on one page, but individual heads have no relation to one another.

1927/6

c. AUGUST – SEPTEMBER

Sketchbook with cloth-covered cardboard covers and rounded corners. Sewn page block. Pages of slightly textured, cream, wove paper with square corners.
Cover dimensions: 49.7 x 33.0 cm
Page dimensions: 48.6 x 31.7 cm
98 pages [plus 2 cover pages]
no missing pages
no blank pages
98 single-sided drawings
no double-sided drawings
Front cover imprinted with gold lettering: Peter 1927 Marseille Cassis; Meiner lieben Frau Weihnachten 1929; cover page inscribed: To Pete & Lil & Karin & Michael from Pop July 1956
Technique: Graphite.
Subject: Drawings of the artist's son, Peter. Peter sitting, standing, and walking, as well as portraits. Armchair, dressing table, and baby shoes. Drawings very detailed and carefully shaded.

1927/7 [75]

OCTOBER

Sketch pad with gray cardboard covers, green cloth spine, and rounded corners. Stapled page block. Perforated pages of smooth-surfaced, cream, wove paper with rounded corners.

Cover dimensions: 19.3 x 12.5 cm
Page dimensions: same
66 pages
no missing pages
3 blank pages
62 single-sided drawings
1 double-sided drawing
Front cover inscribed: 39 Cassis/Oktober 1927; **Front cover imprinted:** Carnet Croquis [with logo]; inside back cover: [additional manufacturer's information]
Technique: Graphite, prepared chalk, and crayon.
Subject: People, building facades, lighthouses, cars. Several portraits of men with large noses in profile. Man with large neck brace, bald man with beard. Stands and shop entrances with advertising signs. Notes and calculations on front and back covers.

1928/1 [91]

JANUARY

Exercise book with blue paper covers and square corners. White paper label attached to front cover. Sewn page block. Pages of smooth-surfaced, cream, wove paper with square corners.
Cover dimensions: 16.4 x 10.4 cm
Page dimensions: same
16 pages
no missing pages
1 blank page
14 single-sided drawings
1 double-sided drawing
Front cover label inscribed: 40; Jan 1928 [?]; in another hand: 1928; Nr. 91; ?(1925+) 1928 [*sic*]; **first page inscribed:** 40
Technique: Prepared chalk.
Subject: People. Two portraits of "Schweijk." (The play *The*

1928/1, 5 verso and 6 recto

Adventures of the Good Soldier Schweijk was produced by Erwin Piscator; Grosz produced drawings for the production that were used as cutouts or projected as background. Schweijk was played by Max Pallenberg.) Man on tricycle, people seen from behind. Clothing details focus on women's hats and dresses.

1928/2, 6 verso

1928/2 [77]

15 JANUARY

Sketchbook with cloth-covered light cardboard covers and square corners. Sewn page block. Pages of smooth-surfaced, cream, wove paper with square corners.
Cover dimensions: 11.9 x 19.5 cm
Page dimensions: same
52 pages
1 missing page
2 blank pages
21 single-sided drawings
29 double-sided drawings
Front cover inscribed: 41; **inside front cover inscribed:** 41; 15 Januar 1928; inside back cover: [Marseilles retailer's stamp]
Technique: Graphite and prepared chalk; one ink drawing.
Subject: People. Passersby, policemen directing traffic, and a bicyclist. A few drawings of men with sandwich boards, dummies and window displays, building facades, street cars, automobiles, and horse-drawn carts. Drawing on inside back cover.

1928/3 [89]

JULY – SEPTEMBER

Exercise book with black textured paper-covered cardboard covers, and square corners. Tan paper label with brown edging attached to front cover.
Stapled page block. Pages of smooth-surfaced, cream, wove paper with purple lines and square corners.
Cover dimensions: 16.5 x 10.3 cm
Page dimensions: same
24 pages
no missing pages
no blank pages
5 single-sided drawings
19 double-sided drawings
Front label inscribed: 43; Juli - Sept 1928; **inside front cover inscribed:** No 43 Juli - Sept 1928 Wustrow i.M. Berlin
Technique: Graphite; some prepared chalk.
Subject: Depictions of people. Blind man, beggar with box and sign on his lap. Sign reads, "Erblindet seit 1894" (blind since 1894). Window cleaner with ladder and bucket on a bicycle. Seated woman, reading. Drawing on inside back cover.

1928/4 [90]

SEPTEMBER

Exercise book with blue paper covers and square corners. Last page cut and attached to rigid cardboard support. White paper label attached to front cover. Stapled page block. Pages of smooth-surfaced, tan, wove paper with blue lines and square corners.
Cover dimensions: 16.2 x 10.1 cm
Page dimensions: same
16 pages
no missing pages
no blank pages
8 single-sided drawings
6 double-sided drawings
Front cover label inscribed: No 44 September 1928; by another hand: Nr 90; **first page inscribed:** No. 44 Sept 1928
Technique: Graphite.
Subject: Drawings related to Grosz's trip to London in September 1928. People, window displays, and advertisements. British policemen, beggar playing a mouth organ, butcher's window display, building facade. Last three pages contain addresses, notes, and exchange rates. Notes on cardboard support.

1928/5 [86]

4 OCTOBER – 25 OCTOBER

Notebook with purple cardboard covers and rounded corners. Stapled page block with purple-colored sides. Pages of

1928/5, 12 verso

smooth-surfaced, thin, cream, wove paper with rounded corners.
Cover dimensions: 16.7 x 9.8 cm
Page dimensions: same
39 pages
1 missing page
no blank pages
14 single-sided drawings
25 double-sided drawings
Front cover inscribed: No 45; manufacturer's imprint: Merkbuch; **first page inscribed:** No 45 4 Oktober 1928 [-] 25 Oktober 1928
Technique: Graphite; one blue ink drawing.
Subject: Men and women. Focus on clothing details, not on faces. Women from behind, nuns, and a policeman. Male standing behind the carcass of a butchered pig, hanging with its hind legs tied to a support. Carts, advertising signs, and a few window displays. Last page has various notes and an address.

1928/6 [87]

25 OCTOBER – 31 OCTOBER

Notebook with purple cardboard covers and rounded corners. Rough-surfaced front cover. Stapled page block with purple-colored sides. Pages of smooth-surfaced, thin, cream, wove paper with rounded corners.
Cover dimensions: 16.7 x 9.8 cm

Page dimensions: same
40 pages
no missing pages
no blank pages
14 single-sided drawings
26 double-sided drawings
Front cover inscribed: No 46 [possibly by another hand]; **first page inscribed:** No 46 25 Oktober 1928 [-] 31 Okt 1928
Technique: Graphite; ink drawings.
Subject: People, automobiles, horse-drawn carts, and bicycles. Series of small ink drawings featuring window displays framed by advertisements. Among others, exotic fruit, furniture, and hairdresser's window display.

1928/7 [88]

31 OCTOBER – 15 NOVEMBER

Notebook with purple cardboard covers and rounded corners. Stapled page block with purple-colored sides. Pages of smooth-surfaced, thin, cream, wove paper with rounded corners.
Cover dimensions: 16.7 x 9.8 cm
Page dimensions: same
39 pages
1 missing page
no blank pages
8 single-sided drawings
30 double-sided drawings
Front cover inscribed: 47; manufacturer's imprint: Merkbuch; **first page inscribed:** 31 Oktober 28 - 15 Nov 28
Technique: Graphite.
Subject: People, street signs, automobiles, items of daily life, and advertising logos. Among others, "Shell" (gas), "Odol" (mouthwash) and "Erdal" (shoe polish). Carts, some pushed by people, and larger ones, which might be pulled by a horse. Profile of a woman in checked dress and thick fur collar. Man walking along the street with a flowerpot and briefcase, uniformed men, nurses, and bicyclist.

1928/8 [85]

16 NOVEMBER 1928 – 2 MARCH 1929

Notebook with purple cardboard covers and rounded corners. Stapled page block with purple-colored sides. Pages of smooth-surfaced, thin, cream, wove paper with rounded corners.
Cover dimensions: 16.7 x 9.8 cm
Page dimensions: same
40 pages
no missing pages
no blank pages
1 single-sided drawing
39 double-sided drawings

Front cover inscribed: 48; manufacturer's imprint: Merkbuch; **first page inscribed:** 16 November 1928 [-] 2 März 1929
Technique: Graphite.
Subject: Window displays, advertising logos, including "Shell" and a pharmacy sign. People from behind, women in aprons, studies of men in uniform, including a porter and a policeman with badge. Cars and details of a mechanical device. Elegantly dressed women, woman with shopping bags, some portraits, and boy scout with flag and sleeping bag.

1929/1 [78]

2 MARCH – 27 MARCH

Notebook with purple cardboard covers and rounded corners. Stapled page block with purple-colored sides. Pages of smooth-surfaced, cream, wove paper with square corners.
Cover dimensions: 16.9 x 10.0 cm
Page dimensions: same
39 pages
1 missing page
no blank pages
13 single-sided drawings
26 double-sided drawings
Front cover inscribed: 49; manufacturer's imprint: Merkbuch; **first page inscribed:** No 49; 2 März 1929 - 27 März
Technique: Graphite.
Subject: Window displays, people, cars, and advertising slogans. Butcher's window with hams, sausages, and decapitated pig. Other displays feature clothes, shoes, bottles, and cakes.

1929/2 [80]

27 MARCH – 19 APRIL

Notebook with purple cardboard covers and rounded corners. Back cover was cut and previously attached to rigid cardboard support, which is now missing. Stapled page block with purple-colored sides. Pages of smooth-surfaced, cream, wove paper with rounded corners.
Cover dimensions: 17.0 x 10.1 cm
Page dimensions: same
40 pages
no missing pages
no blank pages
14 single-sided drawings
26 double-sided drawings
Front cover inscribed: 50 1929 März; **Front cover imprinted:** Merkbuch; **first page inscribed:** 27 März 29 [-] 19 April 29
Technique: Graphite.
Subject: Window displays and advertisements for food, shoes, perfumes, soaps, and hats, among other things. Magician's equipment: cards, candlestick, human skull, magic rings. One slogan reads, "Zaubern Sie und Sie sind sofort der Liebling

jeder Gesellschaft" (Be a magician and you are immediately the favorite in any company). Sketches of women are usually only recognizable through clothes, since facial features are hardly ever defined.

1929/3 [82]

19 APRIL – 6 MAY

Notebook with purple cardboard covers and rounded corners. Stapled page block with purple-colored sides. Pages of smooth-surfaced, cream, wove paper with rounded corners.
Cover dimensions: 17.0 x 10.0 cm
Page dimensions: same
34 pages
no missing pages
no blank pages
11 single-sided drawings
23 double-sided drawings
Front cover inscribed: 51 April 29; manufacturer's imprint: Merkbuch; **first page inscribed:** 19 April 29 - 6 Mai 29
Technique: Graphite.
Subject: People, advertisements, and window displays. Signs for Mareck's bug gas feature skeleton with scythe. Ad for women's shampoo with a nude woman washing her hair at a fountain. Female figures in underwear, cleaning woman, elderly people, a police uniform (holster depicted in detail), man in manhole, and people carrying heavy loads. Hebrew sign for kosher meat.

1929/3, 1 recto

1929/4, 22 recto

1929/4 [84]

6 MAY – 10 MAY

Notebook with purple cardboard covers and rounded corners. Stapled page block with purple-colored sides. Pages of smooth-surfaced, cream, wove pages with rounded corners.
Cover dimensions: 16.7 x 9.8 cm
Page dimensions: same
40 pages
no missing pages
no blank pages
18 single-sided drawings
22 double-sided drawings
Front cover inscribed: 52 Mai 29; manufacturer's imprint: Merkbuch; **first page inscribed:** 6.5.29. - 10.5.29
Technique: Graphite.
Subject: People, clothing, and accessories dominate. Focus on patterns of coats, dresses, etc., otherwise only figures' outlines. Man working at an open manhole; worker's tools are carefully drawn and shaded. Ice-cream cart and a few window displays.

1929/5 [81]

10 MAY – 5 JULY

Notebook with purple cardboard covers and rounded corners. Stapled page block with purple-colored sides. Pages of smooth-surfaced, cream, wove paper with rounded corners.
Cover dimensions: 16.8 x 9.7 cm

Page dimensions: same
40 pages
no missing pages
no blank pages
23 single-sided drawings
17 double-sided drawings
Front cover inscribed: 53 Mai 1929; manufacturer's imprint: Merkbuch; first page inscribed: 10.5.29 - 5.7.29
Technique: Graphite; one prepared chalk drawing.
Subject: Men and women, faces in profile. Violin player, man pulling a cart, and person with tennis racket. Advertisements, including dummy with restaurant menu, hairdresser's advertisements for coloring hair. Double-sided drawings of automobiles traveling down a street.

1929/6 [79]
5 July – 26 July

Notebook with purple cardboard covers and rounded corners. Stapled page block with purple-colored sides. Pages of smooth-surfaced, cream, wove paper with rounded corners.
Cover dimensions: 16.8 x 9.8 cm
Page dimensions: same
40 pages
no missing pages
3 blank pages
15 single-sided drawings
21 double-sided drawings
Front cover inscribed: 54; manufacturer's imprint: Merkbuch; first page inscribed: 5 Juli 29 - 26 Juli 29
Technique: Graphite; one watercolor; one ink.
Subject: Men working with hammer and trowel in bent positions, drawings of wooden structure, shape of a tripod. Watercolor of a woman wearing a blue dress. Homily in gothic lettering reads, "Häusliche Zufriedenheit ist himmlische Glückseligkeit" (domestic satisfaction is divine rapture). The last pages have titles and sketches that could relate to the book *Über alles die Liebe* (Berlin, 1930).

1929/7 [83]
September – 4 November

Exercise book with green-coated, cloth-covered cardboard covers, and rounded corners. Coating partially disintegrated, white paper attached to covers. Stapled page block with blue-colored sides. Pages of smooth-surfaced, cream, wove paper with purple lines and rounded corners.
Cover dimensions: 17.0 x 10.8 cm
Page dimensions: same
48 pages
no missing pages
no blank pages
20 single-sided drawings

26 double-sided drawings
Inside front cover inscribed: No 55 September 1929 - 4 Nov 1929; 55; inside front cover: [Carolus logo and Berlin retailer's stamp]
Technique: Graphite and prepared chalk; one colored-crayon inscription.
Subject: Men and women in the streets. Promenading women, men carrying boxes, street worker handling a pneumatic drill, woman in apron, and policeman. Two waiters, man behind steering wheel, and horse-drawn cart. Advertisements; back inside cover has various notes.

1929/8 [98]
8 December 1929 – 10 January 1930

Sketchbook with blue covers and square corners. Rigid cardboard riveted between page block and back cover. Riveted page block. Pages of smooth-surfaced, thin, cream, wove paper with square corners.
Cover dimensions: 16.1 x 11.0 cm
Page dimensions: same
60 pages
no missing pages
5 blank pages
55 single-sided drawings
no double-sided drawings
Front cover inscribed: 57; Front cover imprinted: Georess [and other manufacturer's information and logo]; inside front cover inscribed: 8 Dezember 1929 bis [no date given]; first page inscribed: 1929 / 8 Dezember - 10 Jan 1930
Technique: Graphite.
Subject: Men, women, mannequins, rough sketches of horses and carts. Street cleaners, businessmen, and well-dressed women in lavish fur coats. A few window displays feature meat, fish, sausages, bottles, and sweets. Automobiles, shop signs, and architectural details.

1930/1 [95]
10 January – 18 January

Sketchbook with brown paper covers and square corners [worn]. Back cover cut and attached to rigid cardboard support. Stapled page block. Perforated pages of smooth-surfaced, thin, cream, wove paper with square corners.
Cover dimensions: 16.8 x 12.8 cm
Page dimensions: 16.8 x 11.8 cm
59 pages
1 missing page [?]
7 blank pages
52 single-sided drawings
no double-sided drawings
Front cover inscribed: 58. Jan 1930; [stamped and crossed out:

28. März 1923]; first page inscribed: 10 Jan 1930 - 18. Jan 30; [stamped and crossed out: 28. März 1923]
Technique: Graphite.
Subject: Working-class people. Window cleaner, chimney sweep, and several people carrying heavy loads. Man carrying a toilet basin on his shoulder. Shop entrances and window displays—among them, exotic fruit such as pineapples and bananas. Automobiles, various carts, horse, and advertisements. Floor plan of two rooms.

1930/2 [92]
18 January – 22 March

Notebook with black-coated cardboard covers and rounded corners. Stapled page block with red-colored sides. Pages of smooth-surfaced, cream, wove paper with rounded corners.
Cover dimensions: 20.0 x 12.4 cm
Page dimensions: same
69 pages
1 missing page
no blank pages
62 single-sided drawings
7 double-sided drawings
Front cover inscribed: 59; inside front cover inscribed: No 59; 18 Januar 1930 - 22 März 1930; [Ashelm manufacturer's logo and imprint]
Technique: Graphite.
Subject: Elderly women, men with briefcases, bakery apprentices, a window cleaner, and several women shown from behind. Several elderly women dressed in coat and head scarf. Carefully shaded drawing of a woman with coat, hat, and handbag. Two advertisements for "Coffin" magazine ("Sarg Magazin Nord West"). One of the sketches renders letters and coffins in great detail. Dentist's advertisement attached to inside back cover.

1930/3 [93]
Begun 22 March

Notebook with black-coated cardboard covers and rounded corners. Stapled page block with red-colored sides. Pages of smooth-surfaced, cream, wove paper with rounded corners.
Cover dimensions: 20.0 x 12.3 cm
Page dimensions: same
66 pages
4 missing pages
12 blank pages
43 single-sided drawings
11 double-sided drawings
Front cover inscribed: 60; inside front cover inscribed: No 60 22 März 1930-; [Ashelm manufacturer's logo and imprint]
Technique: Graphite.

Subject: Drawings of a butcher shop. Single pieces of meat surrounded by a thick layer of fat and skin, animal torsos, and legs. Man carrying carcass over his shoulder, butcher's window display with two rows of sausages and a large piece of meat above a withering plant. Four pig claws juxtaposed with a human foot and a hand. Men and women, window displays, advertisement signs and ornaments. Ice-cream ad, sign for "Hassan Baba," with pentagrams and half moons.

1930/4 [94]

12 MAY

Notebook with black-coated cardboard covers and rounded corners. Stapled page block with red-colored sides. Pages of smooth-surfaced, cream, wove paper with blue lines and rounded corners.
Cover dimensions: 19.9 x 12.6 cm
Page dimensions: same
46 pages
no missing pages
1 blank page
32 single-sided drawings
13 double-sided drawings
Front cover inscribed: 61; **inside front cover inscribed:** No 61; 12 Mai 1930; 11 x Training; 6 x
Technique: Graphite.
Subject: Women, some in elegant dresses. The sketches are often accompanied by detailed notes on colors of clothes. Children in school uniform, cab driver, street vendor, and a nurse pushing a wheelchair. Street cleaners at work, window cleaner, street workers' tools, the brick pattern, basket, and a few drawings of flowers. Window displays and advertisements. Inside back cover has address and Ashelm manufacturer's logo and imprint.

1930/5 [100]

JULY

Exercise book with blue paper covers and square corners. Rigid cardboard attached to inside back cover. White paper label attached to front cover. Stapled page block. Pages of smooth-surfaced, cream, wove paper with square corners.
Cover dimensions: 16.4 x 10.0 cm
Page dimensions: same
31 pages
1 missing page
no blank pages
12 single-sided drawings
19 double-sided drawings
Front cover label inscribed: 62a; July 1930; **first page inscribed:** 62a; July 1930
Technique: Graphite.

Subject: Men and women, advertising signs, window displays, and shop entrances. Ads promoting shoe dying, tights, furs, and food. Carts transformed into market stands, detail of a woven basket. Woman on a bicycle, man wearing suit and top hat carrying a large bunch of flowers.

1930/6 [97]

17 OCTOBER – 21 NOVEMBER

Notebook with green-coated, cloth-covered paper covers and rounded corners. [Green coating has disintegrated and a sheet of white paper has been adhered to the cover.] Stapled page block with blue-colored sides. Pages of smooth-surfaced, cream, wove squared paper with rounded corners.
Cover dimensions: 18.0 x 11.5 cm
Page dimensions: same
48 pages
no missing pages
1 blank page
39 single-sided drawings
8 double-sided drawings
Inside front cover inscribed: No 63; 17 Oktober 1930 21 Nov 1930; [Ashelm manufacturer's logo and imprint]
Technique: Graphite.
Subject: Women in coats and hats, as well as fox-fur collars. Usually, women are depicted from behind with fox heads dangling over their shoulders. Woman wearing a long veil, street cleaners, bicyclist. Window displays and shop entrances.

1930/6, 47 verso

1930/7, 15 recto

1930/7 [96]

21 NOVEMBER – 27 DECEMBER

Sketch pad with soft cardboard front cover, rigid cardboard back cover and square corners. Stapled page block. Perforated pages of smooth-surfaced, thin, cream, wove paper with square corners.
Cover dimensions: 16.1 x 12.3 cm
Page dimensions: 15.0 x 12.3 cm
60 pages
no missing pages
4 blank pages
56 single-sided drawings
no double-sided drawings
Front cover inscribed: 64; 21 Nov 1930; 27 Dez 1930; **first page inscribed:** 64; 21 Nov 1930; back cover: [Berlin retailer's sticker]
Technique: Graphite.
Subject: People. Man selling Christmas trees. Isolated body parts such as a hand holding some pine branches, a female leg and boot, and rough outline of a female figure carrying a large basket. Slaughtered duck or goose (Grosz remarks that the animal's throat is still bloody). Several window displays and man playing drums. Calculations on back cover.

1930/8 [99]

27 DECEMBER 1930 – 10 MARCH 1931

Sketch pad with orange cardboard covers and rounded corners. Rigid cardboard support between stapled page block and back cover. Perforated pages of smooth-surfaced, cream, wove paper with rounded corners.
Cover dimensions: 16.0 x 11.0 cm
Page dimensions: same
49 pages

no missing pages
no blank pages
46 single-sided drawings
3 double-sided drawings
Front page inscribed: 63 [crossed out] 64; manufacturer's imprint: Monachia-Block [logo and other manufacturer's information also appear]; **inside front cover inscribed:** No 64a; 27 Dezember 1930 - 10 März 1931; [Berlin retailer's sticker]
Technique: Graphite; occasional use of watercolor, ink, and crayon.
Subject: Men and women, window displays with chicken, sausages, bottles, and cookies under glass covers. Shoe equipment, display of a fuel-supply store. Two signs inside the window advertise room for rent. Two watercolors of women, a few carts, items of daily life, architectural detail, two bathroom interiors, and advertisements. Address on the cardboard support.

1931/1 [104]

10 MARCH – 25 APRIL

Notebook with green-coated paper covers and rounded corners. [Green coating has disintegrated and a sheet of white paper has been adhered to the cover.] Rigid cardboard support attached to back cover. Stapled page block with blue-colored sides. Pages of smooth-surfaced, cream, wove, squared paper with rounded corners.
Cover dimensions: 18.0 x 11.0 cm
Page dimensions: same
48 pages
no missing pages
no blank pages
47 single-sided drawings
1 double-sided drawing
Front inside cover inscribed: No 65; 10 März 1931 - 25 April 31; [Ashelm manufacturer's imprint and logo]
Technique: Graphite and crayon.
Subject: People, advertisements, mannequin busts, items of daily life. "Berliner Kindl" beer sign, drugstore, and hairdresser signs. Blind man selling goods on a vendor's tray, woman dusting windows and airing beds, woman wearing apron. Picket fences, fan, building facades, horse-pulled carts, and automobile.

1931/2 [105]

25 APRIL – 16 AUGUST

Sketchbook with black, cloth-coated paper covers and rounded corners. Stapled page block with blue-colored sides. Pages of smooth-surfaced, cream, wove paper with blue lines and rounded corners.
Cover dimensions: 16.6 x 10.1 cm
Page dimensions: same

1931/2, 1 recto

48 pages
no missing pages
no blank pages
8 single-sided drawings
40 double-sided drawings
Front cover inscribed: P; 66; **inside front cover inscribed:** No 66 25 April 1931 - 16 August 31 Prerow
Technique: Graphite and prepared chalk; crayon is used once.
Subject: Summer holiday in Prerow (village on a peninsula in the Baltic Sea). Village houses, shop signs, and people. Juxtaposition of rural village life and tourism. Signs for "Night Club," "Central Hotel," and images of pigs in a barn, farmer with horse-pulled cart. Bicyclists, well-dressed women, and village people carrying yokes with baskets.

1931/3 [109]

13 JUNE

Exercise pad with light brown heavy paper covers and rounded corners. Riveted page block. Pages of smooth-surfaced, cream, wove, squared paper with rounded corners.
Cover dimensions: 14.7 x 8.2 cm
Page dimensions: 13.2 x 8.2 cm
48 pages
no missing pages
6 blank pages
25 single-sided drawings
15 double-sided drawings
Manufacturer's imprint and logo on front cover: Georess Block 4B; **inside front cover inscribed:** 13 Juni 31

Technique: Graphite and crayon.
Subject: Rough sketches of men and women. Drawings of women focus on clothing. Little detail, some sketches supplemented with color notes and other remarks. Man driving a car. Advertisements, among others an undertaker's ad reading, "Eigene Sarg Fabrikation, Erd- und Feurbestattungen in jeder Preislage" (in-house coffin manufacturing, burials and cremations at prices to suit every pocket). Ice-cream signs and "Odol" mouthwash ad. First and last pages contain addresses and notes.

1931/4 [108]

SUMMER

Notebook with light brown cardboard covers and rounded corners. Stapled page block. Pages of smooth-surfaced, cream, wove squared paper with rounded corners.
Cover dimensions: 15.8 x 9.7 cm
Page dimensions: same
50 pages
no blank pages
no missing pages
20 single-sided drawings
30 double-sided drawings
Front cover inscribed: P; 67; 31; No 67; **manufacturer's imprint:** Merkbuch; **inside front cover inscribed:** Prerow 31
Technique: Graphite and crayon; one watercolor.
Subject: Promenading people. Photographer and model, two men sawing wood, man pulling cart loaded with two wicker beach chairs. Drawing of woman with large breasts is complemented on the following page by an adolescent boy with longing expression, clasping his hands in front of his genitals. Wicker beach chairs with sun shades, flowers, boats, village houses, and a few shop signs.

1931/5 [100A]

16 AUGUST

Notebook with orange cardboard covers and rounded corners. Stapled page block. Pages of smooth-surfaced, cream, wove, squared paper with rounded corners.
Cover dimensions: 15.8 x 9.7 cm
Page dimensions: same
50 pages
no missing pages
1 blank page
23 single-sided drawings
26 double-sided drawings
Front cover inscribed: 68; Prerow 31; [manufacturer's imprint: Merkbuch]; Prerow; 31; No 68; **first page inscribed:** Haus Mansfeld-Balden Prerow 16 August 31
Technique: Graphite and crayon.
Subject: People at the beach, farmers, wicker beach chairs

with sun shades, houses, flowers. People reading, sleeping, or walking along the beach, two voyeuristic images of women changing clothes. Clothes on a line, fishing net, woman carrying two buckets on a yoke. Marching girl with braids holding a German flag "black red white."

1931/6 [107]

SUMMER

Exercise book with blue paper covers and square corners. White paper label attached to front cover. Stapled page block. Pages of smooth-surfaced, cream, wove paper with blue lines and square corners.
Cover dimensions: 16.4 x 10.1 cm
Page dimensions: same
16 pages
no missing pages
no blank pages
1 single-sided drawing
14 double-sided drawings
Front cover and label inscribed: No 69; Prerow 31; P 31; 69; 17 [crossed out]
Technique: Graphite.
Subject: Promenading people, some equipped with walking sticks and umbrellas. A woman hoeing, village houses, flowers, two advertisements for margarine ("Rama"), and chewing tobacco. Butchered animal.

1931/7 [103]

SUMMER

Sketchbook with gray cardboard covers, black cloth spine, and

1931/7, 14 verso

rounded corners. Sewn page block. Pages of slightly textured, cream, wove paper with square corners.
Cover dimensions: 17.7 x 12.8 cm
Page dimensions: 17.0 x 12.0 cm
20 pages
no missing pages
2 blank pages
4 single-sided drawings
14 double-sided drawings
Front cover inscribed: Prerow 31; P; No 70
Technique: Graphite; a few watercolor drawings.
Subject: Promenading people, hay making. Women with rakes, men with horses and carts, haystack. People with towels, watercolor of man in dressing gown carrying a toy crocodile under his arm. Some people have towels. Elderly man with cane and checked jacket, stout man next to skinny girl with braids. Some village houses and a few advertising signs.

1931/8, 15 recto

1931/8 [103A]

SUMMER

Sketchbook with gray cardboard covers, black cloth spine, and rounded corners. Sewn page block. Pages of slightly textured, cream, wove paper with square corners.
Cover dimensions: 17.7 x 12.8 cm
Page dimensions: 17.0 x 12.0 cm
20 pages
no missing pages
no blank pages
2 single-sided drawings
18 double-sided drawings
Front cover inscribed: Prerow 31; P; No 71

Technique: Graphite and prepared chalk; two watercolor drawings.
Subject: Country fair and people at the beach. Merry-go-round, several animals such as horses and swans drawn in detail. Men in suits and ties carrying guns or shooting. Guns in racks, some muzzles decorated with flowers. Men and women in swimsuits or dressing gowns; woman carrying bucket, ball, and towel.

1931/9 [102]

22 SEPTEMBER – 26 OCTOBER

Notebook with black-coated paper covers and rounded corners. Stapled page block with red-colored sides. Pages of smooth-surfaced, cream, wove paper with blue lines and rounded corners.
Cover dimensions: 18.8 x 11 cm
Page dimensions: same
48 pages
no missing pages
1 blank page
27 single-sided drawings
20 double-sided drawings
Front cover inscribed: 72; 31; **inside front cover inscribed:** No 72; 22 Sept 31 - 26 Oktober 31; [Ashelm manufacturer's imprint and logo]
Technique: Graphite; occasionally prepared chalk.
Subject: Advertisements, window displays, and people. Chimney sweep, window cleaner, street cleaners, elegantly

1931/9, 12 recto

dressed women, and working-class women. Depiction of a man in suit, hat, and tie wearing small glasses and carrying a briefcase. Some of the signs overlap: Agfa film logo placed next to pesticide advertisement.

1931/10, 30 recto

1931/10 [101]

26 OCTOBER – 13 NOVEMBER

Notebook with cloth-covered [cloth now lost] paper covers and rounded corners. Stapled page block with blue-colored sides. Pages of smooth-surfaced, cream, wove paper with blue lines and rounded corners.

Cover dimensions: 19.1 x 12.0 cm
Page dimensions: same
48 pages
no missing pages
no blank pages
2 single-sided drawings
46 double-sided drawings
Inside front cover inscribed: No 73; 26 Oktober 1931 - 13 Nov 1931; [Carolus manufacturer's logo]
Technique: Graphite and prepared chalk.
Subject: Advertisements, window displays, and shop entrances. Ads include beer, wine, drugstore items, office services, and clothes. Cigarette sign depicts a masked woman smoking. Sketches of blind men and cripples. Blind man with badge selling shoelaces on a vendor's tray. Drawings of people in the streets, carts, and bar interior.

1931/11, 19 recto

1931/11 [106]

20 NOVEMBER – 18 DECEMBER

Exercise book with blue paper covers and square corners. White paper label attached to front cover. Sewn page block. Pages of smooth-surfaced, cream, wove paper with blue lines and square corners.

Cover dimensions: 16.4 x 10.3 cm
Page dimensions: same
32 pages
no missing pages
no blank pages
16 single-sided drawings
16 double-sided drawings
Front cover and label inscribed: 74 [was corrected from 72 to 74]; 20 Nov - 18 Dez 31; 74; 1931; 74; **first page inscribed:** 20 Nov 31
Technique: Graphite.
Subject: Elegantly dressed women in fur coats, signs, window displays. Some Christmas decorations and window display promoting "Prämierte Weihnachtsgeschichten" (award-winning Christmas stories). Advertisements promote delicatessen, drugstore items (among others, "Creme Musson"), and tailor services. Two drawings of women walking dogs, women sweeping the ground, children on sleighs, one street cleaner. Several addresses on last page.

1931/12 [119]

DECEMBER 1931 AND
2 FEBRUARY – 14 APRIL 1932

Notebook with black, cloth-covered paper covers and rounded corners. Stapled page block with blue-colored sides. Pages of smooth-surfaced, cream, wove paper with blue lines and rounded corners.

Cover dimensions: 16.7 x 10.0 cm
Page dimensions: same
96 pages
no missing pages
3 blank pages
85 single-sided drawings
8 double-sided drawings
Front cover inscribed: 75; **inside front cover inscribed:** 75; 2 Februar 1932 - 14 April 1932; [an older number and date reading 73 18 Dezember 1931, has been crossed out]; **first page inscribed:** 2 Febru. 1932 - 14 April 1932
Technique: Graphite; occasionally watercolor; one colored ink drawing.
Subject: Women, some stout and elderly. Advertisements such as "Sanella" margarine and a "Berliner Kindl" beer sign. Automobiles and carts. One cart is filled with barrels; another one, piled with household goods, is pulled by two men. Christmas decorations, pine-tree twigs and parcels, Christmas bakery items. (The Christmas images suggest that the sketchbook was started in December 1931 and was continued later; see inscription.) Notes on inside front cover.

1932/1 [125]

22 APRIL – C. JUNE

Sketchbook with light gray cardboard covers, black cloth spine, and rounded corners. Sewn page block. Pages of slightly textured, cream, laid paper with square corners.

Cover dimensions: 17.7 x 12.7 cm
Page dimensions: 17.0 x 12.2 cm
20 pages
no missing pages
no blank pages
8 single-sided drawings
11 double-sided drawings
Front cover inscribed: 1 New York 1932 [Grosz arrived in New York in early June]; 77; **inside front cover inscribed:** 22 April 1932-
Technique: Graphite; prepared chalk; one watercolor.
Subject: Drawings of Berlin and New York. Interior of a "police department." A policeman in German uniform, office desks. Men in marine uniforms (perhaps drawn on the boat trip from Germany to the United States). The last pages feature New York City imagery such as black street vendor selling ice cream, a salesman and client "at Macy's." Two portraits, one of which depicts an elderly woman with hat, glasses, purse, and umbrella.

1932/2 [118]

12 JUNE

Notebook with black, cloth-coated paper covers and rounded corners. Rigid cardboard support attached to inside back cover. Stapled page block with red-colored sides. Pages of smooth-surfaced, cream, wove squared paper with rounded corners.

Cover dimensions: 13.5 x 8.0 cm
Page dimensions: same
40 pages
no missing pages
no blank pages
3 single-sided drawings
37 double-sided drawings
Inside front cover inscribed: 1; New York; 12 Juni 32
Technique: Graphite.
Subject: People, advertisements, items of daily life such as fire escapes, windows, and fire hydrant. Mailman, waiter, a "Pullman porter," numerous young and elegantly dressed women. People sitting in lounge chairs reading newspapers, woman reading a book. Man watching a woman in front of him. Voyeuristic elements can be found in other depictions of women. Male portrait, drawing of an elderly woman. Notes and addresses on inside front cover and cardboard support.

1932/3 [120]

22 JUNE – 26 JUNE

Notebook with black, cloth-coated paper covers and rounded corners. Stapled page block with blue sides. Pages of smooth-surfaced, cream, wove paper with blue lines and rounded corners.

Cover dimensions: 16.9 x 10 cm
Page dimensions: same
57 pages
1 missing page
no blank pages
18 single-sided drawings
39 double-sided drawings
Inside front cover inscribed: Grosz 57th Street; New York 22 June 32 - 26 June 32; Great Northern; 2
Technique: Graphite; occasionally watercolor.
Subject: Sports events. Baseball players in various poses. Spectators in stands surrounded by large-scale advertisements. Boxing match, stock exchange or betting office. Rooftop with chimneys and skylights, house facade with fire escape. People in the streets, porter standing at a Madison Hotel entrance. Detailed study of a policeman with police cap, badge, and baton. Advertisements and window displays, several notes, and addresses. Addresses and telephone numbers on inside front cover and first and last pages.

1932/3, 54 verso

1932/4

26 JUNE

Notebook with black cardboard covers and rounded corners. Stapled page block. Pages of smooth-surfaced, cream, wove paper with blue lines and rounded corners.

Cover dimensions: 16.9 x 10.2 cm
Page dimensions: 16.9 x 9.9 cm
61 pages
no missing pages
one blank page
ca. 51 single-sided drawings
9 double-sided drawings
Inside front cover inscribed: New York 26 june 32.; Grosz; Great Northern 118 West 57 street. With a dedication by Eva Grosz: To my old friend Arthur Nortman in memory of Grosz; Eva Grosz May 30th, 1960
Technique: Graphite, ink and watercolor.
Subject: People in the street, and advertisements. Among others, elegantly dressed women, shoeshine boys, street musicians, and a baseball player. Few burlesque show scenes, a Fifth Avenue double-decker bus, and drawings of a military parade. Several restaurant or café counters. Street scene with Hotel Tudor entrance and building facades. Cf. facsimile edition as George Grosz, *New York*, eds. Walter Huder and Karl Riha (Siegen, 1985).
(Information kindly provided by Gudrun Schmidt, Akademie der Künste, Berlin)

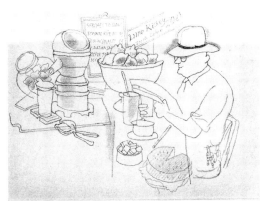

1932/5, 1 recto

1932/5 [126]

28 JUNE

Sketchbook with light gray cardboard covers, black cloth spine, and rounded corners. Sewn page block. Pages of slightly textured, cream, laid paper with watermark and square corners.

Cover dimensions: 17.7 x 12.7 cm
Page dimensions: 17.0 x 12.0 cm
22 pages
no missing pages
no blank pages
21 single-sided drawings
1 double-sided drawing
Front cover inscribed: 2 New York 1932; **inside front cover inscribed:** New York 28. June 32; Grosz Great Northern Hotel 57 Room 1128
Technique: Graphite; occasionally watercolor.
Subject: Restaurant interiors. Still-life arrangement of table, chairs, and coat racks. Waitress attending tables, Asian man sitting at table. Detailed drawing of man sitting at a counter reading a newspaper. Benches on a boat, sign for lifesaver. Two women talking to each other, women selling flowers, unemployed man with stubble beard selling goods on a vendor's tray. Watercolor of brick stone facade with open window and parking garage advertisements. Some of these have been reproduced in Flavell, pp. 76, 110-111.

1932/6 [127]

6 JULY

Sketchbook with light gray cardboard covers, black cloth spine, and rounded corners. Sewn page block. Pages of slightly textured, cream, laid paper with watermarks and square corners.
Cover dimensions: 17.7 x 12.7 cm
Page dimensions: 17.0 x 12.0 cm

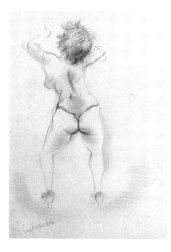

1932/6, 7 recto

18 pages
no missing pages
1 blank page
11 single-sided drawings
6 double-sided drawings
Front cover inscribed: New York 1932 3; **inside front cover inscribed:** New York 6. July 32 Grosz; Great Northern Hotel 57th Street. [The address of a Dr. Wolff is also included.]
Technique: Graphite; one watercolor; one prepared chalk drawing.
Subject: Burlesque show, automobiles, restaurant tables, advertisements. Women performing in the nude, or seminude. If male counterparts appear, they are fully dressed. Mailbox, details of interior, two drawings of elegantly dressed elderly women.

1932/7 [128]

6 JULY

Sketchbook with light gray cardboard covers, black cloth spine, and rounded corners. Sewn page block. Pages of slightly textured, cream, laid paper with watermark and square corners.
Cover dimensions: 17.7 x 12.6 cm
Page dimensions: 17.0 x 11.9 cm
20 pages
no missing pages
no blank pages
14 single-sided drawings
6 double-sided drawings
Front cover inscribed: New York 1932 4 [number 66 crossed

1932/7, 16 verso

out]; **inside front cover inscribed:** Grosz New York Great Northern Hotel 57the [*sic*] Street 118 West 6 July 1932
Technique: Graphite; occasional use of prepared chalk and watercolor.
Subject: Fashionable women in the streets. Drawings emphasize large breasts and buttocks underneath tight-fitting clothes. Automobiles, Fifth Avenue bus, and horse-pulled car inscribed "New York Laundery" [*sic*]. Watercolors of uniformed porter and woman in tight-fitting dress, building facade with fire escape, and black worker. Several heads of women and a male portrait.

1932/8 [129]

7 JULY

Sketchbook with light gray cardboard covers, black cloth spine, and rounded corners. Sewn page block. Pages of slightly textured, cream, laid paper with square corners.
Cover dimensions: 17.7 x 12.8 cm
Page dimensions: 17.0 x 12.0 cm
16 pages
no missing pages
no blank pages
9 single-sided drawings
7 double-sided drawings
Front cover inscribed: 5 New York; **inside front cover inscribed:** Grosz New York; 7 July 1932; Great Northern Hotel 57th Street; Room 1128
Technique: Graphite and watercolor.
Subject: Fashionable young women talking on the telephone, eating ice cream, etc. Watercolor of a young woman in blue, low-cut, tight-fitting dress. Watercolor titled "Ital. Ice Cream Männer Union Square" (Italian ice cream men Union Square)

shows an older man and a young man carrying a box. One window display. (Ice cream drawings illustrated in Flavell, p. 86-87.)

1932/9 [130]

9 JULY

Sketchbook with light gray cardboard covers, black cloth spine, and rounded corners. Sewn page block. Pages of slightly textured, cream, laid paper with watermark and square corners.
Cover dimensions: 17.8 x 12.6 cm
Page dimensions: 17.0 x 12.1 cm
20 pages
no missing pages
no blank pages
13 single-sided drawings
7 double-sided drawings
Front cover inscribed: 6 New York; **inside front cover inscribed:** Grosz New York 9 July 32; Great Northern Hotel 57th Street; 118 West Room 1128
Technique: Graphite; occasionally blue ink.
Subject: Train interiors, houses, boats, and automobiles. Luggage racks, conductor, suburban houses with porches and electrical wires. Small sailboat and a ship. Last pages have burlesque-show scenes. Among others, a stage with three seminude women and two bald spectators in the front row.

1932/10 [131]

C. 10–11 JULY

Sketchbook with light gray cardboard covers, black cloth spine, and rounded corners. Several loose pages. Sewn page block. Pages of slightly textured, cream, laid paper with watermark and square corners.
Cover dimensions: 12.8 x 20.4 cm
Page dimensions: 12.0 x 20. cm
16 pages
missing pages [?]
no blank pages
14 single-sided drawings
2 double-sided drawings
Front cover inscribed: 7 New York [number 42 was crossed out]; **inside front cover inscribed:** George Grosz Great Northern Hotel; 57th Street 118 West Room 1128; [13 Febr. 1928, crossed out]
Technique: Ink and graphite; occasionally watercolor.
Subject: Theatrical performances. Some of the drawings are labeled "Billy Minsky burlesque." Numerous actors in costumes, chorus girls dancing in line, several seminude women. A band and three men singing in front of a microphone. Other drawings feature puppeteers and marionettes, one of them titled *Italian Theater New York 32*. Magazine clipping attached

1932/10, 4 recto

to inside back cover explains the history of the Italian theater. Watercolor of a street scene reproduced in Flavell, p. 123.

1932/11 [112]

12 JULY

Sketchbook with brown paper covers and square corners. Back cover is made of rigid cardboard. Stapled page block. Pages of smooth-surfaced, thin, cream, wove paper with square corners.
Cover dimensions: 12.7 x 10.0 cm
Page dimensions: 12.7 x 9.0 cm
60 pages
no missing pages
3 blank pages
56 single-sided drawings
no double-sided drawings
Front cover inscribed: New York 1932; 7; 12 July Great Northern Hotel; 67 [crossed out]
Technique: Graphite.
Subject: People and advertisements. Elevator operator, Yale student with university emblem on his sweater, waitresses, shoeshine boys, policemen, and elegantly dressed women. Young woman selling small bouquets of flowers at a street corner, shop signs, building entrances. Tailor's advertisement reads, "Damages on Garments Made Invisible" and shows a man's jacket being ripped by a dog. A vendor's cart advertises "Red Hot Frankfurters and Ice Cold Lemonade." Inside back cover has a drawing and a few notes.

1932/12 [122]

JULY – AUGUST

Sketchbook with gray cardboard covers, dark gray cloth spine, and square corners. Stapled page block. Pages of slightly textured, cream, laid paper with square corners.
Cover dimensions: 12.5 x 17.8 cm
Page dimensions: same
26 pages
no missing pages
1 blank page
24 single-sided drawings
2 double-sided drawings
Front cover inscribed: New York 1932 July August Great Northern Hotel
Technique: Graphite.
Subject: Fashionable young women. Black family, waiter, elderly man with Prussian-style beard smoking pipe, and two drawings of men watching something in the distance. Still life with plates, cup, lamp. Workhorse, trash can, advertisements. Window displays, including women's accessories, and a sign advertising frozen custard ornamented with two pineapples.

1932/13, 38 recto

1932/13 [116]

c. JULY – AUGUST

Notebook with brown paper covers, black cloth spine, and rounded corners. Sewn page block. Pages of smooth-surfaced,

cream, wove paper with blue lines and rounded corners.
Cover dimensions: 17.3 x 10.4 cm
Page dimensions: same
48 pages
2 missing pages
no blank pages
43 single-sided drawings
5 double-sided drawings
Front cover inscribed: New York 1932 August Great Northern Hotel; **first page inscribed:** New York 17 July 32 16 West 77 Street 11E
Technique: Graphite; occasionally watercolor; one ink and one prepared chalk drawing.
Subject: Men and women. Black man polishing the shoes of a white man. Black boys selling the *New York Mirror*, carrying large parcels. Crippled man sitting on a small rolling platform, selling pencils. One drawing shows Flatiron Building, numerous advertisements, shop signs, and entrances. A few watercolors of men and women. Advertisements.

1932/14, 6 recto

1932/14 [121]

21 JULY – AUGUST

Sketchbook with gray cardboard covers, dark gray cloth spine, and square corners. Stapled page block. Pages of slightly textured, cream, laid paper with square corners.
Cover dimensions: 12.5 x 17.8 cm
Page dimensions: same
25 pages
1 missing page
no blank pages
21 single-sided drawings
4 double-sided drawings

Front cover inscribed: New York 1932 July - August; Grosz Great Northern 118 West 57 Street; **inside front cover inscribed:** Grosz New York 1932; 21 July Great Northern Hotel 118 West 57t [*sic*] Street

Technique: Graphite; occasionally ink, watercolor, and prepared chalk.

Subject: People. Shop assistants, beggars, and street vendors. Unemployed worker carries large sign that reads, "Help unemployed family men [*sic*] with 4 small children who are dying of starvation. My children are crying for food her poor mother has nothing to offer." Two drawings of cabaret or burlesque show: viewers, stage, and dancing woman in seminude. Charlie Chaplin drawing, some advertisements.

1932/15 [113]
24 JULY – AUGUST

Notebook with brown paper covers, black cloth spine, and square corners. Sewn page block. Pages of smooth-surfaced, cream, wove paper with blue lines and square corners.

Cover dimensions: 15.0 x 9.5 cm
Page dimensions: same
96 pages
no missing pages
no blank pages
55 single-sided drawings
38 double-sided drawings
Front cover inscribed: Grosz New York July. Aug. 1932, [manufacturer's imprint: Notes, and logo]; **inside front cover inscribed:** New York; 24 July 1932; Great Northern Hotel; Grosz
Technique: Graphite and prepared chalk, some watercolors.
Subject: People, building facades, street corners with traffic lights, movie-theater interior, delicatessen displays, shoeshine equipment. Waiter behind counter, rough sketch of shoeshine man. Young women in elegant dresses, some men with sandwich boards, nuns, and people in buses or trains. Billboard wearer carrying sign "Dont look at me back?" reproduced in Flavell p. 135.

1932/16 [111]
AUGUST

Notebook with tan paper covers, black paper spine, and square corners. Sewn page block. Pages of smooth-surfaced, cream, wove paper with blue lines and square corners.

Cover dimensions: 15.0 x 9.1 cm
Page dimensions: same
40 pages
no missing pages
no blank pages
27 single-sided drawings
13 double-sided drawings

Front cover inscribed: New York 1932 August; Great Northern; front cover imprinted: Joredco Memo
Technique: Graphite and prepared chalk.
Subject: Several elegantly dressed women, seen mostly from behind. Two elderly women who seem to be engaged in a conversation, waitress, and man leaning against a fire hydrant. Detailed drawing of a restaurant's coffee machine, restaurant interiors, flights of stairs, a barber pole, and a few advertisements.

1932/17, 40 recto

1932/17 [114]
AUGUST

Notebook with brown paper covers, black cloth spine, and rounded corners. Sewn page block. Pages of smooth-surfaced, cream, wove paper with blue lines and rounded corners.

Cover dimensions: 17.3 x 10.4 cm
Page dimensions: same
48 pages
no missing pages
no blank pages
33 single-sided drawings
15 double-sided drawings
Front cover inscribed: New York August 32 Great Northern
Technique: Graphite, prepared chalk, and a few watercolor and gouache drawings.

Subject: Shop signs, advertisements, and various people. Elderly woman wearing a flowered dress and fashionable hat with bow. Man in shirt with open collar, loosely slung tie, rolled-up shirt sleeves, hands in his pockets. Restaurant signs, advertisements. Cabaret or burlesque show scenes—among others, "Chief and Princess White Eagle." Two clowns, represented twice, are studies for *Burlesque 42nd Street New York,* 1932 [see Hess, p. 176]. A black man holding a peeled banana in one hand is shown with a skeleton behind his back.

1932/18 [123]
AUGUST

Sketchbook with gray cardboard covers, dark gray cloth spine, and square corners. Stapled page block. Pages of slightly textured, cream, laid paper with square corners.

Cover dimensions: 12.5 x 17.8 cm
Page dimensions: same
26 pages
no missing pages
no blank pages
23 single-sided drawings
3 double-sided drawings
Front cover inscribed: Grosz New York August 32 Great Northern Hotel 57 Street
Technique: Graphite and prepared chalk; red watercolor is spilled over several pages.
Subject: Several drawings show New York skyscrapers, building facades, and technical items such as ventilation shafts, water towers, and fire hydrants. Advertisements, among them a "Big clearance sale," and the "Beautiful Girls Orchestra." One-way street sign and a counter with a "Chock full o' Nuts" advertisement. A few sketches feature people, most of them women.

1932/18, 25 verso

1932/19 [110]

c. September

Notebook with tan paper covers, black paper spine, and square corners. Sewn page block. Pages of smooth-surfaced, cream, wove paper with blue lines and square corners.
Cover dimensions: 15.0 x 9.1 cm
Page dimensions: same
40 pages
no missing pages
no blank pages
32 single-sided drawings
4 double-sided drawings
Front cover inscribed: New York 32; **front cover imprinted:** Joredco Memo
Technique: Graphite and crayon; traces of ink.
Subject: People, shop signs, and advertisements including "Coca-Cola," "Chock full o' Nuts," and "Maxwell House Coffee." Street cleaner, a policeman, black porter in uniform, and elegantly dressed women. Water tower on rooftop, a few building facades, and cars. Notes and addresses throughout.

1932/20, 3 recto

1932/20 [115]

September

Notebook with brown paper covers, black cloth spine, and rounded corners. Sewn page block. Pages of smooth-surfaced, cream, wove paper with blue lines and rounded corners.
Cover dimensions: 17.2 x 10.4 cm

Page dimensions: same
50 pages
no missing pages
no blank pages
49 single-sided drawings
1 double-sided drawing
Front cover inscribed: Grosz New York 1932 Sept. Great Northern Hotel
Technique: Prepared chalk; occasional use of graphite; one with watercolor and ink.
Subject: Men and women. Well-dressed women with fashionable hats, gloves, fur collars or scarves, and jewelry. Beggars, street musicians, and street vendors. Man carrying a watch-shaped sign that reads, "Watch repairing 1.50 no more," and man selling Domino Sugar. Automobiles, barber poles, and a few advertisements.

1932/21 [117]

September

Notebook with brown paper covers, black cloth spine, and rounded corners. Sewn page block. Pages of smooth-surfaced, cream, wove paper with blue lines and rounded corners.
Cover dimensions: 17.3 x 10.3 cm
Page dimensions: same
48 pages
no missing pages
no blank pages

1932/21, 23 recto

40 single-sided drawings
8 double-sided drawings
Front cover inscribed: Grosz New York 1932 September
Technique: Prepared chalk and graphite; two watercolor drawings.
Subject: Elegantly dressed women, a series of elderly women with hats, fans, jewelry, and high-heeled shoes. Baseball player and field with players. New York City double-decker buses, and automobiles. Advertisements and street signs include diverse items such as "Uncle Sam House tatooing," [*sic*] "Hunter Beauty School," and "5¢ drinks." U.S. mailbox rendered in great detail. The first and last pages contain a few notes and addresses.

1932/22 [124]

September

Sketchbook with gray cardboard covers, dark gray cloth spine, and square corners. Stapled page block. Pages of slightly textured, cream, laid paper with square corners.
Cover dimensions: 12.5 x 17.8 cm
Page dimensions: same
26 pages
no missing pages
no blank pages
26 single-sided drawings
no double-sided drawings
Front cover inscribed: Grosz New York Sept 32 Great Northern 118 West 57 Street
Technique: Graphite, prepared chalk, and crayon; occasionally watercolor.
Subject: People, advertisements, and building facades. Women walking past a mailbox; a white, middle-aged woman passing a black window cleaner who stands on a ladder. Detailed drawing of an older couple and a blind man selling shoes. Lunch table with Tabasco sauce and Budweiser beer, and a man pushing a cart with wrapped clothes (possibly a laundry or hotel employee). Elegantly dressed women and a few studies of heads.

1933/1 [143]

c. 1933 [date written by another hand]

Exercise book with blue paper covers and square corners. White paper label attached to front cover. Sewn page block. Pages of smooth-surfaced, cream, wove paper with square corners.
Cover dimensions: 21.0 x 15.7 cm
Page dimensions: same
7 pages
7 missing pages
no blank pages

no single-sided drawings
7 double-sided drawings
Cover label inscribed: Kassette 3.; Otto [name, illeg.]; Dresden 1 Zeitschriften [A red asterisk appears in the lower left corner of the label.]
Technique: Graphite.
Subject: Advertisements and notes, presumably from different time periods. First and last pages feature New York advertisements, thus the approximate date of c. 1933. The front cover label inscription as well as the type of exercise book might indicate that the book is much older, while a written list of 107 items in a different handwriting might date later than 1933 or not be written by Grosz himself. The list includes titles such as "head," "old man," "on the beach," "worker," "funeral," "married couple," or "beggars." (The first 14 entries are missing.) Rough sketches of reclining female figure and woman standing behind cash register. Several small, framed images appear next to the list.

1933/2 [134]
4 FEBRUARY

Notebook with brown paper covers, black cloth spine, and square corners. Sewn page block. Pages of smooth-surfaced, cream, wove paper with blue lines and square corners.
Cover dimensions: 14.3 x 9.1 cm
Page dimensions: same
102 pages
no missing pages
2 blank pages
74 single-sided drawings
26 double-sided drawings
Front cover inscribed: 2; 4 Febr. 33; New York; 33
Technique: Graphite and prepared chalk; occasionally watercolor.
Subject: Fashionable women, people with advertisements, and a few street scenes. Two interesting watercolor portraits of black women. Two women with dark-outlined eyes and mean expressions on their faces, person asleep in a building entrance. Street signs and a few high-rise buildings. Advertisements, cars, and shoeshine utensils and foot stand on which is inscribed "Unemployed Veteran."

1933/3 [139]
15 FEBRUARY

Notebook with brown paper covers, brown paper spine, and rounded corners. Sewn page block. Pages of smooth-surfaced, cream, wove paper with blue lines and rounded corners.
Cover dimensions: 17.5 x 10.0 cm
Page dimensions: same
94 pages
no missing pages

1933/3, 78 verso

no blank pages
66 single-sided drawings
28 double-sided drawings
Front cover inscribed: No 1 1933 New York 15 Febr; 33; 1; 33
Technique: Graphite and prepared chalk; occasionally watercolor.
Subject: Fashionable women (often with fur collars and coats), horses, people on horseback. Mailman, newspaper boy, window cleaner with a wiper tucked in his belt. Two dogs, one with a blanket. Advertisements and window displays. Some automobiles and a horse-drawn cart inscribed "Dairy Man's Milk." Addresses on last page.

1933/4 [142]
30 MARCH

Sketchbook with gray paper covers, dark gray cloth spine, and square corners. Rigid cardboard support attached to back inside cover. Stapled page block. Pages of slightly textured, cream, laid paper with square corners.
Cover dimensions: 17.9 x 12.5 cm
Page dimensions: same
25 pages [1 loose page]
1 missing page
no blank pages
21 single-sided drawings

4 double-sided drawings
Front cover inscribed: 33; 3 New York 30 March 33; **first page inscribed:** 7 East 14 Street Emanuel
Technique: Prepared chalk, graphite, one watercolor.
Subject: People, special focus on men. Two men repairing a car, a porter or chauffeur talking on a telephone, man riding a tricycle, and boy in baseball gear. Worker walking down a street, wearing apron and cap. Several window displays, including a butcher's shop with two slaughtered sheep and Hebrew inscription for kosher meat (slightly misspelled). Ad of man canoeing; above the drawing a star and the inscription "Remedy." Some sketches of skyscrapers and building facades (one of them possibly the Woolworth Building).

1933/5 [132]
20 APRIL

Notebook with blue paper covers, black cloth spine, and rounded corners. Sewn page block. Pages of smooth-surfaced, cream, wove paper with blue lines and rounded corners.
Cover dimensions: 15.0 x 9.0 cm
Page dimensions: same
96 pages
no missing pages
no blank pages
86 single-sided drawings
10 double-sided drawings
Front cover inscribed: 4 New York 20. April 33; 33 4; manufacturer's logo and imprint: Memobook
Technique: Graphite, prepared chalk, and some watercolor; two blue ink drawings.
Subject: Black men and women, among them a shoeshine boy, street cleaner, man leaning against building facade, and man reading a newspaper. Fashionable black woman holding a paper, a sketch for the watercolor *Portrait of a Lady (On the Subway)*, 1933 (now at the Addison Gallery of American Art, Andover). Street workers, elegantly dressed young women, skyscrapers and buildings, some advertisements. Interior of a barber shop with detailed drawing of the cash register and barber utensils. Watercolor of a chauffeur in uniform, leaning against a car. Ink wash of tightrope dancer.

1933/6 [140]
8 MAY

Sketchbook with light brown front paper cover, rigid cardboard back cover, black cloth spine, and rounded corners. Stapled page block. Perforated pages with smooth-surfaced, cream, wove paper with rounded corners.
Cover dimensions: 10.3 x 17.0 cm
Page dimensions: same
27 pages
3 missing pages

no blank pages
21 single-sided drawings
6 double-sided drawings
Front cover inscribed: 33 8 Mai N.Y. 5; **front cover imprinted:**
Kapeha Skizzen [brand logo and image of a seated painter];
inside front cover inscribed: 8 Mai - 17 Mai New York
Technique: Graphite; occasional watercolor; one blue ink
drawing.
Subject: People, drawings relating to train trip, buildings, cars,
street cleaner's utensils, and New York City skyscrapers. Series
of watercolors of women in fashionable dresses, a porter or
chauffeur in overcoat standing in the rain. Watercolor of street
cleaner, reproduced in Flavell, p. 99. Train attendant walking
through an aisle with coffeepot and cups (inscribed "Train to
Yale New Haven Ice cream! Hot Coffee! Chicken
Sandwiches!"). Conductor and people reading and smoking.
Man in suit standing with one foot on a chair.

1933/7 [141]
17 MAY

Sketchbook with light brown paper front cover, rigid card-
board back cover, and square corners. Stapled page block.
Pages of smooth-surfaced, cream, wove paper with square
corners.
Cover dimensions: 11.1 x 17.0 cm
Page dimensions: 11.1 x 15.7 cm
15 pages [3 loose pages]
no blank pages
3 single-sided drawings
12 double-sided drawings
Front cover inscribed: 17. Mai 33 N.Y. City; 6 1933; **front cover
imprinted:** Skizzenblock [Stein logo and other manufacturer's
information]
Technique: Graphite and watercolor.
Subject: Men and women. Two drawings of church towers,
one of an ornamented tower, the other of a spire between
large advertisements and high-rise buildings. Office interior,
building facades and shop advertisements, including the
Campbell Building with water tower (reproduced in Flavell, p.
134). Elegantly dressed women, two women in equestrian
outfits. Crowd of men standing in an office .

1933/8 [138]
22 MAY

Notebook with black-coated cloth covers and rounded cor-
ners. Rigid cardboard support attached to back inside cover.
Stapled page block with red-colored sides. Perforated pages of
smooth-surfaced, cream, wove, squared paper with rounded
corners.
Cover dimensions: 13.6 x 8.7 cm
Page dimensions: same

48 pages
some missing pages
no blank pages
47 single-sided drawings
1 double-sided drawing
Front cover inscribed: 7 N.Y. 33; **inside front cover inscribed:** 7
1933 New York; **first page inscribed:** 7 1933 New York 22 May 33
Technique: Prepared chalk; occasional use of graphite and
watercolor.
Subject: Fashionable women, both young and old. War veter-
ans, including men on crutches or sitting on the ground beg-
ging or selling flowers (one of these drawings inscribed "New
York Vet 5th Ave"). One veteran with military hat and decora-
tions. Grim-looking elderly man walking a dog, and a few
workers. Some notes.

1933/9 [137]
30 MAY – 5 JULY

Note pad with brown paper covers, black cloth spine, and
square corners. Rigid cardboard attached to back inside cover.
Sewn page block. Pages of smooth-surfaced, cream, wove
paper with blue lines and square corners.
Cover dimensions: 9.2 x 14.2 cm
Page dimensions: same
94 pages
no missing pages
1 blank page
76 single-sided drawings
15 double-sided drawings
Front cover inscribed: 8 N.Y. 33; **front cover imprinted:** Notes
[and logo]; **inside front cover inscribed:** 8 Dienstag 30 May
1933 - 5 July 33; N. York The Cambridge 60 West 62 Street
Technique: Prepared chalk, graphite, and watercolor draw-
ings.
Subject: Well-dressed women, shoeshine boy, window cleaner,
and newspaper boy. Sailor walking arm in arm with a red-
haired woman, cripple sitting on a low platform selling a few
items. Watercolors of black men and women, Jewish man
wearing a yarmulke. Advertisements, often in combination
with facades or shop entrances. Barber poles, chiropodist sign,
ad for mouth wash. Some notes appear on cardboard support.

1933/10 [135]
5 JULY

Notebook with brown paper covers, black cloth spine, and
square corners. Rigid cardboard attached to back inside cover.
Sewn page block. Pages of smooth-surfaced, cream, wove
paper with blue lines and square corners.
Cover dimensions: 14.9 x 8.8 cm
Page dimensions: same
96 pages

no missing pages
no blank pages
60 single-sided drawings
34 double-sided drawings
Front cover inscribed: 9; NY 33; front cover imprinted: Notes
[and logo]; **first page inscribed:** 5 July 33 N.Y Grosz 57
Christopher c/o Brévanner [?]
Technique: Graphite; occasionally watercolor and prepared
chalk.
Subject: Portraits of men and women. Drawings of older men
with chubby chins and necks. Increasing number of black
people, a few children. Couple sitting arm in arm on a bench.
Street cart with umbrella advertises "red hot frankfurters and
ice cold lemonade" (reproduced in Flavell, p. 146). A few
sketches of building facades, and shoeshine equipment. Note
on cardboard support. Addresses and notes on last page and
cardboard support.

1933/11 [133]
1 SEPTEMBER

Notebook with brown paper covers, black cloth spine, and
square corners. Rigid cardboard attached to back inside cover.
Sewn page block. Pages of smooth-surfaced, cream, wove
paper with square corners.
Cover dimensions: 14.9 x 8.8 cm
Page dimensions: same
96 pages
no missing pages
no blank pages
64 single-sided drawings
30 double-sided drawings
Front cover inscribed: 10 N.Y 33; ma⟨⟩ Notes [and logo]; **inside front cove⟨⟩** York; **first page inscribed:** 1 Septe⟨⟩ Street; c/o Brévannes [?]
Technique: Graphite; o⟨⟩
Subject: Men and wor⟨⟩ dresses. Portraits of ⟨⟩ sitting on the steps o⟨⟩ lap. Advertisements, ⟨⟩ Bee⟨⟩ on draught ⟨⟩ nu⟨⟩

80 pages
no missing pages
2 blank pages
42 single-sided drawings
34 double-sided drawings
Front cover inscribed: 11 1933 1934 January N.Y.; [manufacturer's imprint and logo]; **inside front cover inscribed:** No 11; 3 November 1933 New York Hotel Raleigh West 72th [*sic*] Street - 22 Januar 1934 N.Y., L. Island
Technique: Graphite and watercolor; one ink drawing.
Subject: People in the street and on bus or train, advertisements, automobiles. Ads feature diamonds, furniture, and a film poster: *Man's Castle*, with Spencer Tracy and Loretta Young. Street vendor. People on bus or train include a black m an smoking a pipe, and a white man reading a newspaper. Mickey Mouse head, lion from the entrance of the New York Public Library. Various images are used in the watercolor *New York, New York (Times Square)*, (1934). Notes and addresses appear on several pages and inside back cover. [See essay by Catherina Lauer in this volume.]

Pages of smooth-surfaced, cream, wove paper with blue lines, watermark, and rounded corners.
Cover dimensions: 15.1 x 8.5 cm
Page dimensions: same
92 pages
4 missing pages
7 blank pages
55 single-sided drawings
28 double-sided drawings
Front cover inscribed: 12; 1934 N.Y. Bayside L.Isl. 40-41 221 Str.; manufacturer's imprint and logo: Universal Notes; **inside front cover inscribed:** N. 12; 22.1.1934 L.Island Bayside; **first page inscribed:** N. 12; 40-41 221 Street Long Island N.Y. 22 Januar 1934 bis—
Technique: Graphite and prepared chalk; frequently watercolor; a few purple-colored pencil drawings.
Subject: Men standing or sitting on front steps, elegant men and women, street vendors. Man from behind with striped trousers, undershirt, and muscular arms. Building facades, shop windows, and advertisements (often illustrated in watercolor). Building entrance with baroque elements rendered in watercolor. Cars, coal truck, and electric fan. Film title *Flying down to Rio* appears.

1934/2 [155]
10 JULY

Exercise book with blue paper covers and square corners. Rigid cardboard attached to back inside cover with brown paper hinges. Three sheets of slightly textured, cream, laid

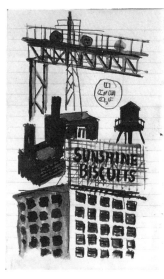

1934/2, 5 verso

sketchbook paper are folded and strung to the book between the page block and back inside cover, creating 6 additional pages. [One of these pages is now missing.] Behind those pages a single exercise book page is attached to the cardboard with a brown paper hinge. White paper label attached to front cover. Sewn page block. Pages of smooth-surfaced, cream, wove paper with blue lines and square corners.
Cover dimensions: 16.7 x 10.5 cm
Page dimensions: same
12 pages [plus 5 additional sketchbook pages]
probably 3 missing pages [two exercise book pages and one sketchbook page]
no blank pages
2 single-sided drawings
10 double-sided drawings
Front cover label inscribed: 1934 Bayside L. Isl.; July Peter; **inside front cover inscribed:** Grosz Bayside 1934 L. Isl. 10 July
Technique: Graphite and watercolor.
Subject: Warehouses, water towers, and industrial steel structure. Two porters and a cart with boxes and bags at a train platform. Freight scale and a few trucks. A couple of people sitting on benches. Baseball player. Two rural house facades with shop entrances. Advertisements. Last page and cardboard support have addresses.

1934/3 [154]
27 AUGUST

Notebook with brown paper covers, black paper spine, and square corners. Rigid cardboard attached to back inside cover with brown paper strips. Sewn page block. Pages of smooth-surfaced, cream, laid paper with blue lines and square corners.
Cover dimensions: 15.0 x 8.5 cm
Page dimensions: same
107 pages
1 missing page
23 blank pages
81 single-sided drawings
1 double-sided drawing
Front cover inscribed: 1934 27 August New York Bayside Lg. Isl. 40-41 221 Street; manufacturer's imprint: Memorandum [and logo]
Technique: Prepared chalk and graphite; occasionally watercolor and gouache. Traces of crayon and graphite in the upper right corner.
Subject: Young women, portraits. Elderly woman with wrinkled face wearing makeup, youthful dress, and hat. (This drawing was integrated into the watercolor *Americans*, 1935; see Hess, p. 192.) Male side views, window cleaner, and a golf player. Buildings, among them the Chrysler building in New York City, and a New England wooden house. Advertisements, fire hydrant, and utility pole. A few notes on cardboard support.

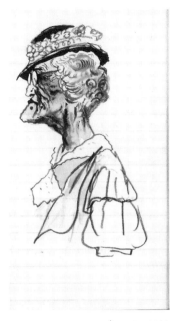

1934/3, 37 recto

1934/4 [157]

1934 – FEBRUARY 1935

Sketchbook with blue paper-covered cardboard covers, and rounded corners. Sewn page block. Perforated pages of smooth-surfaced, thin, cream, wove paper with watermark and rounded corners.
Cover dimensions: 9.5 x 8.5 cm
Page dimensions: 8.9 x 7.4 cm
96 pages plus one binding page
no missing pages
4 blank pages
88 single-sided drawings
4 double-sided drawings
Front cover inscribed: 1935; **inside front cover with label:** The Cambridge "Press" Sketch Book Series [and other manufacturer's information and design]; **label inscribed:** 1934 -1935 bis 20 February Bayside Lg. Island 40-41 221 Street
Technique: Graphite; a few prepared chalk drawings.
Subject: Architectural details such as windows, church spires, water towers, and a canopy. Building site with crane and half-finished steel structure of a high-rise building. Crane hooks, steel rivets, and automobiles. Person ascending stairs of a double-decker bus. A few sketches of people. American flags and Santa Claus. Several addresses and phone numbers on cover page and inside back cover.

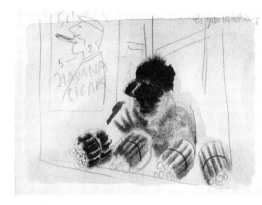

1935/1, 38 verso

1935/1 [151]

20 FEBRUARY

Sketchbook with light green paper covers, green cloth spine, and square corners. Rigid cardboard is attached to both sides of the back cover. Sewn page block. Pages of smooth-surfaced, off-white, wove paper with square corners.
Cover dimensions: 14.9 x 10.1 cm
Page dimensions: same
40 pages
no missing pages
no blank pages
28 single-sided drawings
11 double-sided drawings
Front cover inscribed: 1935; **manufacturer's imprint:** Rich Art sketch book [logo and other manufacturer's information];
inside front cover inscribed: G. Grosz 40-41 221 Street Bayside Lg. Isl. 1935; 20 February
Technique: Graphite, occasionally with watercolor; one colored-crayon drawing.
Subject: People sitting on bus or train, detailed drawings of empty seats. Two sketches of cigar makers, one of them watercolor with advertisement for "Havana cigars." Man on crutches selling flowers, shoeshine stand. Advertisement for "Shooting Gallery" shows cowboy in mountainous landscape with rifle.

1935/2 [146]

UNTIL 24 OCTOBER

Sketchbook with green paper covers, dark green cloth spine, and square corners. Rigid cardboard attached to back inside cover. Sewn page block. Pages of smooth-surfaced, cream, wove paper with square corners.
Cover dimensions: 10.1 x 14.7 cm
Page dimensions: same

40 pages
no missing pages
no blank pages
27 single-sided drawings
12 double-sided drawings
Front cover inscribed: 1935; 35; front cover imprinted: Rich Art sketch book [and other manufacturer's information and logo];
inside front cover inscribed: bis 24 October 1935 Danmark [?] Bayside; **inside back cover:** [address and stamp]
Technique: Graphite; occasionally prepared chalk; a few ink drawings; one watercolor.
Subject: Men and women, landscapes. Field with bushels of wheat, cart loaded with grass or hay, sunset with extensive color notes. Ink drawing of window cleaner, shoeshine boy at work. Advertisements, window displays. First page and back cover have a few addresses and phone numbers.

1935/3 [150]

23 OCTOBER – 12 NOVEMBER

Sketchbook with light green paper covers, green cloth spine, and square corners. Rigid cardboard attached to the inside back cover. Sewn page block. Pages of smooth-surfaced, cream, wove paper with square corners.
Cover dimensions: 10.2 x 14.2 cm
Page dimensions: same
40 pages
no missing pages
no blank pages
33 single-sided drawings
6 double-sided drawings
Front cover inscribed: 23 October - 1935 Bayside - New York; **manufacturer's imprint:** Rich Art Sketch Book [and further manufacturer's information and logo]; **first page inscribed:** 23 October 1935—Bayside—12 November 1935
Technique: Prepared chalk; occasionally graphite and watercolor.
Subject: Men and women, cars, advertisements for "Shell," "Texaco," and "Gulf." Jeweler's window display and barber shops. Signpost indicating directions to Jamaica, New York, and Bayia, etc. Woman sitting in bus or train compartment. Car driving down a street lined by utility poles and wires. Drawing on cardboard support.

1935/4 [145]

13 NOVEMBER

Sketchbook with cream-colored, light cardboard front cover, and square corners. Rigid cardboard back cover. Stapled page block. Pages of slightly textured, cream, laid paper with watermark and square corners.
Cover dimensions: 14.5 x 11.0 cm
Page dimensions: same

58 pages [1 loose page]
no missing pages
2 blank pages
56 single-sided drawings
no double-sided drawings
Front cover inscribed: 1935; **inside front cover inscribed:** 13 November 1935-Grosz Bayside/40-41 221 Street Baysi. 9-4359; **back cover:** [Berlin retailer's stamp]
Technique: Graphite; prepared chalk; a few watercolors and red ink drawings.
Subject: Men and women, two drawings of a Santa Claus, view into train or bus window (reproduced in Flavell, p. 122). Detailed drawings of draped clothes, and several advertisements—among others, "smoke a good clean Havana." Two parked cars in front of a small building with brick walls. Building facades and window displays.

1935/5, 6 recto

1935/5 [144]
1935 AND SUMMER 1939

Sketchbook with black-coated, cloth-covered paper covers, and rounded corners. Stapled page block. Pages of smooth-surfaced, cream, wove paper with rounded corners.
Cover dimensions: 20.4 x 12.5 cm
Page dimensions: same
39 pages
1 missing page
2 blank pages
31 single-sided drawings
7 double-sided drawings
Inside front cover inscribed: 1935 Langeland Dane Morrk [?] Bornholm Justus Rapal [?]; 1939 Truro Cape Cod
Technique: Graphite; prepared chalk; some watercolor.
Subject: Landscapes, drawings of Eva Grosz. Carefully shaded drawings of boulders, fields, and houses at seashore, dog, mostly in reclining poses, two grasshoppers. Women's accessories such as hats, gloves, shoes, and cosmetic items, and draped clothes or towels. Carefully shaded drawing of two ballet slippers and towel hanging on a door. Drawing on inside back cover.

1936/1 [156]
MARCH – 29 APRIL

Sketchbook with blue paper-covered cardboard covers and rounded corners. Sewn page block. Perforated pages of smooth-surfaced, thin, cream, wove paper with rounded corners.
Cover dimensions: 9.5 x 8.5 cm
Page dimensions: same
96 pages plus 1 cover page
no missing pages
4 blank pages
80 single-sided drawings
11 double-sided drawings
Front cover inscribed: 1936; **inside front cover with label:** The Cambridge "Press" Sketch Book Series [and other manufacturer's information and design]; **cover page inscribed:** March - April 1936 bis 29 April 1936 Bayside-Lg Island 40-41 221 Street George Grosz
Technique: Graphite.
Subject: Drawings of building facades, flagpoles, balconies, and architectural ornaments. Elegant women, various hats. Two drawings of double-decker buses, cars, and advertisements. Drawing on inside back cover.

1936/2 [153]
BEGUN APRIL 2

Sketch pad with light green paper covers, green cloth spine, and square corners. A double layer of cardboard attached to back inside cover with brown paper. Sewn page block. Pages of smooth-surfaced, off-white, wove paper with square corners.
Cover dimensions: 14.6 x 10.2 cm
Page dimensions: same
40 pages
no missing pages
no blank pages
30 single-sided drawings
10 double-sided drawings
Front cover inscribed: 29 April - 1936; imprinted: Rich Art sketch book [logo and other manufacturer's information]
Technique: Graphite.
Subject: People, including workers and elegantly dressed women. Bartender with bow tie and apron, background with bottles and certificate that reads, "New York State Retail Wine and Liquor Store License No 221." Advertisements, window displays—among others, "Cuban Cigars"—and a tailor's advertisement. Drawing on inside back cover.

1937/1 [148]
1937

Sketchbook with faded green paper covers and square corners. Rigid cardboard between page block and back inside cover.

1937/1, 38 recto

Riveted page block. Perforated pages of smooth-surfaced, cream, wove paper with square corners.
Cover dimensions: 14.0 x 10.4 cm
Page dimensions: same
50 pages
no missing pages
no blank pages
48 single-sided drawings
1 double-sided drawing
Front cover inscribed: 1937; **imprinted:** Gelka Skizzen-Block [and manufacturer's logo]; **inside front cover:** [Berlin retailer's stamp]
Technique: Graphite.
Subject: People in the streets, train platform, building facades, fragmentary drawings of a ladder, traffic light and trash can. Detailed drawing of toilet bowl, draped towels, and wash basin. Women, policeman, worker with wrench. Some advertisements. Notes and several addresses on last page and cardboard support.

1937/2 [152]
1937 – APRIL 1938

Sketchbook with light green paper covers and square corners. Rigid cardboard between page block and back inside cover. Riveted page block. Perforated pages of smooth-surfaced, cream, wove paper with square corners.
Cover dimensions: 14.8 x 10.4 cm
Page dimensions: same
51 pages [1 loose page]

no missing pages
1 blank page
45 single-sided drawings
5 double-sided drawings
Front cover inscribed: 1937 - 1938 April; **imprinted:** Gelka Skizzen-Block [and manufacturer's logo]; [Berlin retailer's stamp]; **first page inscribed:** Douglaston George Grosz Gelegentliche Skizzen—skizzierte in den Jahren 36, 34, 35 nicht mehr—nachdem ich wieder male mache ich mir nun [?] hie und da Notizen. Back cover inscribed: 1937 1938 Douglaston; [stamp]
Technique: Graphite; occasionally prepared chalk.
Subject: Women in the streets. Several drawings show women with cat eyes, lurking looks, and seductive smiles. Drawings of fences, tree branches, and pond with footbridge. A few half-timbered houses, cars, a dump truck, and modern telephone. Very few advertisements, one of which shows man holding an umbrella that is inscribed "on strike local 332B." Small drawing, addresses, and notes on cardboard support.

1938/1 [147]

3 MAY

Sketchbook with light green paper covers and square corners. Rigid cardboard between page block and back cover. Riveted page block. Perforated pages of smooth-surfaced, cream, wove paper with square corners.
Cover dimensions: 14.8 x 10.4 cm
Page dimensions: 14.8 x 8.8 cm
47 pages
probably 1 missing page
1 blank page
44 single-sided drawings
1 double-sided drawing
Front cover inscribed: 1241 Warburg [?]; manufacturer's imprint: Gelka Skizzen-Block [and logo]; [Berlin retailer's stamp]; **first page inscribed:** 3 May 1938 Douglaston Lg. Isl. Topstone Farm Ridgefield Connecticut E. Herr. 385 Madison
Technique: Graphite; occasionally prepared chalk; one watercolor.
Subject: Men and women, hilly coastal landscape with house and ship on the sea. Technical details of train interiors, such as handles and benches. Elegant women, man on tricycle, porter, and two women with head scarves. Notes and addresses on first page, cardboard support, and back cover.

1939/1

JUNE – SEPTEMBER

Sketchbook with light brown cardboard covers, black cloth spine, and rounded corners [corners worn]. Sewn page block [appears to be rebound]. Pages of smooth-surfaced, cream, wove paper with square corners, glassine paper attached to each page.

Cover dimensions: 39.1 x 32.9 cm
Page dimensions: 38.5 x 32 cm
27 pages, plus 1 page 20.2 x 28.1 cm attached to p. 22
c. 2 missing pages
no blank pages
23 single-sided drawings
4 double-sided drawings
Front cover inscribed and painted: Truro Cape Cod June - Sept. 1939; **inside front cover inscribed:** George Grosz Sketches from Sohrenboom 1927 & Truro Cape Cod Mass. 1939 Sketches from Truro 1939 August; [Berlin retailer's sticker]
Technique: Ink and watercolor drawings [some partially fixed]; occasionally graphite.
Subject: Large-scale drawings of dunes and vegetation. Detailed ink drawings of trees and grass. Page opening with watercolor of wooded landscape. Wood house and sailboat. Two drawings on separate sheets of paper are attached to sketchbook pages. Drawing technique varies from large brush strokes to detailed drawing style, which is characteristic of many of the landscapes.

1939/2, 15 recto

1939/2 [158]

c. AUGUST

Sketchbook with faded green paper covers and square corners [corners quite worn]. Rigid cardboard between page block and back inside cover. Riveted page block. Perforated pages of smooth-surfaced, cream, wove paper with square corners. One slightly textured, cream, wove paper is adhered to one of the sketchbook pages.

Cover dimensions: 14.8 x 10.3 cm
Page dimensions: same
49 pages
probably 1 missing page
7 blank pages
42 single-sided drawings
no double-sided drawings
Front cover inscribed: 1939 [by another hand]; front cover imprinted: Gelka Skizzen-Block [and manufacturer's logo]; inside front cover: [Berlin retailer's stamp]
Technique: Graphite and prepared chalk; occasionally watercolor and green ink.
Subject: Summer holiday in Truro, Cape Cod. Eva Grosz in bathing suit or in the nude. Coastline, dunes. Insects such as spiders, dragonflies, and beetles. House in the dunes, telephone and receiver, and drawings of draped clothes. One drawing by Grosz's son Martin depicts the sailboat "Wimcycle." (This drawing is inscribed: "Truro, Mass. Aug. 6, 1939".)

1945/1 [125?]

JULY, AUGUST, SEPTEMBER

Sketchbook with faded green paper front cover, rigid cardboard back cover, green cloth spine, and square corners [corners worn]. Glued page block. Pages of slightly textured, cream, laid paper with square corners. Several pages have glassine paper attached.
Cover dimensions: 23.1 x 31.7 cm
Page dimensions: 23.1 x 30.5 cm
21 pages
1 [?] missing page
5 blank pages
15 single-sided drawings
1 double-sided drawing
Front cover inscribed: Wellfleet 1945 July, Aug, Sept
Technique: Watercolor and graphite; occasionally prepared chalk, ink, and charcoal.
Subject: Summer holiday in Wellfleet, Cape Cod. Detailed drawings of landscapes, seashore and dunes, beached fishing boat. Several half-barren pine trees, débris on the beach such as a broken barrel, lobster trap, and rope. Several whole-page color studies are included.

1950/1 [166]

1950

Sketchbook page block without covers. Glued page block. Pages of smooth-surfaced, cream, wove paper with square corners.
Page dimensions: 7.6 x 12.8 cm
21 pages
missing pages [?]

no blank pages
1 single-sided drawing
19 double-sided drawings
First page inscribed: 1950 A.ST.Lg. [Art Students League]
Technique: Graphite and prepared chalk.
Subject: Technical sketches that seem to relate to Grosz's teaching at the Art Students League in New York. Muscle structures of the human body, geometric designs in juxtaposition to free lines. The figure 8 appears occasionally as a structural element.

1950/2 [168]
1950

Sketch pad with gray, front paper cover, cardboard back cover, spiral binding, and square corners. Pages of smooth-surfaced, cream, wove paper with square corners.
Cover dimensions: 14.8 x 10.2 cm
Page dimensions: 14.3 x 10.2 cm
20 pages
no missing pages
no blank pages
17 single-sided drawings
3 double-sided drawings
Front cover inscribed: George Grosz [small design also appears]; **imprinted:** The Stuart Sketch Pad No. 760 [and other manufacturer's information]; **inside front cover imprinted:** 1950 Art ST. Lg
Technique: Graphite.
Subject: Drawing exercises, including figure studies, portraits, and still lifes. Female figure holding a child, studies of upper body, face, and legs. Light-and-shade exercises, draped cloth, hands and eyes. Swastika appears on one of the first pages.

1950/3 [159]
SUMMER

Sketchbook with gray front paper cover, rigid cardboard back cover, and square corners. Stapled page block. Pages of slightly textured, cream, laid paper with square corners.
Cover dimensions: 14.4 x 11.2 cm
Page dimensions: 14.4 x 10.3 cm
66 pages
no missing pages
8 blank pages
58 single-sided drawings
no double-sided drawings
Front cover inscribed, perhaps by another hand: 1950; **back cover:** [Berlin retailer's stamp]
Technique: Graphite; occasionally watercolor, crayon, and prepared chalk.
Subject: Landscapes, among them drawings of dunes and

fishing boats along the seashore. Dunes, vegetation, grass, dune flowers and insects. Débris on the beach such as wooden planks, a barrel, etc. Woman (Eva Grosz?) in the nude or semi-nude, drawings of clothes. Series of detailed drawings of mice in traps, one alive (see for comparison 1950/7).

1950/4 [167]
SUMMER

Sketch pad with tan cardboard covers, spiral binding, and square corners. Pages of slightly textured, cream, wove paper with square corners.
Cover dimensions: 15.3 x 10.0 cm
Page dimensions: 14.5 x 10.0 cm
29 pages
1 missing page
no blank pages
2 single-sided drawings
27 double-sided drawings
Front cover inscribed: Art Students Lg. Summer 1950; **imprinted:** Fav-o-Rite Sketch Book [and other manufacturer's information]
Technique: Graphite and prepared chalk; occasionally watercolor.
Subject: Drawing exercises, torsos, heads, arms, and ears seem to be studies of life models. Basic forms of the human figure are drawn with auxiliary lines such as heart shapes and the figure 8. Exercises relate to contrast and color value, as well as organic and geometric shapes.

1950/5 [169]
SUMMER

Sketch pad with gray cardboard covers, spiral binding, and square corners. Pages of smooth-surfaced, thin, off-white, wove paper with square corners.
Cover dimensions: 15.0 x 10.0 cm
Page dimensions: same
97 pages
missing pages [?]
31 blank pages
48 single-sided drawings
18 double-sided drawings
Front cover imprinted: Visual Sketching No. 780; **inside front cover inscribed:** ART League painting class very hot summer 1950 [measures for stretcher also appear]
Technique: Graphite and prepared chalk.
Subject: Drawing exercises. Facial expressions, shading, and contrast. Eyes, noses, and profile studies, a few drawings of female nude. Geometric shapes in contrast to free-flowing lines. Series of vegetables. Drawings by a child.

1950/6 [168A]
1950 – 1951 [?]

Sketch pad with light brown, front cardboard cover, rigid cardboard back cover, spiral binding, and square corners. Pages of slightly textured, cream, wove paper with square corners.
Cover dimensions: 14.5 x 9.8 cm
Page dimensions: 14.2 x 9.8 cm
24 pages
no missing pages
20 blank pages
4 single-sided drawings
no double-sided drawings
Front cover has manufacturer's logo and imprint: Strathmore Alexis Drawing [and other information]; **inside front cover inscribed:** George Grosz NY 1950
Technique: Graphite drawings, some with watercolor.
Subject: Four drawings of New York street scenes. Hotel entrances and porter. Couple and taxi, draped cloth.

1950/7
1950 – 1951

Sketchbook with green cardboard covers, black cloth spine, and square corners. Sewn page block. Perforated pages of smooth-surfaced, cream, wove paper with square corners.
Cover dimensions: 23.3 x 15.3 cm
Page dimensions: same
37 pages
missing pages [?]
4 blank pages
28 single-sided drawings
5 double-sided drawings
Front cover inscribed: 1950,51 George Grosz; Huntington; The Cottage Hilaire Farm; To Leon Harris with all my best wishes George Grosz June 1952 * Huntington
Technique: Graphite; frequently watercolor.
Subject: Sketchbook divided in two parts. First part features New York City skyline from elevated viewpoint. According to a letter of 30 March 1956, drawings are studies for an oil painting for the novelist Kathleen Winsor executed on the balcony of her Manhattan apartment. Second part has detailed drawings of mice in mouse traps. Back of female nude, draped cloth, and tied bow. [See essay by Beeke Sell Tower in this volume.]

1950/8 [160]
C. 1950 – SUMMER 1955

Sketch pad with brown cardboard covers and rounded corners. Spiral bound page block. Pages of smooth-surfaced, cream, wove paper with rounded corners. Glassine paper is attached to each page.

1950/8, 13 recto

Cover dimensions: 20.0 x 12.5 cm
Page dimensions: 19.5 x 12.5 cm
19 pages
1 missing page
no blank pages
9 single-sided drawings
10 double-sided drawings
Front cover has manufacturer's imprint: Rembrandt Oil and Water Colors [logo and other information]; **inside front cover inscribed:** 1950/55 [by another hand]
Technique: Watercolor and graphite drawings; some crayon.
Subject: Seashore and dunes. Occasionally roads and utility poles appear with landscapes. Some fishing boats, either bobbing up and down in calm water or beached. Partially rotten fish. Village houses, and a church. Houses in wooded area and on top of a dune. Insects and plants, two rough sketches of a deer.

1951/1 [165]

SEPTEMBER 1951 AND AUGUST 1956

Sketchbook with light brown paper covers, black cloth spine and square corners. Rigid cardboard support attached to inside back cover with brown paper strip. Sewn page block. Perforated pages of slightly textured, cream, laid paper with square corners.
Cover dimensions: 23.7 x 15.4 cm
Page dimensions: same
38 pages
missing pages [?]
5 blank pages
27 single-sided drawings
6 double-sided drawings
Front inside cover inscribed: Bei Bayrisch Zell Curt Kyriss Bauer im Dorf 1951 Sept.; Htg. [Huntington] - Lg. Island Aug 1956; [Paris retailer's stamp]

1951/1, 14 verso and 15 recto

Technique: Graphite, charcoal, and ink drawings; occasionally watercolor.
Subject: Mountainous landscapes and pine-tree forests. Delicate drawings of rocks by the water, brook in lightly wooded area. Studies of grass, flowers, and plants. Most of these drawings executed in long wavy brush or pen strokes, with the exception of a delicately shaded bow. Horizontal 8 shapes next to leaves inscribed: "the figure 8 its always there in nature." Back yard with tree and clothes hanging on a line.

1952/1 [170]

JANUARY

Sketch pad with faded green front paper cover, rigid cardboard back cover, spiral binding, and square corners. Pages of slightly textured, cream, wove paper with square corners.
Cover dimensions: 15.3 x 10.2 cm
Page dimensions: 14.6 x 10.2 cm
20 pages
no missing pages
no blank pages
3 single-sided drawings
17 double-sided drawings
Front cover inscribed: School Htg. 1952 January George Grosz; **cover imprinted:** Morilla Spiral Sketch Pad [logo and other manufacturer's information]
Technique: Graphite; occasionally watercolor.
Subject: Drawing exercises. Color studies and technical aspects of painting—for example, painting materials such as palette and brushes. Reverse side of a painting with stretchers. Watercolor with outline of a figure inscribed "Rembrandt." Extensive color notes. Vegetables and ropes appear on the last pages of the book.

1952/2 [161]

c. FEBRUARY 1952

Notebook with brown paper covers, black cloth spine, and rounded corners. Sewn page block. Pages of smooth-surfaced, cream, wove paper with blue lines and rounded corners.
Cover dimensions: 19.0 x 12.2 cm
Page dimensions: same
84 pages
no missing pages
17 blank pages
59 single-sided drawings
6 double-sided drawings
Front cover is marked with an asterisk; **first page inscribed** 1951/52 [date by another hand]
Technique: Watercolor and graphite; occasionally prepared chalk and blue, black, and brown ink.
Subject: Stickmen, nude women, vaginas, street vendor. Includes two drawings which appeared in *Interregnum* (1936). [See Dückers SII, 5 "Die Stimme der Vernunft (The Voice of Reason)," and SII, 37 "Art is eternal," pp. 87, 92.] Drawing inscribed "Stilleben" (still life) features blood-covered club next to bloody boot. Several pages filled with ideas for drawings ("Geschichte einer Granate, etc."). Uprooted stickman next to paper clipping with orbiting electrons, which Grosz inscribed "Atom bomb." Woman with rabbit mask and tail, hermaphrodite. Grotesque smiling faces inscribed "keep on smiling," palette with teeth, etc. Two drawings dated February 1952. Images such as *Interregnum* drawings or street vendors may indicate an earlier use of the book in the late 1930s. Two clippings from newspapers or magazines attached to pages.

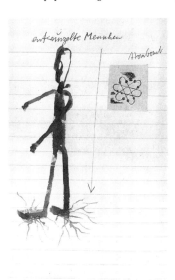

1952/2, 11 verso

1952/3 [171]

FEBRUARY

Sketch pad with light brown cardboard covers, spiral binding, and square corners. Pages of slightly textured, cream, wove paper with square corners.

Cover dimensions: 15.1 x 10.0 cm
Page dimensions: 14.5 x 10.0 cm
29 pages
1 missing page
2 blank pages
8 single-sided drawings
19 double-sided drawings
Front cover inscribed: George Grosz Art Class Hg 1952 February; imprinted: Fav-o-Rite Sketch Book [and other manufacturer's information]
Technique: Graphite; occasionally watercolor.
Subject: Drawing exercises. Still lifes: jars, vessels, and drapery. Ivy leaves, lemons, and a rope. Watercolor studies of Rembrandt self-portrait, as well as female figure (titled "Spitzweg's Colors/Schauspielergesellschaft (Actors' Association)"). A few people and studies of body parts such as arms, eyes, or ears. One auxiliary grid structure.

1952/4 [172]

1952 – 1953

Notebook with black-and-white paper-covered cardboard covers, black cloth spine, and rounded corners. Sewn page block. Pages of smooth-surfaced, off-white, wove paper with blue horizontal lines, one red vertical line, and rounded corners.

Cover dimensions: 24.4 x 18.7 cm
Page dimensions: same
87 pages
1 [?] missing page
no blank pages
2 single-sided drawings
80 double-sided drawings
Front cover inscription: School Htg. 1952-53 George Grosz Nov. 1952; front cover label has manufacturer's imprint: Sterling Note Book Property of School; **inside front cover inscribed:** George Grosz Art School Htg. 1952; [same imprint as front cover]
Technique: Graphite and charcoal; occasionally watercolor, crayon, and ink. Some of the watercolors in some areas are treated with a fixative.
Subject: Drawing exercises. Contrast and shading, perspective drawings, and still-life arrangements. Drawings with auxiliary lines such as the figure 8 and heart shapes. Drapery and outlines of the human figure. Small drawing taped to inside front cover. Several sketches on inside back cover.

1954/1

1954

Notebook with light brown cardboard covers and rounded corners. Spiral bound page block. Pages of smooth-surfaced, cream, wove paper with blue lines and rounded corners.

Cover dimensions: 25.3 x 20.3 cm
Page dimensions: 25.3 x 19.7 cm
17 pages [in one case half a page is missing]
missing pages [?]
no blank pages
4 single-sided drawings
13 double-sided drawings
Front cover inscribed: School Art Class Htg. 1954; **front cover imprinted:** Columbia University [with description and address]
Technique: Graphite drawings; occasionally watercolor, charcoal, and ink.
Subject: Studies of human figure, flowers, and composition. Series of small nude drawings titled "Matisse." Two portraits of a wounded or dead soldier, flies hovering over his wounds. One of these drawings titled "Old soldiers never die. The little Boy who wanted to play soldier." Several notes appear, a few small drawings presumably executed by Martin Grosz.

1954/2 [173]

1954

Note pad with light brown cardboard covers, spiral binding, and rounded corners. Pages of smooth-surfaced, cream, wove paper with blue horizontal lines, one vertical red line, and rounded corners.

Cover dimensions: 21.3 x 17.6 cm
Page dimensions: 21.3 x 17.0 cm
41 pages
missing pages [?]
no blank pages
approximately 7 single-sided drawings by George Grosz
approximately 10 double-sided drawings by Martin Grosz
Front cover inscribed: School Htg. 54; **front cover imprinted:** Columbia University [with description and address]
Technique: Graphite, charcoal, and crayon drawings; occasionally watercolor.
Subject: Only a few drawings can be attributed to George Grosz. Those are drawing exercises, including the outline of a female nude. Most pages are filled with English-German vocabulary, caricatures, and music by Martin Grosz. Several drawings by Martin Grosz are on the inside front and back covers.

1954/3 [162]

c. MAY AND OCTOBER

Notebook with brown paper covers, red paper spine, and rounded corners. Rigid cardboard attached to inside back cover

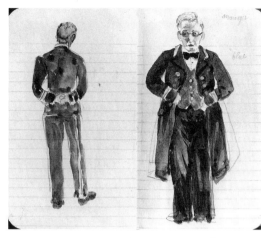

1954/3, 19 verso and 20 recto

with brown paper strip. Sewn page block. Pages of smooth-surfaced, cream, wove paper with blue lines and rounded corners.

Cover dimensions: 14.9 x 9.3 cm
Page dimensions: same
36 pages
4 missing pages
no blank pages
9 single-sided drawings
27 double-sided drawings
Front cover inscribed: New York & London Okt 1954; White's Hotel Lancaster Gate W2
Technique: Graphite, watercolor with gouache; occasionally blue and purple ink.
Subject: People, street signs, architectural details, technical equipment, and interiors. Bobbies, men in black suit, bowler hat, and umbrella. Street cleaners, policemen, and street vendors, sandwich man advertising palm reader "Madam Sandra." Watercolor of a black man in coat, scarf, and hat. Oxford Circus street sign, lamps, ash trays, and a desk pad. Still life of English breakfast table at the White's Hotel. Two women with dogs. Several addresses and phone numbers on last pages and cardboard support.

1954/4 [163]

OCTOBER

Sketchbook with gray-green, paper-covered, rigid cardboard covers, gray-green paper spine, and square corners. Sewn page block. Pages of smooth-surfaced, cream, wove paper with square corners.

Cover dimensions: 8.8 x 12.6 cm
Page dimensions: same
28 pages
2 missing pages

9 blank pages
6 single-sided drawings
10 double-sided drawings
Front cover inscribed: George Grosz London W2; White's Hotel Lancaster Gate; October 1954; **imprinted:** The "Kingsland" Sketch Book Series 351 [and other manufacturer's information]; **first page inscribed:** Lancaster Gate-London/White's Hotel; October 1954
Technique: Graphite; watercolor with graphite.
Subject: People in the street. Doodles. Women carrying a dog, selling flowers, and pushing a baby carriage. Several children, elderly woman with bandaged arm, blind beggar, and man wearing a Russian jacket and fur cap. Two fruit stands, a flower stand, and a few advertisements. Inside front cover has addresses and calculations, inside back cover has small map, addresses, and advertisement.

1954/5 [164]

3 OCTOBER

Notebook with brown paper covers, black cloth spine, and rounded corners. Rigid cardboard attached to back inside cover. Sewn page block. Pages of smooth-surfaced, cream, wove paper with blue and red lines and rounded corners.
Cover dimensions: 14.9 x 9.0 cm
Page dimensions: same
50 pages
no missing pages
no blank pages
28 single-sided drawings
21 double-sided drawings
Front cover inscribed: George Grosz London 3 Okt 1954; White's Hotel Lancaster Gate London W2; **inside front cover imprinted:** Standard Memo Book [and other manufacturer's information]
Technique: Graphite, watercolor and gouache; occasionally ink.
Subject: People in the street: Bobbies, street vendors, people sitting in bus or train, boy in school uniform. Two watercolors with street musicians (one playing accordion, the other playing lute). Three drawings of gladiators, including two engaged in combat, victorious fighter standing with raised sword surrounded by dead bodies. A few house facades, bar and lounge interiors. Lamps, traffic lights, and cast-iron fences. First and last pages and cardboard support have notes and addresses.

1955/1

1955

Outer folder of smooth-surfaced, cream, wove, Tuftear with rounded corners. Sketchbook with sewn page block of smooth-surfaced, tan, wove paper with square corners.
Folder dimensions: 30.0 x 24.1 cm
Page block dimensions: 30.1 x 22.0 cm

14 pages
c. half of the signature missing
no blank pages
4 single-sided drawings
10 double-sided drawings
Folder inscribed: Art Class Htg. 1955
Technique: Graphite, pastel, and charcoal.
Subject: Exercises. Still life arrangements, the human figure, isolated parts of the body. A perspective drawing and two sketches of landscapes are also included.

1956/1 [174]

1956

Hardbound sketchbook with green, cloth-covered, cardboard covers, and square corners. Sewn page block. Pages of smooth-surfaced, cream, wove paper with square corners.
Cover dimensions: 17.7 x 12.0 cm
Page dimensions: 17.1 x 11.7 cm
103 pages
5–7 missing pages
no blank pages
29 single-sided drawings
72 double-sided drawings
Front cover inscribed: 1956 Notebook class Htg. [with small design]; **imprint:** The Scribble=in Book [trademark and logo]
Technique: Graphite; occasionally pastel, prepared chalk; a few with colored pencil, charcoal, traces of oil.
Subject: Exercises and color studies. Compositional studies of placement of horizon line and perspective drawings. Contrast of light and dark planes in a ratio of 1:2. Shading objects, figures in movement. Still lifes, boats, trees, and walls. Several sketches of leaves implement the figure 8 as basic compositional element. Drawings on inside front and back covers.

1956/2 [175]

1956

Notebook with brown paper covers, spiral binding, and rounded corners. Pages of smooth-surfaced, cream, wove paper with blue lines and rounded corners.
Cover dimensions: 22.7 x 15.1 cm
Page dimensions: 22.7 x 14.6 cm
23 pages
missing pages [?]
no blank pages
1 single-sided drawing
22 double-sided drawings
Front cover inscribed: School 1956 Htg Lg. Island; **front cover imprinted:** The Spiral Note Book [logo and other manufacturer's information]
Technique: Graphite; a few watercolors, prepared chalk, traces of oil.

Subject: Drawing exercises. Focus on composition. Placement and effect of objects within a picture plane, perspective drawings, and effects of contrast and shading. Vases, leaves, and geometric shapes such as squares, triangles, and circles. Some fragmentary sketches of figures and drawings of dogs.

1956/3 [176]

1956

Sketch pad with gray front paper cover, rigid cardboard back cover, and square corners. Stapled page block. Perforated pages of smooth, thin, cream, wove paper with square corners.
Cover dimensions: 23.1 x 19.0 cm
Page dimensions: 23.0 x 17.9 cm
45 pages
several missing pages
no blank pages
41 single-sided drawings
4 double-sided drawings
Front cover inscribed: School Notebook 56 Htg
Technique: Crayon, graphite, and watercolor drawings; occasionally with charcoal and ink.
Subject: Drawing exercises address issues of light and shade, contrast, complementary, cool, and warm colors as well as still life and landscape studies. Watercolor with contrasting foreground and background.

1956/4 [177]

1956

Sketch pad with gray front cover, cardboard back cover, and square corners. Stapled page block. Perforated pages of smooth, thin, cream, wove paper with square corners.
Cover dimensions: 23.1 x 19.0 cm
Page dimensions: 23.0 x 17.9 cm
25 pages
several missing pages
no blank pages
19 single-sided drawings
6 double-sided drawings
Front cover inscribed: School Notebook 56 Htg. "Venus de Milo" possibly inscribed by another hand; **back cover:** [Berlin retailer's sticker]
Technique: Graphite and crayon drawings; occasionally charcoal and ink.
Subject: Drawing exercises that address issues such as composition, geometric and organic shapes, perspective, and reflections. Partial construction of a standing figure with auxiliary lines. Slightly twisted upper body and missing arms are possibly a study of the Venus de Milo.

1956/5 [180]

1956

Sketch pad with light brown cardboard covers and rounded corners. Stapled page block. Perforated pages of smooth-surfaced, cream, wove paper with rounded corners.

Cover dimensions: 41.3 x 27.5 cm
Page dimensions: 41.3 x 26.4 cm
8 pages
approximately 20 missing pages
no blank pages
2 single-sided drawings
6 double-sided drawings
Front cover inscribed: Note Book School Htg. 56; **manufacturer's imprint:** same as IX. 179?; **inside front cover:** [Berlin retailer's sticker]
Technique: Pastel, graphite, and a few charcoal drawings; in one case, watercolor.
Subject: Studies of the human figure. Special emphasis on head and eyes. Shading exercises and geometric contrasts. A loose palette. Cover sheet has drawings of nudes and bottles.

1957/1 [181]

1957

Note pad with brown paper covers, spiral binding, and rounded corners. Pages of smooth-surfaced, cream, wove paper with blue lines and rounded corners.

Cover dimensions: 12.7 x 7.6 cm
Page dimensions: 12.1 x 7.6 cm
49 pages
1 [?] missing page
3 blank pages
14 single-sided drawings
31 double-sided drawings
First page inscribed: Skowhegan 1957
Technique: Graphite; some pastel; one colored-pencil drawing.
Subject: Drawing exercises. Several seem to relate to life-study classes. Figure in various poses, including *contrapposto*. Drawings incorporate auxiliary lines, which help to design a figure's pose and muscle structure. A few sketches of portraits show similar auxiliary lines. Other exercises relate to volume, angle, and perspective. Series of shading exercises.

1957/2 [183]

1957

Sketch pad with blue front paper cover, rigid cardboard back cover, spiral binding, and square corners. Pages of slightly textured, cream, wove paper with square corners.
Cover dimensions: 19.9 x 14.7 cm
Page dimensions: 19.3 x 14.7 cm

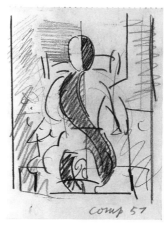

1957/2, 12 recto

21 pages
3 missing pages
no blank pages
no single-sided drawings
21 double-sided drawings
Front cover inscribed: School 57; **imprinted:** Strathmore Alexis Drawing [logo, and other manufacturer's information]
Technique: Graphite; occasional use of watercolor, prepared chalk, charcoal; a few pastel drawings.
Subject: Exercises that focus on still lifes and landscapes. Several renderings of bottles and pots with auxiliary lines or shading. Coal stove, linear perspectives, and a few figures. Abstracted drawing of a figure that emphasizes symmetry and line.

1957/3 [184]

1957

Sketch pad with blue front paper cover, rigid cardboard back cover, spiral binding, and square corners. Pages of slightly textured, cream, wove paper with square corners.
Cover dimensions: 20.1 x 14.7 cm
Page dimensions: 19.4 x 14.7 cm
17 pages
7 missing pages
no blank pages
2 single-sided drawings
15 double-sided drawings
Front cover inscribed: School 57; imprinted: Strathmore Alexis Drawing [logo and other manufacturer's information]
Technique: Graphite; occasional use of watercolor, pastel; trace of oil.
Subject: Exercises in composition and perspective. Frontal

1957/3, 5 verso

views and bird's eye perspectives. Balls, bottles, and faces drawn with auxiliary lines. Two drawings of cellos, geometric forms, grids.

1957/4 [185]

1957

Sketch pad with blue front paper cover, rigid cardboard back cover, spiral binding, and square corners. Pages of slightly textured, cream, wove paper with square corners.
Cover dimensions: 20.1 x 14.7 cm
Page dimensions: 19.4 x 14.7 cm
19 pages
5 missing pages

1957/4, 8 recto

no blank pages
1 single-sided drawing
18 double-sided drawings
Front cover inscribed: School 57; [asterisk also appears];
imprinted: Strathmore Alexis Drawing [logo and other information]
Technique: Graphite; occasionally watercolor, oil, charcoal, and pastel.
Subject: Drawing exercises. Still-life arrangement of bottle, cone, and drapery appears in various techniques throughout the book. The image develops from a rough outline into a shaded drawing and is finally translated into two oil sketches. Portraits, several watercolors, and a pastel drawing of a landscape.

1957/5

1957

Sketch pad with light brown cardboard covers and rounded corners. Stapled page block. Perforated pages of smooth-surfaced, cream, wove paper with rounded corners.
Cover dimensions: 41.3 x 27.5 cm
Page dimensions: 41.3 x 26.4 cm
22 pages
approximately 10 missing pages
no blank pages
14 single-sided drawings
8 double-sided drawings
Front cover inscribed: Note book School Htg. 57; **front cover has manufacturer's imprint:** Monachia-Block [also logo and other information]
Technique: Graphite, pastel, and charcoal drawings; occasionally watercolor.
Subject: Geometric and organic shapes. Still-life compositions and the human figure. Development of two inverted trapezoids into the shape of a cello and finally translated into the outline of a female torso. Various drawings of leaves, fruit, and drapery. Several drawings on inside front cover.

1957/6 [182]

NOVEMBER – DECEMBER

Sketch pad with blue paper front cover, rigid cardboard back cover, spiral binding, and square corners. Pages of slightly textured, cream, wove paper with square corners.
Cover dimensions: 20.0 x 14.8 cm
Page dimensions: 19.4 x 14.8 cm
22 pages
2 missing pages
no blank pages
no single-sided drawings
22 double-sided drawings

1957/6, 16 recto

Front cover inscribed: 1957; Des Moines Nov - Dec 57; Strathmore Alexis Drawing [logo and other information]
Technique: Graphite, watercolor, and prepared chalk; two pastel drawings.
Subject: Exercises. Still-life arrangements of bottles, draperies, flowerpots, and vegetables. Landscapes and cityscapes focus on coloring, shading, and perspective. Series of drawings of a boat on the water inscribed "P. Breugel." Portraits and linear-perspective exercises with two vanishing points.

1957/7 [188]

1957 – 1958

Note book with black-and-white paper-covered cardboard covers, black cloth spine, and rounded corners. Sewn page block. Pages of smooth-surfaced, off-white, wove paper with blue horizontal lines, one vertical red line, and rounded corners. Taped to inside back cover are 3 separate sheets of paper.
Cover dimensions: 24.6 x 19.0 cm
Page dimensions: same
119 pages
1 [?] missing page
22 blank pages
15 single-sided drawings
82 double-sided drawings
Front cover inscribed: Art School 1957; 1957 Skowhegan 1958; **manufacturer's imprint:** Jameco Composition [logo also appears]; **inside front cover inscribed:** June 1957 Htg. Lg. Island
Technique: Graphite and charcoal; occasional use of crayon and watercolor.
Subject: Studies of shading, contrast, and perspective. Human figure, still-life arrangements, geometric and organic shapes, sketches of flowers and vegetables. Two reproductions taped to

inside front cover of El Greco's *Carpenter* and a Greek relief with female portrait. Two drawings are on these separate sheets, one featuring the right arm of the *Carpenter*.

1958/1 [187]

C. 1958

Sketch pad with gray cardboard front cover, rigid cardboard back cover, spiral binding, and square corners. Pages of slightly textured, cream, wove paper with square corners.
Cover dimensions: 20.1 x 14.7 cm
Page dimensions: 19.5 x 14.7 cm
20 pages
4 missing pages
no blank pages
5 single-sided drawings
15 double-sided drawings
Front cover imprinted: Strathmore Alexis Drawing [also logo and other manufacturer's information]
Technique: Graphite; occasionally prepared chalk, colored pencil.
Subject: Exercises of shading, geometric shapes, and volumes. Draped clothes, human figures, architectural drawings, and construction details. Rough sketches of seated male nude and a figure in motion (the latter designed with an *8* as auxiliary line). Number of children's drawings (possibly by one of Grosz's grandchildren). In several cases Grosz seems to have drawn examples that the child copied.

1958/2 [186]

JANUARY

Sketch pad with gray cardboard front cover, rigid cardboard back cover, spiral binding, and square corners. Pages of slightly textured, cream, wove paper with square corners.
Cover dimensions: 20.1 x 14.7 cm
Page dimensions: 19.5 x 14.7 cm
21 pages
3 missing pages
no blank pages
1 single-sided drawing
20 double-sided drawings
Front cover inscribed: School 1958 January; **imprinted:** Strathmore Alexis Drawing Pad [with logo and other manufacturer's information]
Technique: Graphite; occasionally watercolor, prepared chalk, and traces of pastel.
Subject: Studies of hands, feet, face, and occasionally, the whole figure. Gradual development from auxiliary lines and triangle into female torso. Two seated figures with triangle as basic compositional element. Several exercises address contrast and composition. Some branches and a foot and shoe.